ROTOSCOPING

ROTOSCOPING
Techniques and Tools for the Aspiring Artist

BENJAMIN BRATT

UNIVERSITY OF WINCHESTER
LIBRARY

ELSEVIER

AMSTERDAM • BOSTON • HEIDELBERG • LONDON • NEW YORK • OXFORD
PARIS • SAN DIEGO • SAN FRANCISCO • SINGAPORE • SYDNEY • TOKYO
Focal Press is an imprint of Elsevier

Focal Press is an imprint of Elsevier
30 Corporate Drive, Suite 400, Burlington, MA 01803, USA
The Boulevard, Langford Lane, Kidlington, Oxford, OX5 1GB, UK

Notices
Knowledge and best practice in this field are constantly changing. As new research and experience
broaden our understanding, changes in research methods, professional practices, or medical
treatment may become necessary.

Practitioners and researchers must always rely on their own experience and knowledge in evaluating
and using any information, methods, compounds, or experiments described herein. In using
such information or methods they should be mindful of their own safety and the safety of others,
including parties for whom they have a professional responsibility.

To the fullest extent of the law, neither the Publisher nor the authors, contributors, or editors,
assume any liability for any injury and/or damage to persons or property as a matter of products
liability, negligence or otherwise, or from any use or operation of any methods, products,
instructions, or ideas contained in the material herein.

Library of Congress Cataloging-in-Publication Data
Application submitted

British Library Cataloguing-in-Publication Data
A catalogue record for this book is available from the British Library.

ISBN: 978-0-240-81704-0

For information on all Focal Press publications
visit our website at www.elsevierdirect.com

11 12 13 14 5 4 3 2 1
Printed in China

CONTENTS

ACKNOWLEDGMENTS

I am grateful to a number of people. These are just a few of the individuals who helped this book become a reality.

Steve Wright was absolutely essential in the creation of this roto book. His wise insights and vast industry knowledge played a crucial role in the development of this text, which couldn't have been completed without him. Well, it technically *could* have been done without him; the point I'm trying to make is that it wouldn't have been done *as well* without him. I'm also grateful for his wonderful advice on writing, without which none of the following would have made as much sense. Thank you, sir.

Marco Paolini and the founders and creators of Silhouette were a welcome source of information and helped me around every turn. Their top-notch roto software was a key component in the creation of this book.

Aaron Muszalski was my rotoscoping instructor at the Academy of Art in San Francisco. Through him I learned not only the techniques and principles of speedy matte creation but that this work is more than merely splines and key frames. His passion and enthusiasm for education led me to a deeper understanding of rotoscoping. I'm eternally in his debt.

Dennis McGonagle and Carlin Reagan, my contacts at Focal Press, have been very understanding and exceptionally patient with my rookie questions and constant bothering. They've made my transition to the written word bearable, or at the very least a bit more legible.

Katherine Tate and Tom Bertino are two world-class educators at the Academy of Art. Their knowledge and teaching ability have inspired hundreds of VFX professionals—me included—to thrive in the industry.

Max Walters and Sharon Youngue put up with my youthful vigor and somehow managed to educate me at the Art Institute of Pittsburgh in my days as a wee lad. Also thanks to Mike Schwab who introduced me to my first animation table.

Big thanks must go to Michele Yamazaki for introducing me to the wonderful people at Focal Press.

Angie Mistretta, Danial Zen, Erin Lehmkühl, Nate Caauwe, Tim Sazama, and Beverly Sage were all nice enough to let me use their footage or their likenesses for the various exercises and examples that follow. Their cooperation is very much appreciated.

Special thanks to Nate Caauwe for his valued input on a few of the tougher chapters.

Jessica Albritton has been patient and completely accepting of the troubles I encountered for the duration. She's been a constant source of love, beauty, and understanding, and I can't begin to tell you how important she's been to me.

And of course, thanks to my family.

INTRODUCTION

Rotoscoping is very much an invisible art form. For roto artists to do our jobs correctly is to avoid being seen. We are the ninja of the compositing world, and our stealth is near legendary.

What we do can be challenging, but a perfect matte is its own reward. After you've tackled the edges, motion, and varying blurs of a complex focus object, creating a perfect black-and-white replica that clearly communicates the edge and movement of those elements, you can sit well with the knowledge that you've managed something great.

The beauty of rotoscoping is that you can do it after the fact. All the creative decisions don't have to be made on set, that day, while the camera is rolling. Instead elements can be added, changed, color corrected, or taken away once the shot is in the can, without reliance on a green-screen stage or reshoots. It gives a tremendous amount of artistic freedom to the creative forces behind the production.

The flexibility that roto allows for altering shots, regardless of how they were originally photographed, means that roto artists play an essential role in any production, whatever its size. Whether that endeavor is a small, independent film, a television pilot, or a summer blockbuster, rotoscoping is a vital part of any visual effects creation.

Modern production pipelines are extremely reliant on the art of matte creation. No matter what the production or production house, a capable roto artist is a highly valued member of the visual effects (VFX) team.

Large VFX companies have entire departments dedicated solely to creating mattes for elements so that the compositors will be able to correctly isolate and manipulate the images to the director's liking. Smaller, more streamlined companies probably won't have dedicated roto departments, so the responsibility will generally fall on a shot's compositor to generate the mattes for their own use.

Even if you aren't destined to become a roto artist, it is an essential skill for any working compositor. This book will help you perform rotoscoping faster and more efficiently than ever before.

The purpose of this book is to give budding VFX artists and seasoned professionals alike the core skills necessary to create accurate and usable mattes. With these principles, you'll be

able to quickly break down a shot into its basic movements and shapes and then formulate a plan of attack as to the best method of isolation. There is knowledge enough for everyone in the following pages, whether you're at the beginning of your career or have years of experience under your belt.

The book's chapters cover the following:

- Estimating and planning the most efficient way to tackle a shot
- Optimal shape breakdown for both simple and complex focus objects
- Streamlined key framing structures, with focus on minimizing the number of necessary key frames
- Spline creation that will maximize your ability to use and reuse shapes
- Techniques to increase the versatility of your rotoscoping workflow
- Keeping your shapes consistent and minimizing "jitter"
- Incorporating the use of tracking to drive the transforms of your shapes, helping to automate the matte creation process
- Easily creating mattes for complex focus objects, with special attention to hair, human motion, and motion blur
- Perspectives that will allow you to focus your attention for long periods of time

When I was introduced to roto many years ago, I immediately took a liking to it. It might have been my background in animation, or perhaps the technique simply meshed with my particular worldview or skill set. In either case, I had found something that I loved to do. When you do something you love long enough, though, you occasionally forget why you loved it in the first place. Writing this book has afforded me the opportunity to relive my beginnings in rotoscoping and has increased my appreciation for the subtle artistry necessary for creating quality mattes. In writing this book I remembered why I became passionate about roto and how much satisfaction it gives me. I hope I can relay some of that passion to you.

Benjamin Bratt
www.bbrattvfx.com
October 2010

ORIGINS OF ROTO

1.1 Origins of Roto

In 1917, a cel animation house called Fleischer Studios, based in New York, was approved for a patent. The newly official machine had been in use for several years, to great success, to create the *Out of the Inkwell* series. They called this machine the *Rotoscope*.

With this device, Fleischer Studios went on to produce more than a few notable cartoons and characters. The more significant of their creations were Koko the Clown, Betty Boop, and Popeye the Sailor. They were also responsible (in conjunction with Famous Studios) for the well-known Superman cartoons released in the early 1940s.

The Rotoscope consisted of a camera mounted behind an animation desk, projecting film footage onto a slate of frosted glass. The animator would trace the frames of live action onto paper. A system of pulleys allowed the animator to advance the film, frame by frame. Once the artist had completed the animation, the reams of paper the artist produced would be traced onto clear animation cels and painted accordingly.

The innovation of the Rotoscope was the opportunity to study human movement within the medium of cel animation. Before this device was invented, animators would take great care to accumulate references for their shots. These references ranged from photographs and projected film footage to acting out the movements themselves in front of a mirror. This reference material, though helpful, still had to be communicated from memory to paper. With the Rotoscope, an animator could emulate the subtlety of human movement as it was taken directly from the subject of his or her animation.

Along with the Rotoscope, the artists at Fleischer pioneered the practice of having the lead animator draw the "key" poses

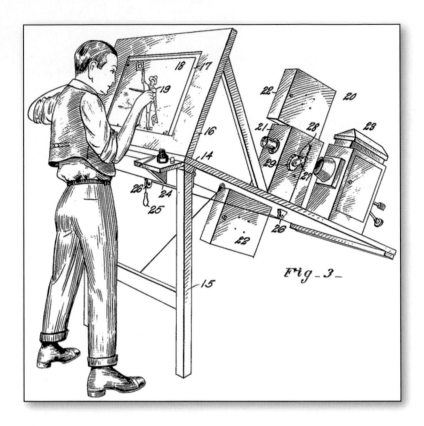

Figure 1.1 Patent drawing of the Rotoscope.

while a subordinate artist filled in the in-between animation. This practice is still used by modern 2D animation studios.

Rotoscoping began to evolve, and not just as an animation tool. Filmmakers used the Rotoscope to create hold-out mattes so that other optical effects and images could be inserted behind elements in the footage. Roto artists would trace the foreground elements onto cels and then fill the traced area with a toxic-smelling black opaquing fluid so that the images placed behind them wouldn't bleed through.

This technique was used frequently to add visual sophistication to shots. A director was no longer limited to what could be created on set and filmed. If a shot called for an actor to be chased by a pack of wild birds, the two elements could be filmed separately and put together after the fact. The moviemakers weren't required to try to wrangle all the elements of the shot together at the same time.

This system of hand-painted optical mattes was used until digital compositing became the standard in the early 1990s.

1.2 Modern Roto

The beginnings of VFX are important for rotoscoping artists to understand. Ideas and techniques that were established early on have influenced the way our industry has evolved and how we interact with our media. If you take Fleischer's Rotoscope (including the idea of having animators make "key" drawings) and you throw in Disney's multiplane animation camera, you have the beginnings of digital visual effects, which allowed animation artists to:

- View the footage while animating
- Isolate and separate layers of the footage
- Establish key frames

All these innovations became the groundwork for software developers and artists in the film industry. The idea of key frames is used in many aspects of VFX programs: 3D animation, particle creation, compositing, motion graphics, and rotoscoping. All these programs and focuses make user-defined key frames the basis for element creation.

The workflow of predigital roto artists hasn't changed significantly. The base concepts of roto still apply. Then, as today, roto artists are required to create accurate, usable mattes in the shortest time possible. The most defining difference between the way artists worked then and the way they work now is the tool set of a modern roto artist. Digital rotoscoping software has turned the work of an entire roomful of people, done in a few weeks, to an artist with one workstation who is able to complete the same task in a few days.

The principles that govern an animator's work also apply to modern roto artists. Modern roto is like animation but in reverse. Roto artists are responsible for holding true to the real world. The difference is that roto artists don't create the real world; they mimic it.

Animation principles are based on actual, real-world movements. It is a roto artist's job to accurately mimic that movement. Understanding the principles of creating that movement is key to becoming a solid roto artist and visually emulating that movement through:

- Secondary motion
- Squash and stretch
- Antici . . . pation

Although a thorough knowledge of animation principles isn't necessary for a roto artist, it does help to know where the art came from as well as to understand what to look for and compensate for.

Artistic roto is still used in modern films and commercials. The films *A Scanner Darkly* and *Waking Life* used this technique

to great effect by convincingly portraying the altered reality states of characters and tone in both films. Bob Sabiston created software called Rotoshop, which specifically translates the workflow of the original Rotoscope into the digital age of filmmaking. This proprietary software was used on both these films and numerous shorts and commercials, but it has not been made available for public use.

Though the effect of artistic rotoscoping is visually interesting, the process of converting film images into fully realized roto-enhanced frames is still a big investment. It isn't simple matte creation. Every contour of every object in the shot must be isolated and colored individually. Because of the time, staffing, and budget-intensive nature of artistic rotoscoping, it is used sparingly.

Matte creation has become the main focus of current roto artists. Mattes are used for compositing, color correction, clean plate creation, and a host of other VFX techniques. Isolating individual elements with mattes has become a quiet staple in the industry. It's important because of its application to any shot. Any element within the footage can be isolated without reliance on a green-screen shoot. Rotoscoping gives a large amount of creative control to filmmakers after all is said and done. "Fix it in post" has become all too familiar vernacular in the industry. Once the shot is in the can, a director can keep the actors' perfect performances in a scene but replace a background that has several distracting and unnecessary elements.

Roto is a vital tool for the visual effects industry. Mattes are required for just about everything these days. Whether it's a VFX-heavy film or an independent romantic comedy, chances are there will be some need for a rotoscoping artist on the job.

2

DEFINING THE TERMS

A roto artist must be familiar with a set of terms and definitions. These terms are not only key to understanding rotoscoping, they are necessary for success in the VFX industry:

- *Comp.* Short for *composition*. This is a general term used to describe a digital artist's work area. This includes the timeline, viewing area, and layering and effects windows—pretty much anything that you look at while working in a VFX program. This applies (but is not limited) to roto artists, compositors (also called *compers*), and motion graphic designers.
- *Matte.* A black-and-white frame or set of frames that tells the program what is visible and what isn't. White (color ID 1) is visible; black (color ID 0) is not. Gray areas are visible depending on their numerical position between 1 and 0. Compositors use the matte to isolate areas within the comp.

Figure 2.1 Final mattes.

- *Control points*. Also called simply *points*, these are a series of user-defined locations that, when created, determine the contour of the spline. Points can be broken down into two separate categories:
 - *Nonhandled points*. As a roto artist, you'll generally want to choose the option that doesn't have individual handle control (also called *tangent handles*). This type of spline doesn't allow the user to alter the angle of the incoming or outgoing curve without moving the position of the point itself or its surrounding points. This spline is used most often in roto because, when used correctly, it has a natural, consistent motion, with little chance of adding unintentional jitter to the matte. The only problem with nonhandled points is their inability to make extreme corners without adding extra points. When you're doing articulate roto in After Effects, this sort of point/spline is called Rotobezier. Silhouette's spline of this sort is called B-splines. Though subtly different, these two splines handle themselves in approximately the same way.

Silhouette B-spline.
Figure 2.2

An After Effects Rotobezier spline.

- *Handled points*. This type of point has tangent handles that will increase or decrease the angle of the curve through the point, depending on the distance the handles are from the point. Depending on how you treat these handled points, the curve through the point can be "broken."

Figure 2.3

Silhouette Bezier Spline. After Effects Bezier Spline.

- *Spline*. This is a set of points connected by a line made up of curves. The spline can be animated using either the individual points or the object as a whole. There are several kinds of splines, and each program labels them differently, depending on the kind of point you use to create it.

Figure 2.4 Splines.

- *Shape*. A closed spline; the term refers to the spline as a whole, not merely the individual points.
- *Edge*. This is the outside of the shape and, ultimately, the most important aspect of rotoscoping.

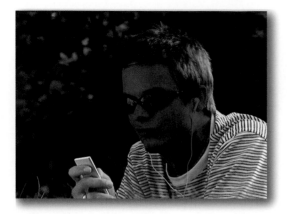

Figure 2.5

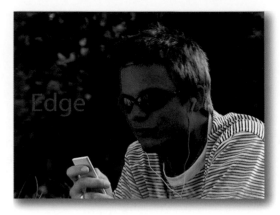

Figure 2.6

- *Motion path.* This is the course an object takes on the screen. In terms of roto, this path should be strictly defined within the X and Y.

Figure 2.7 Motion path.

- *Key frame.* A value within the timeline set by the user to establish a set value for that object at that frame. Anything can have keys set for it, but the majority of roto techniques will involve only Position and Visibility.
- *Focus object.* This is what you'll be isolating and creating a matte for. In reference to this text, it can refer to a whole object (for example, a person) or to a specific section of an element (for example, the screen left arm).
- *Tracking.* The process of creating position, rotation, and/or scale key frames based on an element in the footage. Tracking

can be used to apply the resulting key frames to a spline or set of splines. It can also be used to stabilize jittery footage. There are two types of tracking:

- *Point tracking* will generate key frames based on a single user-defined point within the footage.
- Planar tracking generates key frames by tracking a number of points and treating them as though they were all on the same plane.

- *Alpha channel.* This is a technical name for a black-and-white matte. It can be embedded into certain file types. Compositing programs break down the image into RGBA channels. This can be further expanded to red, green, blue, and alpha.

- *Frame range.* The length of the required number of frames. This term can apply to the entire length of the shot or to a specified smaller portion of the whole.

Figure 2.8

- *Interpolation.* Process whereby the computer creates position or visibility keys between user-defined key frames. Whether X and Y coordinates or visibility range, the values established by the computer are averages of the bordering key frames.

- *Keying.* A process by which sections of the footage are removed by singling out a visual constant. Mattes are created based on the hue or luminance of the image. This technique is largely used when footage is shot on green screen, but it can also be used in conjunction with roto. When a shot is "keyed," the computer will subtract—that is, remove—the areas of the shot that are similar in color or brightness while keeping the unlike areas visible.

Figure 2.9

- *Object mode*. While working in this mode, a roto artist manipulates the shape as a whole, without altering individual points along the spline. It is suggested that you work in this mode as much as humanly possible.
- *Sub-Object mode*. This mode gives access to the individual points along the spline. It is suggested that you manipulate splines in this mode as little as possible. It cannot be avoided in some situations, however.

3

ROTOSCOPING SOFTWARE

A multitude of programs offer rotoscoping as a tool set. These programs aren't all strictly rotoscoping software. Since splines are such an integral part of the compositing workflow, comping programs such as Nuke, Shake, Combustion, Flame, and After Effects all offer some sort of spline-based manipulation.

3.1 Roto Tools

The roto tools among the various comping and rotoscoping programs vary in their use, interface, and capabilities, but as far as roto is concerned, there are many constants. For one thing, they all have spline creation. When you're creating a spline, you select the spline creation option and click on points around your focus object. This generates a spline that will be used to isolate an element in the footage. There are several types of splines in use in the VFX industry; they are all called something different by each program:

- *Bezier splines*. These splines are the forefathers of all the various splines that have come since their creation in the 1970s. The points of a Bezier spline have handles that can be moved to alter the angle and size of the curve as it moves through the point. The handles of these points can be relative to one another, meaning that the angle and size of the curve as the curve moves through the point will stay relatively the same as the handles are altered. Or these points can be "broken," meaning that the angle of one side of the point doesn't necessarily have to be constant; the spline, as it goes through the point, can have decidedly different angles. This type of spline is well suited for hard corners and angularly shaped focus objects. The handles on these splines can be hard to keep consistent when you're manipulating a spline over an amount of time, so they should be handled with care.
- *B-splines*. The angles of the curves as they move through the points of these splines can be changed by their relative position to one another. They aren't great for isolating

hard corners or angular focus objects, but they offer realistic, organic-looking edges that are excellent for communicating human movement. The lack of handle on these points also makes this sort of spline ideal for keeping your shapes consistent as the contour of your focus object changes.

Both these types of spline have strengths and weaknesses, and roto artists are fanatical about their particular spline of choice. If you're just starting out, you might want to begin by using a B-spline (called Rotobezier in After Effects). These splines have a fluidity that is necessary for believable roto and offer the smallest chance that you'll inadvertently introduce jitter into your mattes.

All splines can have some sort of blur, or feathering, applied to them, but the way and manner in which that blur is applied varies a bit from program to program.

These splines can all be manipulated on two levels: Object and Sub-Object. Object mode deals with the spline as a whole, without changing the points individually. When you're working with a shape in Object mode, a bounding box appears around the shape. With this bounding box, a shape can be scaled, rotated, and positioned while keeping its general shape consistent. It is preferable to manipulate the spline in Object mode because it keeps the shape constant for the life of that shape and minimizes jitter.

Moving individual points along the spline can be dealt with in Sub-Object mode. However, moving individual points, though sometimes necessary, will increase the chance that the matte will "chatter" as well as increase the amount of time spent on that shape.

Figure 3.1 Object mode.

It should be noted at this point that you can deal with *sections* of a spline in Object mode. Selecting only a portion of the individual points and then shifting to Object mode is a great way to prolong the use of the shape, without being forced to create a new spline or manipulate the existing one in Sub-Object mode.

Another constant with roto software is a *timeline* (Figure 3.4). After a spline is created, it can be animated by designating position and visibility key frames. These key frames are then visible along the timeline at the user-defined frame.

Note

There's more to learn about working with shapes in Object mode in Chapter 8, "Object Mode Transforms."

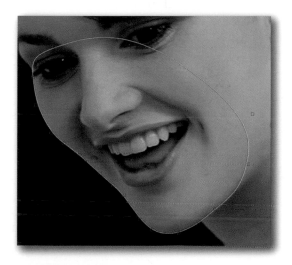

Figure 3.2 Sub-Object mode.

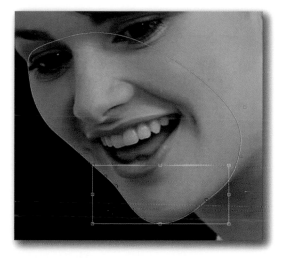

Figure 3.3 A portion of the points being manipulated in Object mode.

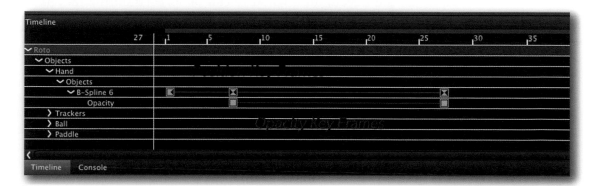

Figure 3.4 Timeline with Position & Opacity Key Frames.

Organizational capabilities also vary in software packages, but they all have the ability to manage the comp such that the individual elements are easily identifiable and can be separated into folders or layers.

Tracking is a key component of roto software. The level, type, and quality of the tracking vary from software to software, but tracking is generally a time-saving option. With tracking capabilities, a spline can be set to follow a motion path as defined by the computer, which creates position key frames based on a consistent point in the footage. Or, on the other end, footage can be stabilized to minimize the motion of the plate.

Motion blur is another staple in roto software. Objects that move with great speed generate a blur and cannot be isolated with simple splines. When used correctly, motion blur can help you create consistent and usable mattes.

Whatever software you prefer, all these tools can be utilized to streamline your workflow and increase your value as a roto artist. Learning what these tools do and how best to use them in whatever package you roto in is the best path to becoming an efficient roto artist.

3.2 Keyboard Shortcuts

While you become more accustomed to the base principles of rotoscoping, you should be looking to streamline that process so that not only do you create solid, usable mattes, but you do so quickly. A fast, consistent roto artist will always be a necessary asset to any VFX house.

Keyboard shortcuts enable you to keep their eyes on the screen for a good majority of the time. There isn't the need to visually "restart" if the tool can be changed without the focus of the artist moving from the screen to the keyboard and then back to the screen. An artist's eye can be focused on the movement and path of the object. Ideally, one would never look away from the screen while the opposite hand roves the keyboard without hesitation. Keyboard shortcuts are important components in a roto artist's arsenal.

While you're going through this book and working along with the exercises and examples, try to learn the keyboard shortcuts of your roto program of choice. These shortcuts will come in handy later. Each program is different; they're obviously going to have a different set of shortcuts. Again, though, all the shortcuts have the same functions. The following are the most frequently used shortcuts when your aim is matte creation.

3.2.1 Creating Spline/Type

- *Spline/shape creation.* A big portion of a roto artist's day is spent creating shapes with splines. With the average spline count reaching into the hundreds, knowing the quickest way to access the tool is a very good way to streamline your workflow. As mentioned, there are several types of splines, and generally there's a keyboard shortcut for creating the different sorts you'll be using, most notably Bezier and B-splines.

3.2.2 Editing Controls

- *Nudge shape/points.* This tool is used frequently for the marginal position changes an object can make. It can be set up to move one pixel at a time or (while holding a control button) 10 at a time. If the distance between keys is minimal, it's very useful to merely nudge the shape/points rather than click and move. These are generally the arrow keys.
- *Deleting shapes/points.* You'll need to delete a fair share of points and shapes as your experience with roto increases.

3.2.3 Timeline Controls

- *Forward/back a frame.* These shortcuts are probably used the most when doing roto because otherwise you would have to move the pointer from your focus object's shape to the on screen forward/back button every time you needed to move within the timeline. It's much faster to keep your eyes and pointer on the focus object and its motion path while scrubbing forward/back with the keyboard shortcut.
- *Next/previous key frame.* Great for quickly checking the accuracy of your shapes at their respective key frames.
- *Jump in/out point.* If you've sectioned off a range of frames in your comp, you'll need to be able to move to the allotted range without hesitation.
- *Jump start/end of clip.* This shortcut comes in very handy when you're starting out a shot using any of the timeline-based key framing methods.

3.2.4 Transformation (Object or Sub-Object)

- *Translate shape/points.* You'll be moving a lot of shapes and points around.
- *Rotate shape/points.* Whether it's the whole shape or a selection of the whole, you'll need to rotate the selection to match the focus object. This tool set varies in its application,

depending on the software used, but within this tool, you'll have the ability to rotate the shape. Also you'll be able to rotate the shape from a user-established rotation point, which is useful for fast roto.

- *Scale shape/points.* This tool set is used frequently because of its ability to change the scale of a shape without changing the contour and relative distance between points along the edge. Moving individual points will create jitter in your matte. Scaling the shape as a whole will minimize that possibility. It should be noted that although you can scale a set of points, the software doesn't create a specific "Scale" line of keys in the timeline.

- *Object/Sub-Object mode.* Switching between these two modes happens frequently. This technique is used often to high-light a selection of points along the spline; then, after switching modes, manipulate just those points. Depending on your particular program, you might not be able to "switch" these modes via a keyboard shortcut.

- *Undo/redo.* Because, hey, no one's perfect. This keyboard shortcut is pretty consistent in all programs.

3.2.5 Viewer Controls

- *Panning.* You'll need to move about the screen quite a bit, par-ticularly if your focus object has a chaotic motion path.

- *View switch.* It is helpful to view the matte in its different forms. Viewing the matte as a different-colored section on top of the footage can expose the difference between the edge of the focus object and the matte, which isn't always obvious when you're viewing just the spline. Things that mar the focus object's edge, such as motion blur and bleed from background items, aren't always immediately apparent. Often when you're creating overlapping shapes, the movement and motion of the mattes create small holes in the mattes where the shapes don't completely overlap. Seeing the matte in just black and white can be very helpful for spotting holes. This viewing option shortcut varies significantly from program to program.

- *Viewer zooming.* This shortcut varies greatly between pro-grams, but it is very necessary to use it to focus in on specific areas of the footage.

- *Stabilized.* Some programs, most notably Silhouette and Mocha, give you the option to view a tracked element within the footage as being stabilized. This viewing option is great for checking the accuracy of a track and saves you from having to reapply the track as a positive transform.

3.3 Silhouette

Silhouette is robust, hard-core, streamlined rotoscoping software. This is a wonderfully intuitive rotoscoping program.

Silhouette was designed purely with roto/paint in mind, and the interface and workflow create an optimal situation in which elements are isolated quickly, allowing the user to easily maneuver the shapes into the correct position. This program allows a roto artist to seamlessly switch tool sets with ease.

The learning curve is low and it is very easy to pick up. Silhouette holds the top position as the roto program of choice among most roto artists.

Perhaps the finest thing about this software is the ease of use and location of the keyboard shortcuts. They are all in the same area on the keyboard and can be easily accessed while your hand is on the "home" typing keys (*a s d f*). This makes changing tools and creating splines very easy. Changing the rotation point of a focus object is a very simple process, as is shifting between Object and Sub-Object mode.

There is an excellent nonuniform scale that allows you to modify a section of a shape without altering already accurate edge sections. It involves pinning down one side or corner of the shape while the user manipulates the opposite side.

Silhouette also has useful keyboard shortcuts that make it very easy to view your shapes, a shaded area of your shapes over the footage (colored overlay), and the alpha channel of your shapes.

The software also has a superb point tracker, which requires little by way of input from the user and usually tracks just about anything you put in front of it. Silhouette has easily accessible tracking options with which you can vary the blur, sharpness, contrast, and noise of the tracking area. It has a great option to view your tracking data as it relates to the footage or with your track as stabilized. This is a great tool for minimizing the work involved when you deal with footage that requires heavy stabilization. Combining (also called *averaging*) several tracks is a button click away. It does have a planar tracking option, but it can be a little glitchy. The keys produced don't always quite stick and require a lot of user input and fine fiddling.

Another great feature is the MultiFrame button, which allows you make changes to your shape to already established key frames. This comes in handy when you've mistakenly included an element in your focus object that isn't something you want included in the matte.

Silhouette does come equipped with some light comping tools, but its main tool set are the Roto and Paint sections. Its organizational features are simple, straightforward, and perfect for roto.

The interface is easily customized to your various rotoscoping needs and has standard viewing options that lend themselves to fast roto.

3.3.1 User Interface

The various screen shots and examples contained in this book will be of Silhouette's user interface, so we'll briefly cover the basics here. Generally speaking, whatever software you choose will have some variation of the controls and windows that follow.

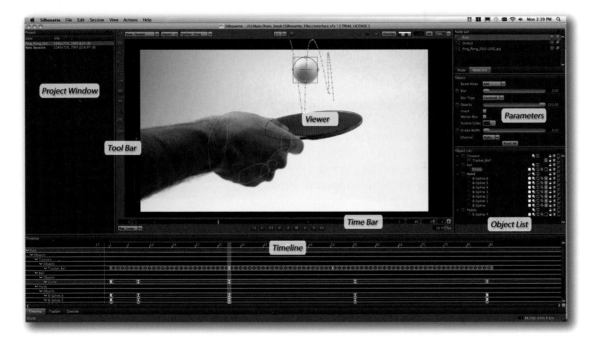

Figure 3.5

Project Window

This is where your footage and individual sessions are located. From here you can replace footage and edit the specifics of your sessions and footage.

Timeline

When you set position and visibility key frames, you'll be able to move, edit, or delete them in this window. This is also where you'll interact with the tracking key frames and where you can access the tracker tools.

Figure 3.6 Timeline.

Figure 3.7 Tracker controls.

Toolbar

The various tool sets are located and accessed here.

Object List

This is the panel where all the shapes you create will be accessed in terms of their various modes. In this window you can select, lock, hide, combine, rename, or delete shapes, layers, or trackers.

Figure 3.8 Object list.

Parameters

When a shape, layer, or tracker is selected, this is where you can change the blur, opacity, spline color, or stroke width or turn on the motion blur. Also from here you can change the mode in which the selected spline reacts with the other splines. This panel gives slightly more in-depth options for your selected shape, layer, or tracker.

Figure 3.9 Parameters.

Viewer

This is where a length of frames is viewed and shapes are manipulated.

Time Bar

This is a convenient little bar that acts like a mini timeline. Key frame indicators appear as objects are selected. It's a great feature when you're working in full viewer mode.

Figure 3.10 Time Bar.

3.4 After Effects

After Effects (AE) is probably the most popular rotoscoping software available. Its popularity stems from its many varied uses and years as an industry standard. AE has good tool sets for roto, paint, comping, keying, and motion graphics.

Though AE refers to its roto tool set as Masking, don't be fooled; its roto tools are solid. It incorporates easy access to and manipulation of splines in both Object and Sub-Object modes with excellent organizational capabilities, although it doesn't make any specific references to these particular spline states in the program.

Because After Effects has such a varied arsenal, the keyboard shortcuts weren't specifically designed with rotoscoping in mind, so it might take a bit of time to become accustomed to them. After a while, though, working in AE becomes second nature, and your hand will soon find the needed keyboard shortcuts without even a glance.

The software doesn't yet have an incorporated "click + key" zoom operation (as of CS5), which can make getting around the view area a bit clunky at times. The tracker isn't as consistent as with some other software, but it is manageable. It might take some time to get a track that sticks, but it will get there eventually.

AE makes combining mattes a very easy process. This layer-based compositing system has a clear and concise process for changing the state of your layers and shapes to create the subsequent matte.

A new addition to AE is the Rotobrush tool. This is a tool designed to identify, isolate, and create mattes without using frame-by-frame roto. The software takes what the user loosely identifies as the matte area and isolates that section. This selection can be feathered, pulled in, or expanded. This new addition works wonderfully for focus objects that don't have too much change in their edges or that have limited movement.

This tool is a great idea, but it falls short in creating consistent mattes for uses outside AE. The generated mattes don't have the realistic flow that rotoed mattes have. As with other automated rotoscoping processes, this one lacks the human artistry required to create convincing and usable mattes. It does have its uses and

will save you time on certain occasions, but generally speaking, if a matte can be generated using Rotobrush, there's a good possibility that the same (or better) matte can be achieved through a key of some sort.

The interface is easily customizable for whatever your specific project needs.

3.5 Mocha

Tracking is always a helpful tool when you're looking to create mattes for a shot. But a good majority of the time, a simple point tracker isn't able to generate usable tracking data, simply because the focus object you're trying to isolate doesn't have any single points that stay visible for the length of the shot or that convey an accurate rendering of that focus object's motion path.

This is why Mocha is such a powerful tool when it comes to isolating elements and creating usable mattes for those elements.

Mocha is top-of-the-line tracking software that currently has the finest planar tracking math in the industry. It was originally designed as a planar tracker, from which the tracking and stabilizing data could be exported to a wide range of compositing programs.

Planar tracking is when an entire set of points is tracked versus the singular points of regular trackers and the resulting tracking data is then applied to a shape (or multiple shapes), which then follow the elements with tremendous accuracy.

Mocha is the rotoscoping version of several different products released by Imagineering Systems that use planar tracking math to expedite various VFX processes. Although Mocha's roto tool set isn't currently as robust as others, the mattes resulting from this program are exceptionally serviceable.

Mocha's timeline and interface are pretty standard for programs of this sort, though the interface can be a little intimidating on first introduction to the software.

Mocha has an excellent system of linking various elements, shapes, and tracks. This sort of intricate linking would normally be somewhat complex, but the simplified linking interface clearly shows what's linked to what, and how. The linking in Mocha is particularly elegant in its presentation.

Mocha has a great viewer option that allows you to view the tracking data as stabilized, which saves you from having to reapply the tracking data after you've isolated the focus object with the tracking data applied as a stabilization.

The planar tracking is very useful, but you don't necessarily need to apply that data as a planar transform or even within the software itself. You can export the planar tracking data from

Mocha and use the coordinates generated as tracking data in other programs. This means that that if your roto program of choice is having a hard time creating a usable track for a particular object, you can track that object in Mocha, then export the planar tracking data as basic XY coordinate data, and apply that to a layer in other programs.

Mocha's strength lies in its ability to track the untrackable.

4

PRE-SHOT WARM-UP

Before you jump into the shot, there are a few things you need to consider. Fight the urge to just start making splines and see what happens. That way lies chaos . . . and a significantly more complicated shot. Training your eyes and brain to visually isolate areas within the focus object is very important when you're learning to roto. It isn't an easy thing to do and can take a few tries before it begins to take shape (pun completely intended). If you're patient and stick with it, however, these techniques will become second nature; after a while you won't even need to think about these beginning steps. This chapter will give you an idea of what to look for before you get started on the shot.

4.1 Establish Specifics

There are roto horror stories that all involve initial misconceptions about what was asked of the roto artist and what was ultimately delivered. Most of these stories revolve around confusing the names of the focus objects and the length of the shot, but if something can be misconstrued, under-explained, or mislabeled, it will bc. What is cxpcctcd of a roto artist within the confines of a shot is exceptionally important to nail down early, before you've started working.

4.1.1 Shot Length

The first thing that needs to be established is the length of the shot. This is important because no matter the artist's level of experience, roto is still a time-consuming process. You're still dealing with a length of frames on a frame-by-frame basis. Establishing the length of the shot (a.k.a. number of frames) needs to be done at the onset of the project.

Roto is often one of the first stages in the post-production world, and compers need mattes to define, separate, and color correct specific areas in the footage. No polished, finalized work can be produced without correct mattes provided by the roto artist.

Frame range. The length of the required number of frames. This term can apply to the entire length of the shot or to a specified smaller portion of the whole.

Occasionally, a roto artist is given more frames than necessary. Although the shot may be 150 frames long, you might only need to create a matte for a focus object within that footage for frames 75–150. Establishing this information early keeps you from wasting time on elements that aren't required. In the aforementioned situation, asking specifics about the shot would have saved you from rotoing frames 1–74.

Another reason you should specify the number of frames up front is because projecting the amount of time a shot is going to take is vital for recurring work.

If you estimate that a shot will take you a day (8–10 hours) and it ends up taking you five days (45–50 hours—don't laugh; it happens), the chances of your staying in that position are slim—without improving your estimation skills, that is. The ability to correctly project how long a shot will take comes with time and experience; don't get too down on yourself if you aren't as fast as you initially think you will be. Speed comes with practice.

> *Matte.* A black-and-white frame or set of frames that tells the program what is visible and what isn't. White (color ID 1) is visible; black (color ID 0) is not. Gray areas are visible depending on their numerical position between 1 and 0.

4.1.2 Define the Focus Object

Once you've established the number of frames you'll be dealing with, the next (and arguably most important) thing to do is figure out what within the footage you'll be responsible for isolating.

To demonstrate, let's take a look at a hypothetical but entirely plausible scenario. In Figure 4.1, the hypothetical instructions from the hypothetical studio are to create mattes for everything but the area in the upper screen right that shows the back of the shooting stage (Figure 4.2). Additionally, the hypothetical studio has asked for a separate matte for the glass decanter on the desk. This sort of situation is common in student films or when the budget of the show is limited. You'll learn to cringe when people say, "Fix it in post."

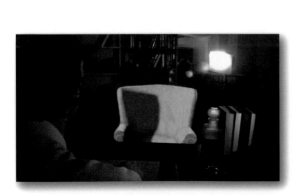

Figure 4.1 Original footage.

Figure 4.2 Isolated area.

So, to isolate this area, you're going to have to create mattes for:

- Bookshelves
- Yellow chair
- Desk and items on top of it
- Guy in suspenders and hat in extreme foreground
- Clear bottle on desk (separate matte)

While you'll be delivering a matte that has all these individual pieces, the final delivery will look something like Figure 4.3. In this situation the roto artist will be responsible for rotoing anything that crosses into and beyond the edge in Figure 4.4.

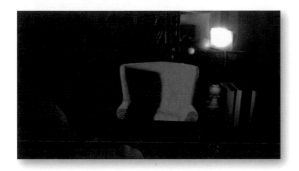 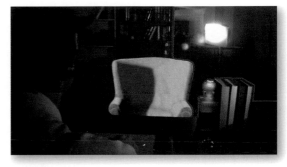

Figure 4.3 **Figure 4.4**

To make our lives a little simpler, the studio has kindly included a finished style frame for the shot (Figure 4.5). A *style frame* is a still or single frame from the raw footage that has been color corrected and stylized and had the rough computer graphics (CG) elements inserted into it so that the various artists working on that shot have an idea what the final product will look like.

Figure 4.5 Style frame.

From this style frame we can deduce the reasons for the mattes. It looks like they want to isolate the area that has the spotlight and shooting stage behind it so that a CG background can replace the set (Figures 4.6 and 4.7). They also want a separate matte for the glass bottle on the desk. If you look at the

original footage, the light is making the decanter glow, which will throw off the believability of the finished scene. They need a separate matte for this object so that they might color correct it differently from the rest of the scene (Figures 4.8 and 4.9).

An additional item to focus on is what, within your focus objects, are you going to be able to get away with not rotoing. For example, if a section of the focus object is within another, larger shape of the focus object, you won't have to isolate that specific section.

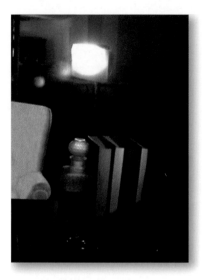

Figure 4.6 Original.

Figure 4.7 Style frame.

Figure 4.8 Original.

Figure 4.9 Style frame.

4.1.3 Matte Usage

Something else to consider when you're starting on a shot is for what exactly the final mattes are going to be used. This can help narrow down the areas of the footage that need more "love" than others. Asking for a style frame, indicating what exactly is going to be done to a shot, is a great way to find exactly what within the shot needs to be isolated.

In Figure 4.10, let's say that a CG fish needs to be inserted behind the woman relaxing by the water. The instructions you receive with the frames are to roto the woman. It would behoove us to figure out where the filmmakers want that little fish to swim.

As long as the little animated fish is going to be swimming in the large open water area on screen left or behind the arms and back of the sunbather, this might be a straightforward shot. If the fish avoids the high detail areas, such as her hair, you might be able to get away with just rotoing the larger clumps of hair and leaving out the wispy bits.

Chances are, however, that the animated fish will be swimming directly in the path of the most complex roto areas. This could be possibly attributed to poor Murphy and his accursed law. (That particular law's application isn't limited to roto, so beware.)

If the path runs behind her head, where all the little wisps of hair are waving contentedly in the summer breeze, this shot might take on some very complex aspects—or at least some time-consuming ones.

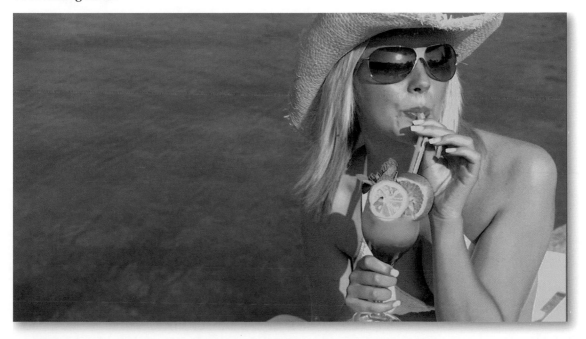

Figure 4.10

Figure 4.11

Figure 4.12

In the close-up of that area, notice how many pixel-thin strands of hair are poking out. Each of these hairs has its own motion paths and secondary motion, so if the shot requires that level of detail, you've just added a significant amount of work.

Or perhaps the fish only crosses the complex hair section very briefly. You could put the detail into her hair roto for those specific frames and leave them less detailed for the remainder of the shot. However, this doesn't allow the creative types supervising the shot to alter their animation or composition without updating the roto.

In a production facility where the comping and roto are done internally, it might be as simple as walking over to the comper's desk and asking for specifics. This isn't always the case, however.

In straight roto houses where shots are farmed out with only a bare minimum of instruction, getting this information might be a bit more complicated. So, it's a good idea to get as much information as possible within the confines of doing your job.

In the instance of the sunbathing woman, if you don't have and cannot get any specifics, the best thing to do is to get as much hair detail as possible *after* you've roughed in the thicker clumps of hair and her body. This way, a majority of the shot will be finished and can be submitted to the client/comper. If they need more, they'll ask for it. Yup, some people definitely ask for it.

Figure 4.13

4.2 Edge and Shape

Once the range of the shot and specific needs to be isolated have been established, a good next step is to just watch the footage. Letting the shot loop through a couple of times is a great way to get a feel for what is going to be important.

What you're looking for while the footage loops, and one of the key principles of rotoscoping, is shape and edge. A roto artist needs to see everything in terms of shape and edge. Training yourself to isolate these elements within the footage and eliminate extraneous ones is key to everything. Every visual element can be separated and defined into smaller, easily animated shapes, which follow a distinctive motion path.

This sort of mindset can be akin to basic drawing techniques. Beginning artists are told to use loose, basic shapes to define the elements. These simple shapes are then put together, piece by piece, to form a larger, more coherent picture. In a word: *roto*.

Edges are another consideration of a roto artist's focus. Edge is technically the most important element when doing roto, since it is ultimately what's getting delivered as the final matte. Rotoing with shapes is a device for artists to easily distinguish and isolate form and motion, but what really needs to be focused on is an accurate edge.

Figure 4.14 Footage.

Figure 4.15 Shapes.

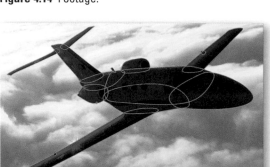

Figure 4.16 Colored overlay.

Figure 4.17 Matte.

Visually defining individual shapes in footage with lots of motion and shifting focus objects can be tough. A good place to start establishing your initial shape is to figure out where in the timeline that specific area of the focus object is wholly on screen. From that point, even if the object goes off screen or disappears behind another element in the footage, you'll still have the whole shape to manipulate. This practice keeps your roto consistent.

Figure 4.18 Shape.

Figure 4.19 Edge.

 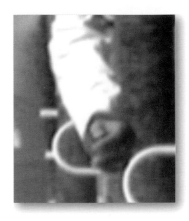

Frame 1. Frame 6. Frame 12.

Figure 4.20

If our focus object was the screen-right sleeve of the woman in Figure 4.20, trying to create a spline that accurately follows the contours of that shape requires us to find the frame in which that object is at its largest and least skewed by perspective. That frame, in this case, is Frame 6. In this frame, the woman's forearm is straight down, appearing at its largest, most easily defined shape. After having found the main key of the focus object, you then move backward (or forward) in the timeline and establish a key for the focus object when it is skewed by perspective.

Frame 1. Frame 6. Frame 12.

Figure 4.21

Because the shape is merely two-dimensional, if you keep the top and bottom of the spline on the same places they fell on her arm relative to the initial main key, all that remains on the further key frames is a simple rotation and scale.

First position. Second position.
Figure 4.22

In Figure 4.22 you'll see the first and second positions of the spline, surrounded by a bounding box. If you were to super-impose the first bounding box over the second (Figure 4.23), you'd find that the only difference between them is a scale and a minor rotation. If you created the shape correctly on the main key frame, where the shape was at it clearest, the secondary key frame should have compensated for the shifting in perspective and fallen nicely around the focus object.

Figure 4.23

Developing one's eyes to distinguish shape is a very complex task. It's difficult because people exist in three dimensions. We perceive depth and length with nothing more than a few years' practice. Depth defines the world and how we interact with it.

Roto doesn't have that kind of depth. When you're doing a roto shot, all that should be considered is the X and Y axes. These are the only two dimensions that come into a roto artist's world. Nothing will happen in the shot that can't be compensated for by moving, rotating, or scaling the shape along the X and Y. Every movement perceived within the shot can be translated into these simple movements. Something to consider is that these are two-dimensional shapes whose movements are limited by two dimensions. They were at one point three-dimensional figures, but in the medium of roto, they have been captured on camera and exist only within the X and the Y.

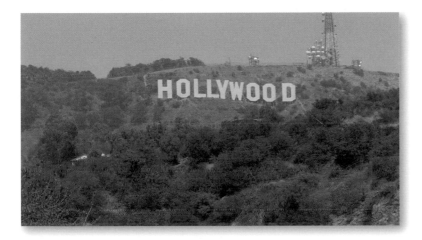

First frame.

 Interpolation. The process whereby the computer creates position or visibility keys between user-defined key frames. Whether X and Y coordinates or visibility range, the values established by the computer are averages of the bordering key frames.

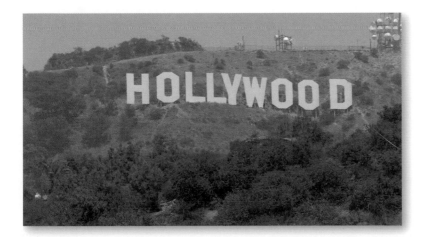

Last frame.
Figure 4.24

In the preceding figures, you can see that on the first frame of the shot, the camera is far away, looking at the iconic Hollywood sign. By the last frame, the camera has zoomed forward, bringing us closer to the letters.

If it makes it easier, think of the camera moving along the Z-axis, toward the hills. If we were to isolate the area around the letters, in a 3D sense, seeing this from above, it might look something like Figure 4.25.

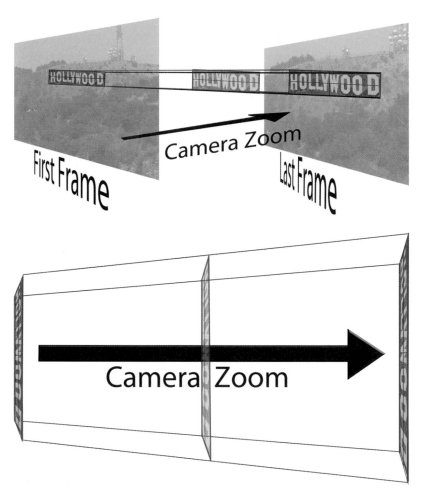

Figure 4.25 Top view.

However, as a roto artist, you can't be fooled by this three-dimensional trickery. You must shift your head into a rotoscoping frame of mind. (The puns, they just keep on a-comin'.) As mentioned, moving or scaling your shapes is the only way to compensate for

movement along the Z axis. If you'll take a gander at Figure 4.26, you'll see how a roto artist might perceive this shot.

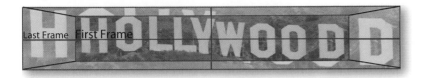

Figure 4.26

Movement along the Z plane shouldn't be ignored completely, but it should only be considered in terms of how that movement relates to the focus object's scale. If something is moving along the Z axis, meaning it is getting closer or farther away from the camera, your only consideration is how that object is scaling in a two-dimensional shape.

However, there are certain aspects of three-dimensionality that come into play. . . . You know what? Strike that. Three-dimensionality isn't exactly the right term. Perhaps a better way to put it would be a visual layering of the footage. Certainly the images we work with look to have dimensionality to them, but in reality, it's more of a separation and isolation of the layers within a two-dimensional matrix. That's what compositors do, isn't it? They separate elements of the footage into layers and then rebuild the scene, adding or subtracting things as called for.

Why not apply that mindset when you're accessing a shot?

4.2.1 Multiple Shapes

Trying to define a focus object with one shape would be a terribly inefficient way to roto—particularly if the focus object has multiple moving and rotating parts. This was the reason you were *just* watching the shot, trying to break down and identify the smaller sections. Breaking down the whole focus object into smaller pieces makes rotoing that object more manageable.

Using just one spline for a focus object with multiple moving parts would be a nightmare in almost any mildly complex roto shot. In Figure 4.27, the girl on the green screen is being isolated with one spline, which looks fine for just the one frame, but when you move to the next key frame, everything about the figure has changed. To create the second key frame, you'd have to move every single point on this spline to a new position—not to mention that all the points that were isolating the bottom of her skirt have all been drafted to become the front of her lower leg.

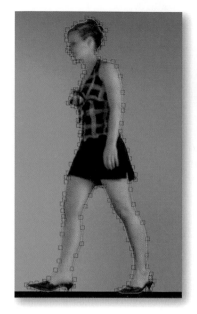 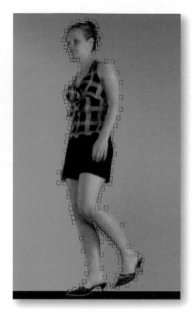 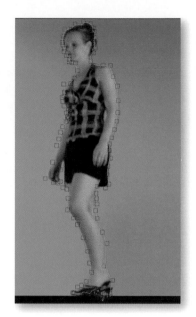

Key frame 01. Key frame 02. Key frame 03.

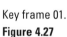
Figure 4.27

Even if you had the patience (or insanity) to establish a third key frame with this spline by moving each point along the spline to its new position, your job isn't finished. As a matter of fact, you'll now have to start all over again.

Key frame 01. Key frame 02. Key frame 03.

Figure 4.28

There's the matter of the hole in the space between the girl's screen-right arm and her torso. In addition, the points that started out at the bottom hem of the skirt have become the bottom of her shoes, creating a disaster area. You've got dozens of points, all packed together to cover the 5×5 pixel area around her sole (Figure 4.28). And what happens now that her back leg

becomes her front leg? All the leading points that were formerly in place around her leading leg must now represent her other leg, which has changed spots.

You can see the hopelessness of this situation. Chances are you'll be moving every point along this spline for every frame of this shot. Every frame will represent a key frame, with every point having a new, manually created position for the duration. No, thank you.

A far simpler solution would be to break this figure into smaller shapes that represent individual sections of the focus object. This method allows you to keep your roto consistent by having these individual shapes isolate that specific area. This will decrease the time you spend creating a matte—and will keep you sane.

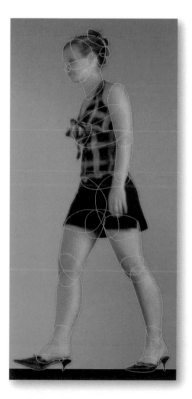 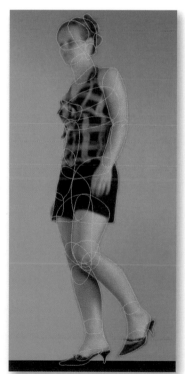 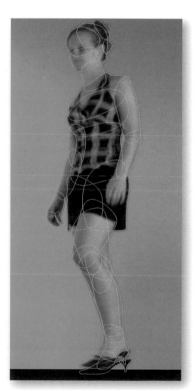

Figure 4.29

4.2.2 Repeating Shapes

You'll want to train your eye to isolate shapes within the focus object that always seem to come back to a version of their original form. These are shapes that continually move but hold their same general form consistently throughout the shot. These

shapes will keep their form but change position and/or rotation. These could also be shapes that disappear for a length of time and then return. This phenomenon happens when elements in the footage are doing the same actions repeatedly.

Our job for this shot is to create a matte for the blue bag in the woman's right hand (screen left; Figure 4.30).

If you were to let this footage loop through a couple of times, you might start noticing a pattern. In Figure 4.31, the highlighted sections indicate the three repeating shapes that can be used to isolate this focus object. These shapes keep their general form consistently throughout the first half of the shot. They might disappear briefly as the woman swings the bag, but they always return as variations of their original form.

 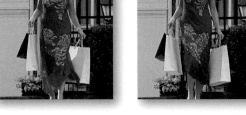 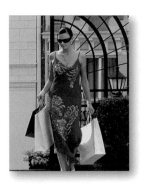 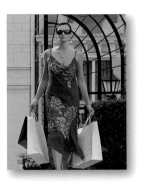

Frame 6.　　　　　　Frame 14.　　　　　　Frame 25.　　　　　　Frame 45.

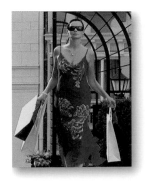 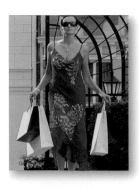 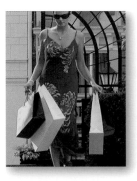 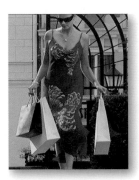

Frame 62.　　　　　　Frame 70.　　　　　　Frame 83.　　　　　　Frame 86.

Figure 4.30

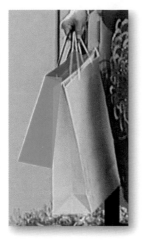
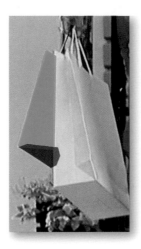
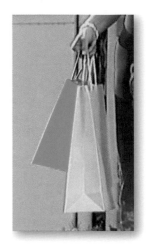

Frame 6. Frame 14. Frame 25. Frame 45.
Figure 4.31

For the remainder of the shot, roughly the second half, the repeating shapes have changed. This is because the woman has shifted the bags to another angle, and the large white bag no longer covers the focus object. This results in a different set of edges for the focus object. The exception would be the orange shape, which transitions between the first and second set of shapes. As with the first, this second set of shapes keeps its form consistently, despite changing position, scale, or rotation.

Each of these individual shapes was created to represent a specific set of edges for the focus object. The only responsibility that these shapes have is to isolate their corresponding edges. Notice how the green shape switches between top and bottom edges, depending on the angle of the bag. When the purple shape swings forward, the green shape is no longer responsible for the bottom edge of the bag. That green shape must stay consistent with both the top peak and the bottom edge, even when either side isn't really an edge.

Although each of these shapes might loosely represent a different side of the three-dimensional object that is the bag, a better way to look at it would be that they each represent *an edge* of the two-dimensional footage of the bag. Yes, the shapes' contours do have a visual relationship with the individual sides in 3D space, but that's only because the inside edges of the shapes happen to follow the interior shape of the bag. The interior edges of the splines that fall within the focus object and do not correlate with an edge are only responsible for filling up the interior of the focus object. You would only want to shape them in that particular way so that when they change position, you have some sort

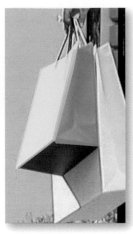
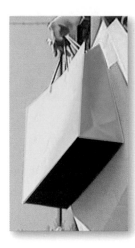
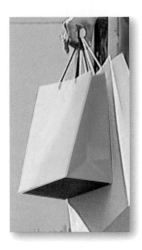

Frame 62. Frame 70. Frame 83. Frame 86.

Figure 4.32

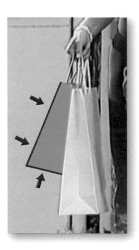
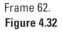
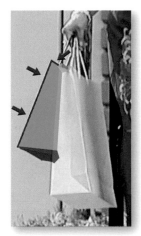
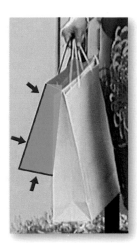
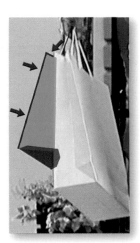

Figure 4.33

of visual reference to keep the shapes consistent when you animate them over time. The internal edges of the splines just have to overlap each other so that the whole matte remains solid.

Something else to point out is that the shapes for the blue bag, although using the first set of shapes, occasionally overlapped the larger, white bag beside it. That's because the white bag was actually in front of the focus object for those frames. Remember, the shapes created to isolate the blue bag were specifically created to correspond with a specific edge of the bag. The shapes weren't created to compensate for the intruding white bag.

You could compensate for the overlapping element by altering the shape of the spline, but that would entail making additional points to the spline, then reshaping it, which is the long, inconvenient way of going about doing it. This shape was created with one purpose: to follow a specific set of edges. If you change this shape to compensate for a secondary focus object, you'll be rotoing negative space. It would probably be a whole lot simpler to let the shapes overlap and roto the positive space of the white bag.

Nice segue, huh?

4.3 Positive Space

Roto artists are constantly asked to roto things that aren't there. They'll be asked to isolate the sky behind the hero's head because heroic clouds must be inserted there, or the area outside a car window needs to be color corrected differently from the interior. In both cases, you're being asked to roto between and behind shapes for which you don't need mattes. The focus object has things passing in front of it. This is an example of rotoing positive space to create a matte.

To single out the area of your focus object, you're going to have to roto the thing in front of it and then subtract the matte. The reason for this is that the element passing in front of the focus object has consistent motion and shape separation, whereas your focus object might not. Negative space doesn't have form or substance or trackable motion paths. It isn't a solid thing.

In Figure 4.34, you might be asked to isolate the windows for one reason or another. You're going to find that this situation happens frequently. Compers always need window and sky mattes for their various color corrections and layering what-have-you's. Whatever that reason is, you're being asked to roto something that doesn't have any substance to it; it's just a window.

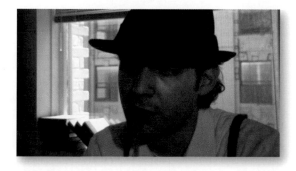

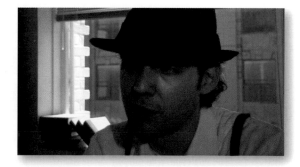

Original footage.
Figure 4.34

Final matte.

Window matte, including the figure.
Figure 4.35

Figure matte.

In this example, you would first need to create a matte for the window. After this matte is finished, go back and isolate the focus objects that have positive space that intersect the windows. Once you've created a matte for the man in the fedora, you can tell the computer to use those shapes as a subtraction matte, which will leave you with a matte for the area outside the window.

The process in which mattes are subtracted from one another changes slightly from program to program, but ultimately this is a very simple set of commands. It's just a matter of changing the way that the positive mattes interact with the negative ones. It might be as easy as inverting the positive matte or telling the computer to change the positive matte to a negative one. Whatever the case, in most situations you'll want to roto things with shape and motion paths rather than roto the negative area.

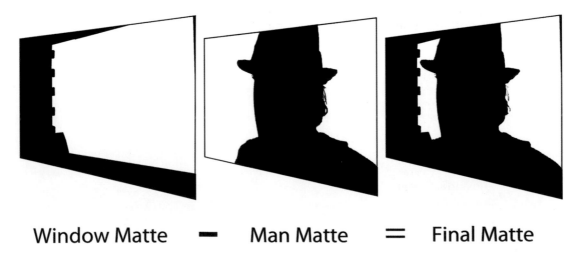

Window Matte — Man Matte = Final Matte

Figure 4.36

It is entirely possible to roto a negative area, but to do so would take a significantly longer time. It would also look inelegant.

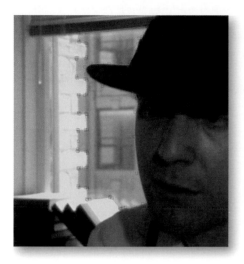

Figure 4.37

In Figure 4.37, the splines are set up to roto the negative space of the window. As you can see with this setup, you'll have one spline to compensate for two different focus objects.

That means that one spline will be compensating for two distinctive motion paths. The splines and points indicated by the blue arrows are positioned to isolate the window edge. The splines and points indicated by the red arrows are positioned to isolate the guy in the fedora. In this example, the blue arrow points would have to stick to the window ledge, while the red arrow points along the right would be following the man and his hat. Half of the shape would have a completely different key frame set than the other half of the shape because both objects have completely different motion paths. As you can see, this is a terribly inefficient way to roto a shot.

There's no flow to negative space roto. It requires you to compensate for edge without dealing with shape. The shortest distance between two points (pun again intended) is to isolate what isn't required in the matte, because it has form, shape, and substance.

4.4 Motion Paths

Motion paths are the routes a shape takes while moving within the shot. Once the general shapes are established, you

need to find the motion paths of these shapes. Defining the big motions and the key frames of that motion is what roto is. Key frames are generally set on the stopping points or direction changes. This is how the computer calculates the motion and animation for the key frames generated between key frames.

THINGS TO REMEMBER

In motion-based roto, key frames are set on the stopping points and direction changes of the focus object.

An important point to remember is that you're looking for that specific shape's motion path. The focus object and the shape within the focus object, though connected, might have different motion paths.

When a movement is defined, you're establishing that the focus object starts at point A and continues to point B. By setting those key frames, you've told the computer that the object is in these two positions at these two points in the timeline. The computer then extrapolates the position data between these two points and moves the spline appropriately. On the timeline, the frame at the center point, between the key frames, is essentially an average of the two key frames—an average of the X position and the Y position.

Figure 4.38

Let's take a look at Figure 4.38. If you use the back end of the saddle as a visual tracking point, you can see the saddle's motion path while traveling from starting point to finishing point. Note the smooth up-and-down wave created by the motion path.

The red dots are the suggested time and position key frames. They are set at the high and low points of the curve, which represent the direction changes of the focus object, which is, in this case, the saddle.

This sort of motion path is important to establish early because it loosely applies to every shape connected to the saddle. Whatever needs to be rotoed, whether the saddle, the rider, the rider's hat, or any part of the horse, will have the same rough motion path and similar key frame structure.

Let's say that after you've finished the matte for the saddle, you're also needed to create a matte for the hindquarters of the horse as well. This means that all the shapes you will establish for the horse will have the same approximate motion path as the saddle. You can use the key frames from the saddle as a guide when you're creating the key frames for the horse. Granted, some of these key frames might vary, some quite a lot, because the motion between objects might not match up exactly. If used as a rough guideline, though, it will make the key frame placement within the timeline go much faster.

Camera movement can often hinder a mostly straightforward roto shot. If the camera is panning, zooming, or jumping around, this will throw a wrench into the process of visually establishing the motion paths. If the shot is anything but a locked-off camera, without any movement whatsoever, you'll be compensating for not only the movement of the focus object but also the movement of the camera. A moving focus object within a moving camera shot will play havoc with your ability to isolate a motion path.

Almost every shot you'll be working with will have the possibility of subpixel jitter. This can be brought into the footage in any number of ways, ranging from a camera that wasn't completely locked off to an inconsistent film scan. Even when a shot appears to be locked off, it might have a subtle shake that cannot be identified simply by looking at it. This situation can easily be remedied by taking a shot that appears to be stable and then identifying and tracking a single, unmoving element within the footage. If the tracking point fails to move, you're set. If your track reveals camera movement or jitter, stabilizing the footage is a great way to simplify the shot and lessen the workload. If this is the situation, however, don't forget to apply that stabilization back onto the roto when you've finished the shot.

A great use for the tracking tools present in roto software is identifying the motion paths of focus objects. You might not necessarily apply the tracking information to a specific shape, but if the motion path of your object is subtle and hard to nail down, tracking an object in the shot is an easy way to get an idea of what your focus object's motion path will look like.

4.5 Keying

While you're looking for stand-out shapes, edges, and motion paths, step back and see if anything in the shot can be keyed.

The name of the game is matte extraction. The fastest, most efficient way to get the mattes you require is the best technique to use. You want to roto as little as possible. If a key can be pulled off part of your image, do it, and then combine it with the roto mattes later.

What you're looking for is a consistent color along the edge of the focus object that the computer can isolate. If you feel that something can be keyed, give it a quick test because that process is largely automated; this is compared to the frame-by-frame approach to doing roto.

This problem happens quite a bit on green-screen shoots. The focus object might pass in front of an ill-placed mic stand or a corner of the green screen that isn't lit correctly. In cases like this, the keying process can isolate only part of the matte. The rest will require roto.

In Figure 4.39, there are some pretty obvious problem areas. There's the cord winding its way inconveniently across the floor, or the areas around the figure's midsection that aren't keying out completely, but perhaps the biggest problem is where the figure is seated. These boxes, though painted the correct green color, aren't lit well enough to make them completely invisible to the keyer. The second figure shows the key and how those areas might need a little roto help. With this footage, it would be

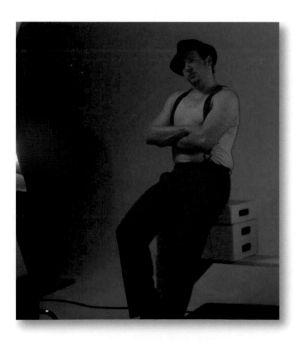

Footage.

Figure 4.39

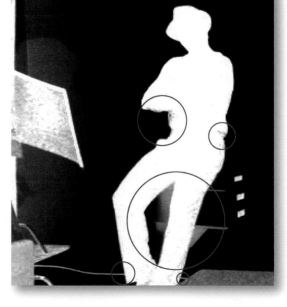

Key.

entirely possible to key out large sections of the matte, but that would also require you to roto out the problem areas.

A major hiccup in comparing keyed mattes and rotoed mattes is the edge consistency. Roto mattes are, by their spline-based nature, smooth. Even with the addition of motion blur to the mattes, everything about them, including gradients and edges, will be visually consistent. Keyed mattes are based on the pixel information of the shot. No matter how good the key is, the edge of a keyed matte won't have the edge consistency of a rotoed one.

If the keyed matte isn't exactly right, you'll get irregularity when it is connected to the rotoed section of the matte. If the key is pulled too loosely or has a jittery perimeter, the edge consistency won't match up. Keys that are pulled too tightly have the same problem. Remember, the whole point is matte extraction. If a key can be pulled, do it, but if the shorter route is roto, don't hesitate to drop the key tools and start making shapes.

Even if a perfect key can be pulled, close attention should be spent on the intersection of the keyed and rotoed mattes. The roto matte needs to match the key one perfectly, which is why this option should be considered but not necessarily relied on to complete a matte.

4.6 Review

- Establish the following early on:
 - What specifically needs to be isolated
 - How many frames the shot is
 - What exactly the mattes are going to be used for
- Visually break down the focus object into smaller, more manageable shapes.
- While breaking down the image into smaller shapes, look for shapes that hold their form consistently, despite moving, scaling, or rotating.
- Compensate for movement along the Z axis by scaling the shapes.
- In most cases, you should only roto positive space when creating a matte for negative space.
- If the camera in the shot moves or jitters, stabilizing the footage will make isolating the motion paths simpler.
- If something can be keyed, do it, but be careful how you integrate the rotoed section of the matte with the keyed section.
- Deliver the exact number of frames you were given.

5

KEY FRAMING TECHNIQUES

There are essentially two ways to go about rotoing a scene: timeline or motion-based key framing. Timeline key framing involves establishing key frames at set intervals within the timeline, without taking into account the motion of the focus object. Motion-based key framing creates key frames based on the movement and direction of the focus object.

5.1 Timeline Key Framing

The setup of this style of roto requires the artist to establish key frames based on the timeline. It's useful in some cases where the focus object lacks a definable pattern or consistent movement but has a similar shape for the duration of its on-screen existence. More often than not, you'll find a shot where the focus object hasn't any consistent, predictable motion, or the motion path is too subtle and happens over such a large time frame that trying to discern the motion path would be impossible. If your focus object changes directions constantly or the movement is too subtle to identify, try using the following timeline-based styles of roto. Timeline roto can also be used if a focus object has a very regular and predictable motion path.

5.1.1 Bifurcation

▎ *Bifurcation. The division of something into two branches or parts: a thing divided in this way or either of the branches.*

As you might have gathered, bifurcation, as it relates to key framing techniques, involves creating key frames in the timeline based on sectioning the distance between key frames by half and then repeating the pattern until you've completely isolated the focus object.

Once the range of frames has been defined, this method involves setting up key frames at the beginning and end of the

shot for the specific shape of the focus object. This could also be limited to the amount of time a specific focus object is on screen.

Take a look at Figure 5.1. Let's say, for example, that we are required to isolate the figure's inside knee and that the footage is 30 frames long. Presumably something needs to be inserted behind her knee but in front of her blouse.

Once you've established a key frame for that shape at the very first frame of the shot, go to the last frame and manipulate the shape so that it accurately isolates the focus area (Figure 5.2).

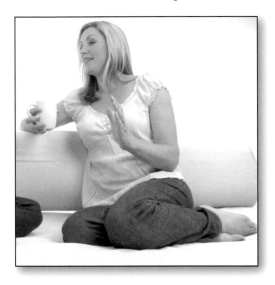

Footage. Matte.

Figure 5.1

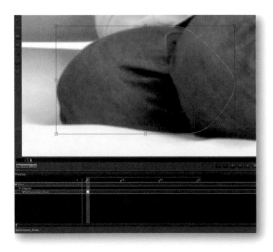

Frame 1. Frame 30.

Figure 5.2

Frame 15: No key frame. Frame 15: New position versus old Frame 15: Key frame.
 position.

Figure 5.3

Scrub through your shot and check the shape's position between the two key frames. If the shape and motion of your spline stick to your focus object, you're finished. However, if the shape doesn't match the focus object, you'll have to create more key frames (Figure 5.3). You now need to find the middle of the shot. At that point in the timeline, directly between the already established key frames, create a new key frame by moving the spline to correctly isolate the focus object.

With this finished, check the motion and contour of your shape between the first and middle key frames (Figure 5.4) and if the shape doesn't match, establish a new key frame between them. At this point, your job is to find the areas within the timeline between the established key frames where the shape doesn't conform to the motion and contour of the focus object. When you do see a difference, you split the key frames with a new one and start anew.

You won't always be able to split the difference exactly in most cases, particularly when the frames start getting closer and closer together, but do your best. The fewer frames there are between key frames, the bigger trouble you'll have establishing exact middle key frames. Follow this pattern of key frame placement until the focus object is sufficiently isolated.

This method of roto is good in the sense that it is structured. It easily narrows down the problem areas of the shot and clearly defines the section in the timeline that you'll be spending the most time on. It is also good because it determines a solid plan of attack at the beginning of every shot.

However, if the motion of the focus object doesn't quite match up with the halving of the key frames, you're going to run into trouble. This happens quite a lot, actually. Since this method is so structured, sometime you'll get a clumping of key frames around

Figure 5.4

high motion areas. Human motion is not quite as structured, but even if you're rotoing nonhuman objects, chances are that the cameraman is human; hence your shot will be limited to the same inconsistencies of human movement.

Bifurcation also makes changes in your roto, after the fact, difficult. With all those key frames, making alterations to your roto will be complicated simply because you're dealing with such a large number of keys. Making as few keys as possible is always the goal with every shot.

THINGS TO REMEMBER

A roto artist wants to make as few keys as possible. Having an overabundance of keys makes altering your roto complex. If corrections are necessary, you'll need to alter every key that's already been established.

Bifurcation will also initially lead to you manipulate your splines with their points rather than dealing with them as a whole. This is because when you're creating your shapes for the focus object at the beginning of the shot, that subsection of the focus object will probably shift its shape over time. It'll probably be something minor and, if it's approached in a linear fashion, rotating and scaling the shape can easily compensate for these subtle changes.

However, bifurcation requires you to create keys at the extremes of the shape's motion path, meaning that that shape probably isn't going to have the exact same shape at the beginning and end of the frame range. This fact is obvious because you're seeing the shape at both its extremes. This could be a good thing, however.

Bifurcation requires you to look at your shape at the beginning and immediately at the end to see whether that shape is still accurate. The differences between the shapes at the opposites of the timeline can lead you to reexamine the contour of the spline at its origin and manipulate its shape so that it is more accurate and can be used longer. It's also helpful if your focus object has a steady increase in its scale. If a focus object is small on the first frame and then very large on the last frame, with the scale of that object increasing steadily between the key frames, establishing a first and last key frame for that object will save you from creating sequential key frames for that object, which might cause you to incorrectly scale it.

5.1.2 Incremental Key Frames

You'll be asked to roto many things—different things that might not conform to any discernable pattern. Your focus object might arbitrarily move and rotate and scale without any way to narrow down a definitive pattern in which to set up your key frames. If the focus object you're isolating can't be nailed down to any set key frame structure, you might want to use incremental key frames to isolate that focus object.

This involves creating a key frame for your focus object, moving forward (or backward) a set amount of frames, and establishing another key. You then repeat this key frame pattern until the shape is sufficiently isolated or is no longer the shape in which it started.

Key frames set at intervals of 2.

Key frames set at intervals of 4.
Figure 5.5

Key frames set at intervals of 8.
Figure 5.5 (Continued)

This key framing structure can be done in increments of two, four, or any number that will allow you to create the fewest key frames and cover most of the focus object. Generally speaking, though, you'll want to stick to increments of two, four, or eight, depending on the frequency of movement of your focus object. Any larger increments will create large gaps between key frames that will almost definitely need to be fixed after the fact.

Once you've created all the incremental key frames for your focus object, you then go back and focus on the shape's position on the frames *between* the set key frames. If you find frames between your incremental key frames where the shape doesn't stick to the focus object, you create a key frame between them. This technique allows you to quickly create position key frames for your focus object.

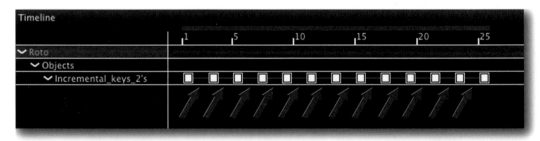

2s.

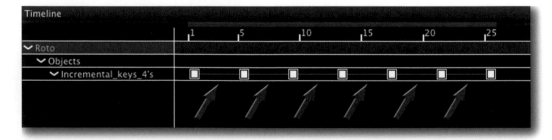

4s.

Figure 5.6

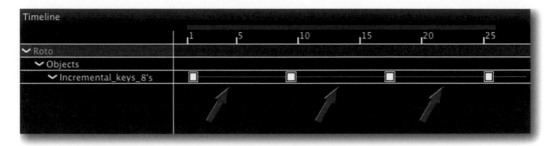

8s.

Figure 5.6 (Continued)

A point to remember when you're rotoing with incremental key frames is that you want to keep a frame within the timeline that lies directly between your established key frames. When you go back and check the spline, the new keys can be set at even intervals.

With this method, you might find yourself making a lot of little changes to your spline as the shape changes in the focus object are more incremental rather than the larger, more obvious, and easily identifiable changes established when you use bifurcation. This technique also creates a lot of key frames, which might become a hassle later if you need to change anything with your shape.

You should always look at the focus object itself and identify traits that will mesh well with the key framing method you choose to employ.

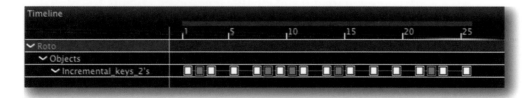

Additional key frames on 2s.

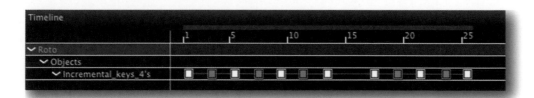

Additional key frames on 4s.

Figure 5.7

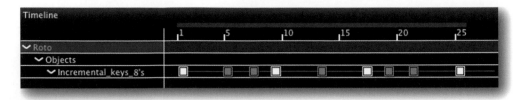

Additional key frames on 8s.

Figure 5.7 (Continued)

5.2 Motion-Based Roto

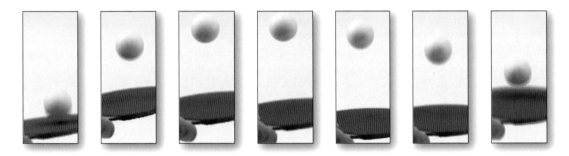

Figure 5.8

While using the motion-based roto technique, you're required to establish key frames based on the focus object's motion. This way, instead of basing the key frame placement solely on the timeline, you can create a more specific key frame structure that stems from the flow and movement of the focus object. This technique requires you to find and identify the stopping points and direction changes of the focus object. This method is a little more intuitive when it comes to motion paths and can take some time to master.

Let's try to find a key frame structure that will isolate the bouncing ping-pong ball without creating an excess of key frames.

First off, just look at the footage. The focus object starts as the paddle strikes it, causing it to rise in a narrow arc and then fall again toward the paddle.

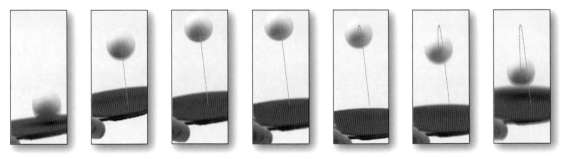

Figure 5.9 Motion path.

If we take the motion path of this focus object into account, we have to create four key frames that represent the directional changes:

- At the bottom of the arc
- The initial top of the arc
- The second top of the arc
- And another at the bottom

Starting point.
Figure 5.10

Initial top of the arc.

Secondary top of the arc.

Motion path: Bottom of the arc.

Figure 5.11 Shape key frames.

These four key frames represent the direction changes that the focus object takes as it follows its motion path. With just these four key frames for our shape, the computer creates a motion path that distributes the distance evenly between keys and doesn't match the motion path of our focus object. The ball, since it's a victim of the physical universe, doesn't move in the evenly spaced measurements of distance in which the mathematically driven computer calculates.

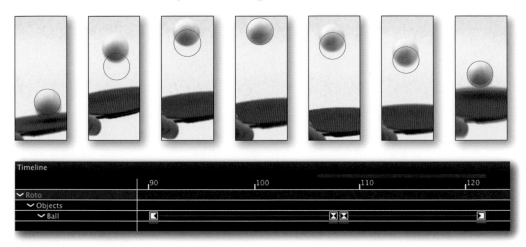

Figure 5.12

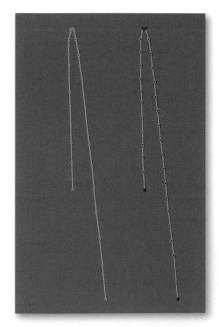

Figure 5.13 Actual motion path versus the computer-generated motion path.

When we compare the computer-generated key frames to the actual motion path of the focus object, the differences are obvious. The real motion path is uneven, with the key frames being spread according to gravity and physics, whereas the computer-generated motion path has key frames at evenly disturbed intervals.

To fix this problem, look at where the motion path of the shape deviates from the actual motion path of the focus object and create key frames accordingly. However, creating arbitrary key frames might lead you to create more key frames than you need. Since motion-based key framing is based on the position and motion of the focus object, you should take into account the way the focus object moves and create your key frames based on that motion.

In this case, the focus object is going to move quickly as the paddle hits it initially until gravity begins taking hold, which slows it down, creating the top of the arc. Once the ball has reached the peak of its arc, it will begin to fall, moving slowly at the start and then increasing in speed the longer it falls.

On the first half of the ball's motion path, you can see that initially it moves quickly, traveling a greater distance per frame and slowing gradually and traveling less. This will require us to create fewer key frames for the initial leg of the arc that are positioned far apart, both in the XY coordinate sense and in the timeline.

Note

There's more on how rotoscoping programs deal with motion and key frames in Chapter 9, "Interpolation and Linear Movement."

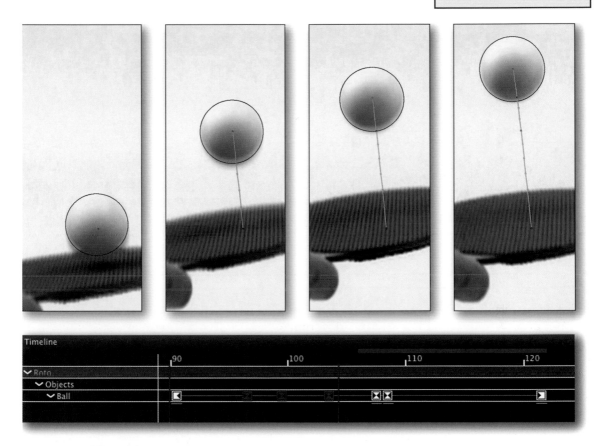

Figure 5.14 Initial leg of the arc.

The top of the focus object's arc will be represented by a key frame structure that, compared with the initial leg of the motion path, will have smaller distances moved per frame over a shorter section of frames. You'll find that when a focus object changes directions slowly, you're going to have to create more keys in that section of the motion path if you want to correctly isolate the focus object.

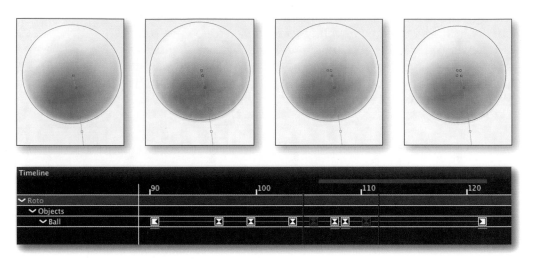

Figure 5.15 Top of the arc.

And finally, as the ball begins its descent, the distance traveled per frame will increase the longer it falls. This will be similar to the first leg of the arc but will occur in the reverse order. These key frames will increase in distance traveled per frame but decrease in frequency.

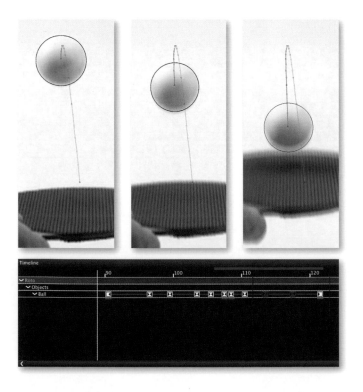

Figure 5.16 Last bit of the arc.

With all your key frames in place, you're going to have a
motion path that looks something like Figures 5.17 and 5.18.
Notice in the timeline how the positions of the motion path keys
relate to their positions in the timeline.

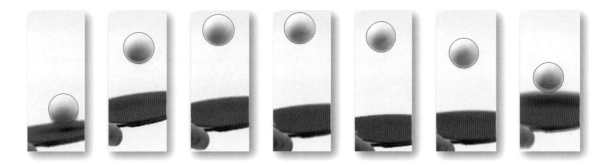

Figure 5.17 Shape with accurate key frames.

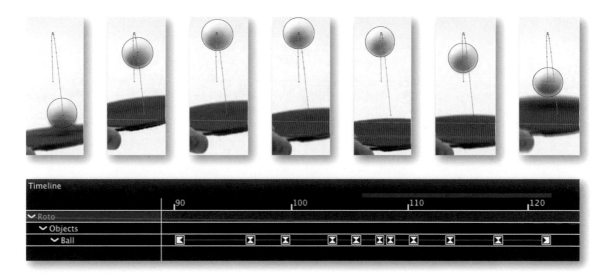

Figure 5.18

This style of roto takes a little while to sink in. It requires you
to break down the motion of the focus object so that the stop-
ping points and direction changes become obvious. It also
requires you to compensate for focus objects that don't necessar-
ily move according to the cold, evenly spaced logic of computer-
driven interpolation. Developing your eye to distinguish the
key frames of a focus object using motion-based key framing
is something that might seem a bit overwhelming at first, but

eventually it will become something you won't even need to think about.

Both timeline and motion-based key framing techniques have good and bad aspects. By far the most streamlined method for an experienced roto artist is motion-based key framing, but if you do it incorrectly, you'll find yourself making loads of excess key frames. It takes a bit of time and training to develop an eye for this technique, but once you're there, the roto goes quickly and doesn't have an overabundance of pointless key frames.

Although incremental key framing and bifurcation do generally necessitate an overabundance of key frames that might not be necessary, they do, however, create a steady and consistent workflow that gets the shot done with fewer fixes after the fact.

Motion-based roto sets up fewer key frames and is easier to fix after the fact. Without all those key frames that are created by default using any timeline-based roto, altering the matte becomes significantly more complicated. Also, if you're creating fewer key frames, you're doing less work.

Figure 5.19 shows the ball footage key frame structure as though it were done with incremental key framing versus motion-based key framing. As you can see, significantly more key frames were created using incremental key framing. These key frames are completely unnecessary, as we found out in the previous exercise, but you have to weigh the time it took you to figure out the correct key framing structure versus how long it would have taken you to do the shot using incremental key framing.

Beginning roto artists might find that they are faster initially using incremental key framing, but once they become accustomed to breaking down the stopping points and direction changes of the focus object, motion-based key framing is faster. Once you nail down your eye and are able to discern the technique that will work best for the shot in front of you, you'll be able to pick and choose the technique that will allow you to finish the shot in the least amount of time.

Figure 5.19

Roto artists don't generally stray from their chosen style of roto and will fanatically stick to the technique that serves them best. Once you become more accustomed and feel out your particular key framing method, you'll start to see that the lines between motion-based roto and timeline-based roto become a little blurred. (Please, make the puns stop!) On occasion, a specific focus object will have a motion path that will require you to start with one style of roto and then shift to another, based on the pattern that has become evident.

The key framing method you choose should be based on how quickly that specific technique will allow you to finish the shot in the shortest amount of time.

5.3 Approaching the Shot

There are several perspectives concerning how one approaches a shot.

One ideology requires you to follow a single shape for the entirety of the footage or until it ceases to be that same general shape. This method is great for finding the motion path of an individual shape and allows you to really get a feel for the focus object's movement.

From this point you can work outward from this shape, creating new shapes as they appear that are adjacent to and overlap the previous one. Once this new shape is complete for the entirety of the footage, you continue this process until the whole focus object is complete.

Another perspective requires that the roto artist block off a section of the footage and finish the entire focus object for the length of that section. The starting and stopping movement of the focus object is a solid way to define individual sections of the footage. This method is great for establishing and reporting progress, since you're completing whole sections at a time. However, it can be a little abrupt in the sense that if the focus object's movement bleeds over the isolated section, you're stuck until the entire roto is finished for that section.

There isn't any one way to complete a shot. Every piece of footage has distinctive qualities and can have different approaches applied to it. While you're figuring out what process works for your particular mind set and a particular shot, being structured with your roto will help you establish a pattern and increase your workflow.

THINGS TO REMEMBER

The way you approach your shot might also depend on how many frames your computer can cache in RAM. You want to be able to view your footage without having to rerender the image every time you move from frame to frame. The way you break up your footage could be determined by how many sequential frames you can view at once without having the computer rerender the frames.

You can also combine roto techniques depending on the motion of the focus object. Sometimes the motion and shape of a focus object will have a pattern that conforms to bifurcation for a section of its life span and then becomes more erratic, requiring you to shift your technique to motion-based roto.

Most important, you need to find a method of rotoscoping that gives you the best chances of creating a complete and perfect matte in the shortest amount of time.

5.4 Review

- Whatever style of key framing you use, try to make as few key frames as possible.
- When rotoing using incremental key frames, always try to keep a blank frame between two keys.
- In motion-based roto, keys are set on the stopping point or direction changes of a focus object.
- The computer generates movement and positions between key frames that are evenly spaced and linear, but very rarely does anything in the real world move in such a calculated fashion.
- Study the footage to determine which key framing technique will work.
- Be fluid with your key framing techniques. Combining techniques can often lead to fewer key frames and faster results.

5.5 Relevant CD Files

- Girls_Couch
- Ping-Pong

CREATING SPLINES

You'll create a significant number of splines during your tenure as a roto artist. When and how you create these shapes can play a pivotal role in the speedy completion of a shot.

First, you want to create your shapes on a frame in which that particular focus object is clearly defined and completely in view. When you create shapes for focus objects when they are at their clearest, you're extending the life of that shape's use as it relates to the focus object.

If our job is to isolate the young woman's screen left fore-arm, we would need to establish the initial contour of our spline on the frame where the focus object is clearly in frame and not being skewed by perspective. When you're first getting started on a particular focus object, you'll want to scrub through the footage and identify on which frame the focus object is at its clearest and most definable and then create your shapes on that frame.

Good frame on which to create the shape.
Figure 6.1

Bad frame on which to create the shape.

A spline is a set of points connected by a line. This can be animated using either the individual points or the object as a whole.

When you create these splines, you'll want to use as few points as possible. A shape that's riddled with points will be harder to control. Get into the practice of defining your shape with the fewest number of points along the spline.

Now, you don't have to create these splines correctly on the first try. As a matter of fact, very few roto artists can get the correct number of points on a spline at the moment it's created. Generally, when you're creating a spline, the best thing to do is simply make the spline look accurate, without limiting the number of points. Make sure the spline has the correct contour and edge of the focus object shape that you're trying to duplicate. With that done, go back and eliminate the unnecessary points.

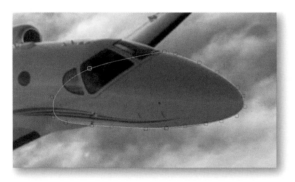 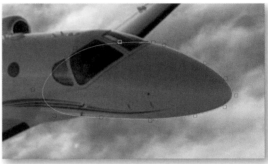

Too many points on the first pass.
Figure 6.2

Just the right number of points.

Tip

If you're having a hard time discerning exactly where the edge of your focus object is, try raising or lowering the gamma on the viewer controls. A hard-to-make-out focus object can often be one gamma click away from easier visibility.

A good starting spot for point reduction would be to delete every other point. This isn't always the case, since your shape might have some angles that need definition, but minimizing the points along the spline with this approach will train your eye to see what points are necessary and what can be deleted.

Also remember that you might not need as many points *in* the shape of your focus object as you will *along the edge* of the focus object. Points within the focus object, that is, points that do not correlate with an edge, don't need to be numerous. This stage of creating the initial spline on its first key frame is very important. It's important because once you've got the shape to a good place, on key frame one, you don't want to change the individual spline points much for the life of that shape.

If you actively plan the location of your points along a spline when it is created, you can potentially save yourself time when you go to create multiple key frames for its position. Creating specific points to represent a specific area of the spline is a great way to keep your splines consistent.

Arm position 1. Arm position 2.

Figure 6.3

In Figure 6.3, we're going to focus on the two ridges in the figure's sweater, along her forearm. These two ridges stay at the same relative position on her arm, no matter at what angle she holds it.

Base points of the arcs. High points of the arcs.

Figure 6.4

These two ridges create arcs along the edge of the focus object. Both arcs have base points that sit along the edge and high points that sit at the high point of the arcs. To isolate this edge's movement, we have to keep the points along that edge the same, no matter what position the arm is in. When we create a shape for this focus object, we want to keep an eye where we put the points relative to the base and high points of those two arcs.

Figure 6.5 shows us that points 2 and 5 both stay at the top of the arc in both positions of the arm; the points representing the high points of those arcs need to stay at the high points in any key frame you set for that shape. The other highlighted points (1 and 3, 4 and 6) represent the respective base points of each bunch and will also need to stay at their approximate relative positions at the base of their arcs in any key frames you create for that spline.

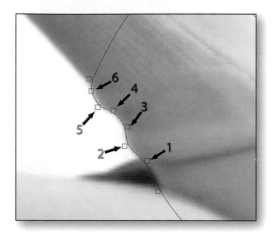
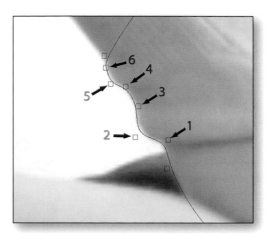

Arm position 1.

Arm position 2.

Figure 6.5

If this particular focus object had an extreme motion path or significant changes to its shape, you might consider breaking each section into separate splines so that the specific point placement of each arc isn't necessary. As long as the intersection points between splines stays consistent and moves together in a similar motion path, this spline setup will automatically keep the base and high points of the arc at their respective positions along the edge.

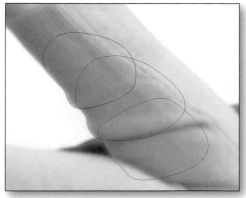
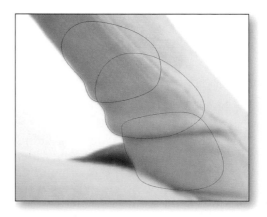

Arm position 1.

Arm position 2.

Figure 6.6

While the edges of your spline should be limited to the specific edge of the focus object, you should also try to keep them limited to one *focus object* per shape.

In Figure 6.7, the red line indicates the edge of the focus object. If we were isolating this figure, we would require the final matte to encompass both her neck and her sweater. So the spline placement in Figure 6.8 is entirely plausible, but it also might bring us trouble later. Though the sweater and the neck do share an edge, their motion paths might differ somewhat, seeing as they are both physically separate items within the focus object.

Footage.
Figure 6.7

Focus edge.

Object mode.
Figure 6.8

Sub-Object mode.

If the sweater were to change position on the neck, like shifting forward or begin to scrunch up, the highlighted points in Figure 6.8 would need to be dealt with individually because they represent the intersection between the neck and the sweater. Separating these elements within the focus object will make your job isolating that edge significantly simpler because each spline can represent the individual motion paths of the two separate items.

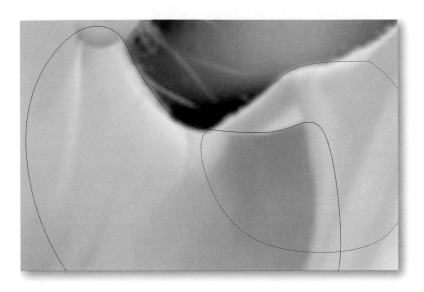

Figure 6.9

Another thing to remember when you're creating splines: Try to avoid using splines with individual handles on which you could alter the angle of the point as the curve continues to the following point.

Roto is time consuming. When you roto using points with handles, you're committing to working not only with the points but with the handles on those points. This will effectively triple your workload. Every time a point is altered, you'll have to modify three things on that single point: the point itself and the two handles. This isn't conducive to quick workflow. Let the computer calculate the angles between points.

If you were to alter the point's angle with the handles, keeping a consistent flow to the matte shape would be nearly impossible. Even the most minor of adjustments to a tangent handle, one that is barely perceptible from key frame to key frame, will become blaringly apparent when we're viewing the matte in motion.

Also, using hard angular points will "break" your matte, leaving it unbelievable and unusable. People see hard angles, whether they realize it or not. Having hard, unforgiving angles in your roto will make the matte look inaccurate.

The edges you'll come across might appear to be absolutely angular, but on closer inspection you'll generally find that there is a subtle curvature to the focus object's corner.

The angles appear hard from this distance …

… but, on closer inspection, we see that they are actually curved.

Figure 6.10

Use the shape of the focus object to tell you where to start and stop your splines. If you look hard enough, you'll find that most images break down very easily into smaller, usable shapes.

In Figure 6.11, the shape is broken up into four splines, each of which is responsible for its own section of edge and a part of whole matte. Now these shapes will represent that individual section of edge for as long as the edge of the focus object matches the edge of the original shape.

Footage.

Shapes.

Figure 6.11

Edge sections.

Colored overlay.

Figure 6.11 (Continued)

> *Object mode.* While working in this mode, a roto artist manipulates the shape as a whole, without altering individual points along the spline.

Arguably, these same edges could have been isolated by using one shape that would do the work of both shapes #2 and #3 (Figure 6.12), but the jean creases create such a nice, clean intersection for that segment of the edge that it's probably faster to break the edge up and use the original shape breakdown. Spline #3 is responsible for only a small part of the edge, but it has to be weighed against the time that that spline can be used and how easily it can be manipulated without too much alteration to

Figure 6.12 Alternative shape breakdown.

the individual points. Remember, you'll want to deal with these splines in Object mode as much as possible. In this case, the angle of the jean between the intersections of splines #3 and #4 (indicated by the red arrow) would require you to change the individual points too much if you were to use one shape for that section of edge.

Note how the shapes intersect with one another. When you begin to animate them, you'll need to keep these splines at the same relative distance from and position to each other. You'll also want to set those individual points on visual markers within the focus object. This will be valuable later when you're animating that spline, because you can keep those points on the same visual markers for the entirety of that spline's life. This will keep your spline movement consistent and increase your workflow.

Multiple shapes representing a specific edge should appear to move together. Shapes along an edge will move together, sharing similar key frame position and motion paths. If you've created too many shapes along that edge, you're going to have a hard time keeping them coordinated; they won't appear to be one solid edge. If a single shape moves incongruously with the other shapes representing that edge, that section of the edge will appear to jitter.

Jitter can be introduced into your matte if the multiple shapes representing a single edge of a focus object don't appear to move together.

6.1 Organizing the Comp

You're going to have a significant number of splines. Keep this fact squarely in your head when you're starting a new shot. At the beginning, when the shot only requires 20–50 shapes, it won't be completely obvious, but by the end, when the aforementioned number has quadrupled several times over, you'll be glad you were organized from the start. Establishing good organizational habits will save roto artists time and improve their workflow.

One of the most important things to do when you're rotoscoping is to name your splines. This task can be somewhat tedious, but it will pay off in the end. Get into the habit of naming each spline when it is created. It will give you a clear idea of what is being done when you're looking at the finished roto and need to make changes. You'll get notes such as "Frames 40–100: area of his arm are showing white around the edges and also look jittery." In this case, you can simply limit the frame range of your viewing area and turn off the visibility of the splines that weren't mentioned in the notes.

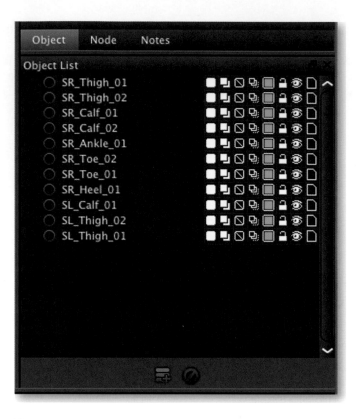

Figure 6.13 The abbreviations SR and SL are short for *screen right* and *screen left*. It's always a good idea to keep the rights and lefts in reference to the screen, since these indicators could change depending on the position and direction of the focus object.

Another technique would be to color coordinate the splines of specific sections of the focus object. This would mean that all the arm sections are red splines whereas the hand is blue.

Naming each individual spline perhaps may feel like too much, particularly when the number of splines begins to grow. Another suggestion might be to break the sections of the roto into separate folders. Each roto software has its own method of organization, but generally speaking, you can arrange multiple splines into specific sections. Grouping a subsection of a focus object's roto enables you to turn a section on and off, which is convenient when all the action is in one area. This means that there will be a heavy grouping of splines in this area. If this is the case, you can turn sections of your roto off when you aren't working on it.

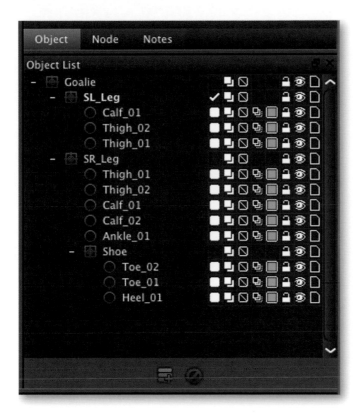

Figure 6.14

6.2 Review

- Create shapes for your focus object where it is clearly defined, completely in view, and at its largest.
- Create splines with as few points as possible. Deleting them after the fact is completely acceptable.
- Limit the edges of your splines to one focus object.
- Avoid using splines with handles on the points.
- Multiple shapes representing a specific edge should appear to move together.
- Name your splines, or at least organize the various splines into easily identifiable groups.

EDGE CONSISTENCY

You might have noticed a few overlapping principles from chapter to chapter of this book. These concepts have been mentioned in reference to specific ideas that pertained specifically to that principle. The reason these methods overlap is that the one, overall, all-encompassing goal when isolating a focus object is to keep your matte consistent. The mattes you create need to effectively and consistently cover your focus object.

These are a few ideas that have already been briefly covered:

- Limit your single splines to one or two edges of the focus object.
- Alter individual points along a spline as little as possible.
- If you must move individual points, try to keep the general proportions and relative point positions consistent between points.
- Keep your splines limited to what they were created to isolate.
- Keep your splines the same relative distance from the edge of the focus object.

These ideas all point to one thing: edge consistency.

The use and function of shapes are to accurately isolate the focus object. To do this, the shape must not only be created correctly, it must be animated correctly as well. Once you've created and closed a spline, it becomes a shape. You then animate that shape to follow that specific area of the focus object until it ceases to resemble the original or cannot be manipulated without significantly altering individual points along that spline. When that shape is no longer usable, hide it and create another.

There are two reasons to change splines:

- The focus object has changed drastically enough that the spline's original shape no longer applies without altering a significant number of individual splines.
- The edges of the focus object that the spline was created to isolate are no longer edges.

Figure 7.1 shows the girl's arm, starting at the top of an arc and finishing downward.

If you've created your shape correctly, you'll be able to get as much use as possible out of that shape, meaning that it will

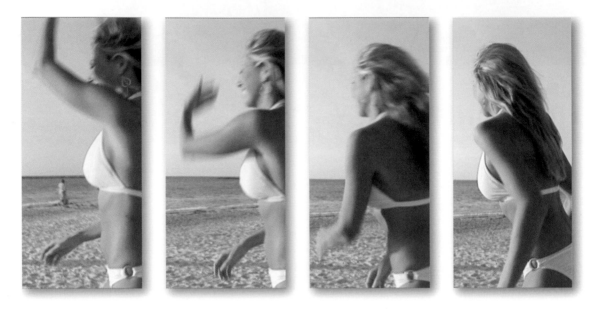

Figure 7.1

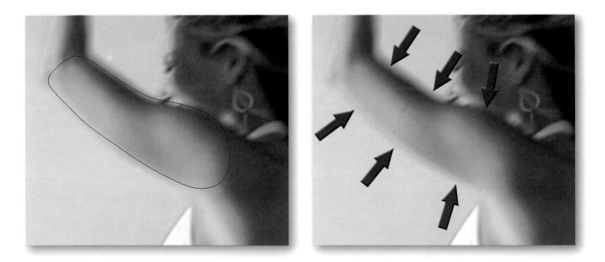

Figure 7.2

accurately cover your focus object for the longest amount of time with the least amount of individual point movement. The spline in Figure 7.2 was created to cover the girl's arm. Note that on the first frame, her shoulder isn't technically an edge but becomes one later on, when her arm is in the bottom position.

The spline created for this focus object does a good job of isolating the focus object but starts to stray as the arm moves downward and into her body (Figure 7.3).

Figure 7.3

Also around that time, the shape no longer becomes as applicable because the parts of her arm that the spline was created to isolate are no longer edges. The specific edges of her arm are not needed any longer because her body has become the dominant edge. Granted, her shoulder, which was covered by the original shape, is still applicable, but the entire shape as a whole doesn't isolate anything more than that. This might be a good time to stop using this shape and create a few more.

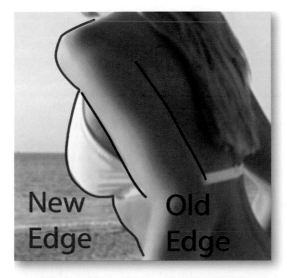

Figure 7.4

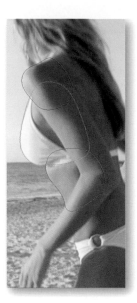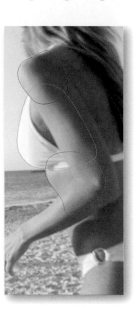

Figure 7.5

7.1 Transitioning Between Shapes

When you're done with shapes, you might be tempted to simply throw them off screen, set a key there, and be done with 'em. When you've hit the zone and your focus objects are quickly disappearing behind your animated shapes, it's been known to happen from time to time.

This, however, isn't the best way to go about getting rid of your shapes. It will leave you with dozens of shapes, all littered about the outside of the viewing area, not to mention generating completely incorrect motion blur, but we'll get into that later.

You always want to animate the transparency of your shapes as they become obsolete for your focus object. Creating visibility key frames for your shapes is a much cleaner and more organized way to create mattes.

Our focus object in the following examples will be the young lady's forearm.

In Figure 7.6, the focus object starts at the top of the screen and quickly swings down screen. The shape being used to isolate that section of our focus object is accurate up to the last figure in Figure 7.6. The movement of her forearm has left the shape somewhat unintelligible. It has lost its distinctive form because it is going through such a forced perspective shift. At this point in the footage, the shape we've created to isolate the focus object has become inaccurate. And creating a new shape at this point in the footage would be extremely difficult because the focus object lacks any distinctive contour.

Frame 1. Frame 2. Frame 3. Frame 4. Frame 5.

Figure 7.6

 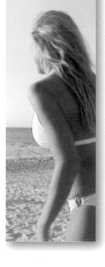 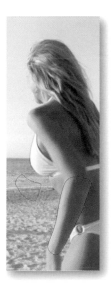

Frame 7. Frame 8. Frame 9. Frame 10. Frame 11.

Figure 7.7

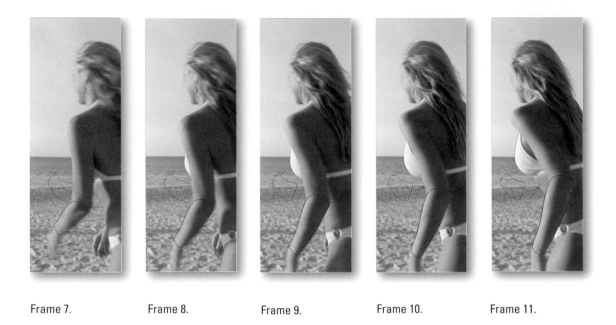

Frame 7. Frame 8. Frame 9. Frame 10. Frame 11.

Figure 7.8

Frame 5. Frame 6. Frame 7.

Figure 7.9

As mentioned earlier, you want to create your shapes when they show the most easily distinctive form. In this case, the focus object doesn't become distinctive until later in the timeline. We'll leave that initial shape there for now while we figure out the next step to isolate the figure's forearm. After identifying the point at which the focus object has again regained a distinct form and can be isolated easily, we can establish a new shape for it.

With the new shape established, you can roto *backward* from that point in the timeline, following the new shape until it starts to meet the previous one.

That leaves us with a conundrum. We have two shapes zoning in on one moment in time where neither will accurately isolate the focus object. You're going to find that this happens a lot when a focus object has extreme motion and an extremely forced perspective. There are a couple of ways to fix this situation.

You could create a shape just for the transition point between the incoming splines (Figure 7.10). Doing this will accurately isolate your focus object and not force you to manipulate any of the shapes in Sub-Object mode.

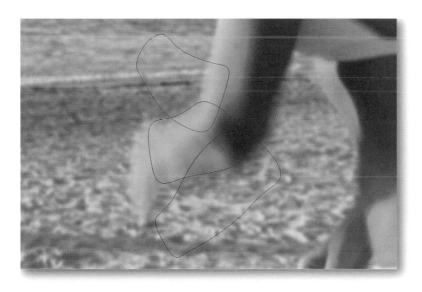

Figure 7.10 Frame 6.

Once the shape is created, we simply need to make sure it is only visible for as long as the other two shapes aren't needed to isolate anything along the focus object. This requires us to then create visibility key frames for the previous two shapes, both becoming invisible while the transition shape is visible (Figure 7.11).

Sub-Object mode. This mode gives access to the individual points along the spline. It is suggested that you manipulate splines in this mode as little as possible. It cannot be avoided in some situations, however.

Frame 5. Red shape: visible; purple shape: not visible; blue shape: not visible.

Frame 6. Red shape: not visible; purple shape: visible; blue shape: not visible.

Frame 7. Red shape: not visible; purple shape: not visible; blue shape: visible.

Figure 7.11

We could have created this spline earlier as her arm swung down and when the red shape stopped being accurate, but had we done it at that point, we couldn't have planned how long we were going to use the shape. The focus object at this point in the footage isn't very clear. It's much simpler to find the shape when it is whole and easily defined later in the footage and then use a transitional shape to bridge the gap. This method will allow you to get the most out of your shapes without altering their individual splines.

Another solution might be to manipulate one of the shapes in Sub-Object mode to match the focus object at the transition point between them (Figure 7.12). Once the shape matches the focus object, you then create visibility key frames when necessary.

Frame 5. Red shape: visible; blue shape: not visible.

Frame 6. Red shape: visible; blue shape: not visible.

Frame 7. Red shape: not visible; blue shape: visible.

Figure 7.12

While this option does require you to interact with the individual points of the spline, it might be faster depending on how many frames the shape needs to hold the transitional position for. It also doesn't require you to create a *new* shape to cover the focus object as it transitions between splines.

How you choose to transition between shapes is entirely based on the fastest way you feel that you can finish those frames.

7.2 Review

- Two reasons to change splines:
 - The focus object has changed drastically enough that the spline's original shape no longer applies without altering a significant number of individual splines.
 - The edges of the focus object that the spline was created to isolate are no longer edges.
- Limit your single splines to one or two edges of the focus object.
- Alter individual points along a spline as little as possible.

- If you must move individual points, try to keep the general proportions and relative point positions consistent between points.
- Limit your splines to isolate what they were *created* to isolate.
- Keep your splines the same relative distance from the edge of the focus object.
- Create shapes for your focus object where it is clearly defined, completely in view, and at its largest.

8

OBJECT MODE TRANSFORMS

For the purposes of this text, the term *Object mode* refers to the state in which you manipulate your shapes as one object and don't alter individual points. Working with shapes in Object mode will allow you to keep your mattes consistent, and as has been mentioned once or twice, mattes need to appear consistent throughout a shot. If a comper is going to use those mattes, they're going to have to be accurate. The most effective way to achieve accuracy when animating the shape over a range of frames is to work with it as a whole rather than moving individual points.

There are several reasons for this. The first and foremost is that when you move the shape as a whole, the individual points along that spline will keep their proportional distance and angle to each other, without wavering. Roto is still a human function in the VFX industry, but it doesn't mean we can't use the tools computers give us. If you were to move a spline using only its individual points, no matter how simple the move, emulating the exact distance and proportion of the original key frame would be terribly hard. The movement of the spline would be jittery and inconsistent.

Move, rotate, and scale the shape as a whole without altering the individual points or by altering them as little as possible. On a frame-by-frame basis, the jitter will not be obvious, but when the matte is played back at full speed, you'll see the edges jumping inconsistently.

There's a much more pragmatic reason for manipulating the shape as a whole as much as possible. Simply put, it takes fewer clicks to move an entire shape than it does to move the individual points. Clicking and dragging once to move the shape is far simpler than moving every point along the spline to its new position.

8.1 Pivot Points

If your focus object rotates, take note of where, *within itself*, that it rotates from. Often a shape will not be rotating from the

First key frame.

Position of the next key frame.

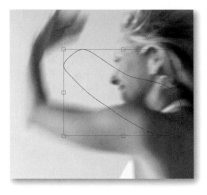

Select the shape and …

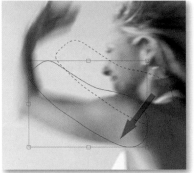

… move it to the new position, using the rotation point of the focus object as the new resting place.

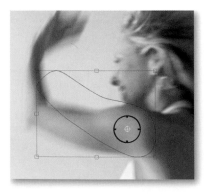

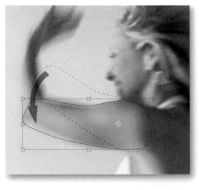

Now establish the rotation point of the shape at rotation point of the focus object …

… and rotate the shape to match the focus object.

Figure 8.1

center of the shape. When this occurs, rotating the shape from the point that the focus object rotates, will speed the process of completing the shot. A faster way would be to shift the rotation point of the whole shape to the rotation point of the focus object and then rotate the shape from the newly established rotation point.

Compensating for the rotation of a shape by using the focus object to find the rotation point will save you from overmanipulating the shape. If you rotate the shape from the correct place, you won't have to scale it to isolate the new position of the focus object—or you'll need to scale it less, anyway. This is a particularly good time-saving option if the position of the focus object *only* changes its rotation, not its position. In this case, rotating the focus object *from its center* will only increase the number of times you select and manipulate that shape while creating that key frame.

You might have noticed that this particular focus object, her arm, has two rotation points: one at the shoulder and one at the elbow. Either point will work to accurately to create a new position key frame without manipulating the shape too much (Figure 8.2).

Controlling the shape in Object mode will help keep your shape consistent and save you loads of time.

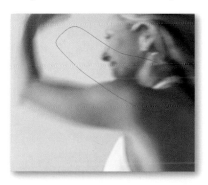 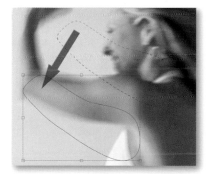

Using an alternative rotation point as the base for your transform ...

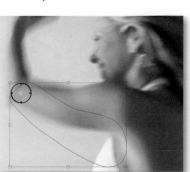 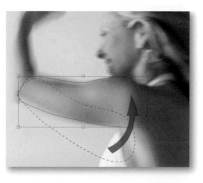

Figure 8.2

... can achieve the same result.

AE Tip

 Command-T is also the keyboard shortcut to Translate elements in Photoshop.

8.1.1 Bounding Boxes in After Effects

After Effects keeps your splines in Sub-Object mode until the spline is double-clicked, which will then give you the ability to move the rotation point, rotate, and scale the object as a whole. When you're doing this sort of translation in which a spline with a rectangular shape is at an angle, the bounding box that controls the spline isn't necessarily positioned to accurately scale the object correctly. In a situation like this, there are a few extra steps to ensure that you won't have to overmanipulate the shape.

After the first key frame is established, double-click on the spline (or press Command-T). This brings the selected shape into Object mode.

Using the rotation point as a base, move the shape to its new position, change the rotation point, and rotate it accordingly.

If the shape isn't entirely accurate to the focus object's edge, you could start scaling it in Object mode. However, the current bounding box doesn't have the same proportions as the new position of the shape. This might cause the shape to scale improperly, requiring you to edit the individual points of the spline.

A way around this minor dilemma is to go into Sub-Object mode (pressing Enter), and then, with the spline still selected, go right back into Object mode. This will create a shape proportional bounding box much more suitable to correctly scaling the spline.

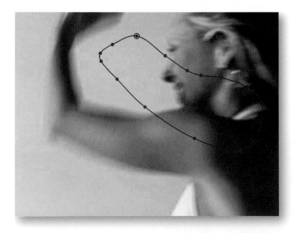

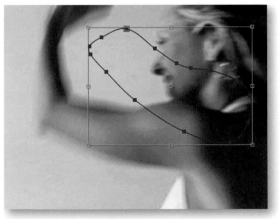

Sub-Object mode.

The spline in Object mode.

Figure 8.3

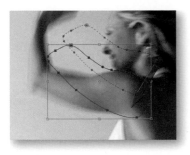
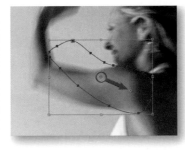
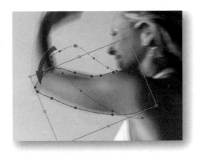

The spline's new position.

The spline's new rotation point.

The spline's new rotation.

Figure 8.4

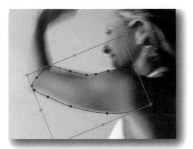
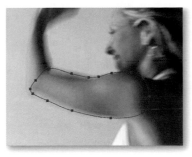
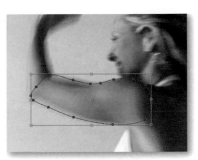

Figure 8.5 Bounding box from original translation.

Exiting Object mode with the spline in the new position.

The new bounding box.

Figure 8.6

8.2 Individual Points

It's inevitable that you'll be forced to move the individual points of a spline at one point or another (another pun!). There will be times when no whole-shape modification can completely isolate a focus object without manipulating individual points. Determining when and where this is acceptable takes time but will become clear when you grow accustomed to the lines of thought (I am so sorry about these puns.) that come from doing roto.

While you make new position key frames for your shape, you might be tempted to adjust single, individual points along its path. This temptation is strong, particularly when the adjustment is minor and seemingly inconsequential, since it doesn't alter the whole shape to a major extent.

Generally speaking, though, you should try to resist this urge, dear friend. On a frame-by-frame viewing of the shot, little might be noticed by way of a single point meandering out of step with its brothers, but cache the frames and hit Play and it might be a different story. This is the sort of thing that can bring jitter into your roto.

Jitter, also called *chattering*, occurs when a single or few points along the spline move incongruously with the rest of the shape. It's particularly noticeable when a majority of the shape points go in one direction and a few of the points go opposite them. In Figure 8.7, the highlighted point is moving back and forth, not altering the shape to any major degree, but look at the curve that's created between the surrounding points. That curve is switching between concave and convex over a very small number of frames. The anomalous position frames of this point will cause the matte to look inaccurate.

Frame 1. Frame 3. Frame 6. Frame 9.
Figure 8.7

If you find yourself in a situation where you think that your shape will require you to move individual points, take a closer look and see if you can match *part* of the edge of the existing shape. If you can get a good majority of your shape's edge to match the edges of the focus object, it might be possible to keep using that shape by altering only a small section of the individual points along the spline.

Focus edge Spline
Figure 8.8

In Figure 8.8, the shape was created to isolate the edge of the girl's face and a bit of her chin as it curves into the neck. It works for the most part, but when the girl begins to laugh, the contour of her face changes drastically—so drastically, in fact, that no amount of Object mode transformations can be used to accurately relocate the shape. The shape sticks to the cheekbone and curve of the chin but strays along the edges between those areas and along the edge leading into her neck.

The differences between the shape and the new contour of the focus object edge can be explained by the physics of skin. The skin between her cheekbone and jawbone is stretching as the distance between those two set points on her face increases. With that in mind, note where the shape strays from the focus object. It stays accurate along the rigid bone structure of her face, but it strays in the areas with the most malleability.

 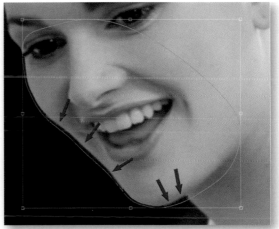

Figure 8.9

You could consider scrapping that shape altogether and starting afresh, but before you do, let's see if we can't make it work by altering only a section of it.

If we rotate the shape, as a whole, using her cheekbone as the rotation point (Figure 8.10), the shape becomes accurate for the upper part of the focus object. There isn't a huge difference between the two positions, but it does make a *good majority* of the spline's edge accurate and still usable. The exception to this is the chin area of the shape, which strays a great deal from the edge.

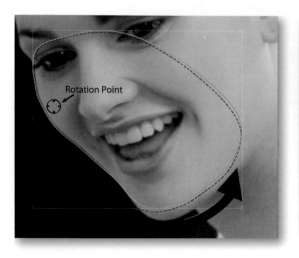

Figure 8.10

From here let's go into Sub-Object mode and select the points along the spline that do not stick to the edge of our focus object. With these points selected, we can now go back into Object mode, which will treat the highlighted points as one object.

 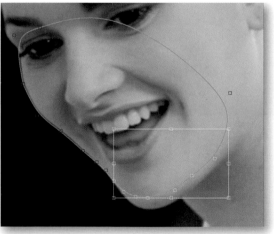

Figure 8.11

Now it's just a simple matter of rotating and scaling the selected points so that they accurately isolate the edge of the focus object.

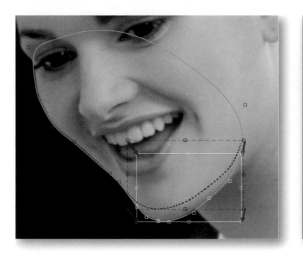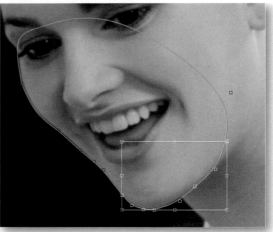

Figure 8.12

If you find yourself consistently moving whole sections of a single spline to compensate for a focus object that changes frequently, you might consider getting rid of the shape and creating two new shapes that compensate for the same edge. When and where you do this is determined by weighing how much time each will take. If you can manipulate sections of the spline quickly and easily, all while keeping the shape consistent, then by all means take this route. However, if you think time can be saved by starting over with new shapes specifically created to compensate for the aberrational edge sections of your focus object, this might be the better option.

Treating sections of your splines as whole objects and manipulating them as such can really extend their life and usefulness. If you modify existing shapes to compensate for minor shifts in the edge of your focus object, you won't be creating an overabundance of shapes *and* you'll be avoiding moving the individual points of the spline, which might result in the edges of your matte chattering.

8.2.1 Referencing Point Location

One way to avoid working with a spline in Sub-Object mode is to note where the individual edge points and internal spline edges fall *within* the focus object.

In Figure 8.13, we'll be isolating the girl in the yellow sweater on screen left. To start, let's focus on the edge of her face between her ear and neck.

Figure 8.13 Focus edge

The suggested spline we're going to use to isolate this specific edge in Figure 8.14 has some important points of note.

The edge in this particular shape is only a very small part of the actual edge of the focus object. It was created to cover areas of the focus object that we don't necessarily need to isolate. You always want to overlap your spline's edge so that your splines will cross one another, which will avoid unsightly holes in your matte. In this case, though, both the extended edges of the spline and the points along those extended edges are going to serve as reference for the position key frames of the girl's face.

Figure 8.14

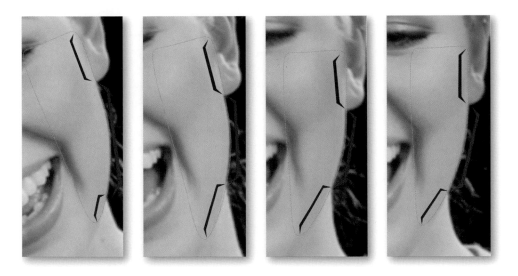

Figure 8.15

If we keep that shape in the relative position it is on every frame, you're going to find that altering the spline as a whole will be a lot easier. In Figure 8.16, you can see the highlighted points always keep their relative distance to the ear. Using these points' positions on the focus object as reference will limit the chance that the points of this spline will "travel" along the edge. As with splines, these points were created to cover a specific area of the focus object's edge. Points that travel, meaning that they don't stay in their relative position on the focus object, are usually indicators that the spline in question was animated using individual

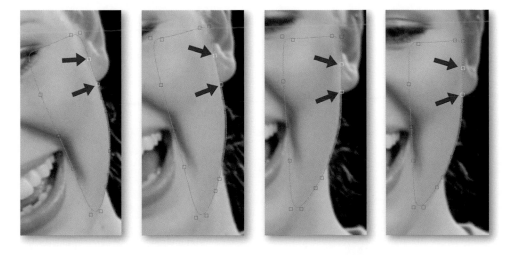

Figure 8.16

points rather than the spline as a whole. The key to keeping these points at the same part consistently throughout the shot isn't to move them individually but to scale, rotate, and position the whole spline in such a way that the shape always follows the edge. If the spline is created and animated correctly, the individual points of that spline will keep their general position along the edge of the focus object.

The interior edges of the spline should also stay in their same general positions within the focus object. However, these internal edges should only *roughly* cover the same area of the focus object. Don't spend too much time trying to make the interior points and edges of the spline match up with their previous positions. They are only useful to us as far as they give us a starting-off point to position the *edge* of our spline. Your focus should be keeping the edge points of the spline consistent with their correlating points along the edge of the focus object.

Another way to keep your shapes consistent using a spline's point location is to note where the individual points and internal spline edges lie *in reference to each other*.

Once you've established a shape that correctly isolates an edge, create an adjacent shape for an adjacent edge of the same focus object and use the established shape's placement to ascertain the position of the new shape.

If we use the jawline shape as reference, the ear shape will always stay in its relative position to the previous shape. If the ear shape in Figure 8.17 is manipulated correctly, the two highlighted points will always straddle the cheek shape roughly around the same area.

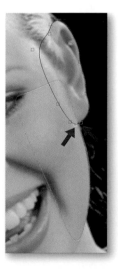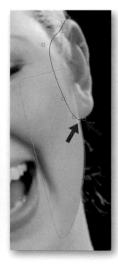

Figure 8.17

It doesn't matter whether or not you're manipulating the spline in Object or Sub-Object mode; the computer only sees the spline from a Sub-Object perspective. The computer will only interpolate the shape between the key frames as position frames for each individual point along the spline. So, even though you might have scaled and rotated the shape in Object mode, the only thing the computer is looking at is how each individual point along the spline differs from its previous position.

8.3 Review

- Manipulate your shapes in Object mode as much as possible.
- Move and rotate your shapes at the same point from which their focus object pivots.
- Jitter is introduced into the matte when the individual points of the shapes are altered without keeping the contour consistent.
- Making a selection of points along a spline and then working with those points in Object mode will allow you to keep using that shape without introducing jitter into your matte.
- Referencing where the internal, non-edge section of your shapes fall within the focus object will help keep your mattes consistent.
- Overlap the various splines as to create an appealing and accurate edge, and avoid the appearance of holes.
- Using a shape's points as reference can limit the chances of creating traveling points.

9

INTERPOLATION AND LINEAR MOVEMENT

A roto artist needs to understand how a computer interpolates the frames between the user-defined keys. Understanding this concept will increase the speed at which you roto and will decrease the number of key frames and shapes you need to create accurate mattes.

The computer sees only in straight, even lines. When two key frames are created, the position frames between them will be created by the computer based on the relative X and Y values of the two keys. The movement projected by the computer will be linear, that is, a straight line between those two points, evenly distributed over the frames in between.

The computer doesn't use the spline as a whole to calculate the position frames. Although you as a roto artist should try to manipulate the shape as a whole, the computer sees only the points along the spline and their relative position to one another. Figure 9.1 shows the first position key frame for the shape; Figure 9.2 shows the second position key frame. The computer will interpolate the shape position for the duration of the frames in between the two keys based solely on the position of the points along the spline. The lines in Figure 9.3 indicate the path that these points will take for the duration of the frames in between the keys. This particular idea is very important because though you, as a roto artist, will be looking at that shape and how it moves, the computer will only be calculating how the position of each individual point along the spline moves.

If you take a look at Figure 9.4, you'll see that a position key frame has been added that isn't parallel between the initial two keys. The new motion path of the individual points is still a straight line from each position key frame to the next.

Figure 9.1 Key frame 1.

Figure 9.2 Key frame 2.

Figure 9.3 The path the individual points will take.

Figure 9.4

Knowing that the computer only sees the positions of the individual points along the spline will also help you avoid trouble. For instance, if your focus object flips 180 degrees and you, being a tireless and accurate roto artist, flip the shape appropriately, the interpolated frames in between your keys might not react as you expect.

If you'll take a look at Figures 9.5, 9.6, and 9.7, you'll see that the first and last figures are the set key frames. Take note of the highlighted points in the circle. These points represent the edge of the throwing disk that the girl is holding onto. In most cases, you'll want to keep your points where they started initially on the focus object. The middle figure, Figure 9.6, is the interpolated in-betweens created by the computer. Remember, the computer only sees the shape in reference to where the individual points lie within an XY coordinate system, so instead of treating this shape like the solid object we perceive it to be, the computer is calculating the linear motion paths of the individual points.

Figure 9.5 Starting position.

Figure 9.6 Computer-generated in-betweens.

Figure 9.7 Ending position.

If we look at the alpha channel of the shapes (Figure 9.8), it's obvious that shifting the shape 180 degrees in this particular instance isn't the best way to go about isolating this focus object. Although the in-betweens created by the computer are mathematically accurate, they aren't remotely visually accurate. Since the throwing disk is essentially the same shape all around, instead of flipping the shape so that the points along the edges stay with their markers along the edge of the focus object, it would be a better idea to just continue the spline's shape when you're establishing the key frames.

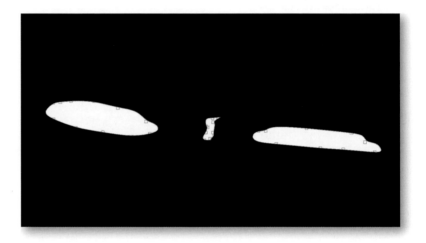

Figure 9.8

When you establish key frames for your spline, another aspect that you need to keep in mind is that although the computer only creates in-between frames for the position changes of each individual point, essentially seeing it only in Sub-Object mode, it doesn't create individual *key frames* for those individual points. When you alter one point along the spline, the computer creates only one key frame in the timeline, despite the fact that no other point along that spline has any other position change.

This is a good thing, really. If the computer were to give you key framing capabilities within the timeline for each individual point along a spline, the organizational problems would be catastrophic. The number of splines you would create, even for a relatively short and straightforward shot, would be high. If you were to break down those splines further into individual points along that spline, the number of things you'd be responsible for controlling and organizing would be impossible.

9.1 Key Frame Placement and Types

Establishing correct placement for key frames within the timeline is almost as important as shape placement in the viewer window.

If you've set two keys based on the focus object's motion, and these two keys are accurate for the two frames that you've set them, but the motion in between is off, don't immediately set a new key between the already established key frames. Go back to the initial key frames and see if you can finagle them in such a way that the established key frames stay accurate without adding new ones. This might entail rotating the shape and then scaling it in such a way that the computer-interpolated keys in between the user set key frames are compensated for accurately without making additional key frames.

It is true that some comping and roto software offers the ability to change the type of key frame used and the rate at which the interpolated movement will be interpreted by the computer. However, a roto artist should get in the habit of using straight, linear key frames for the simple reason that altering the rate at which a single key frame moves is just one more thing to worry about. A roto artist will make thousands of key frames when roto-ing a single shot. Altering the rate at which that single, solitary key frame interpolates is a terribly inaccurate way to find precise key placement.

In Figure 9.9, three identical shapes were given the same two key frames, but each key frame type was changed to, respectively:
- Hold
- Ease in/out
- Linear

Despite the fact that the key frames for all these shapes were set at the same point in the timeline and held the same XY coordinates, the manner in which they traveled between key frames was significantly different.

Another point to remember is that whatever key frame type you change to, whether hold, linear, or ease in/out, that type of movement is set and established by the computer, and if it doesn't match up exactly with the motion of your focus object, you're going to have to change the placement of the key frames in the timeline, which will affect the screen position of the shape, which will in turn throw the roto off its mark.

You could go into the curve editor of the software and alter the curve handles of the key frame to find the exact rate, speed, and distance for that particular motion path, but that is just one set of key frames for one specific subsection of one focus object. As a roto artist, you'll be setting thousands of key frames for thousands of shapes, and you'll need to do this as quickly as possible.

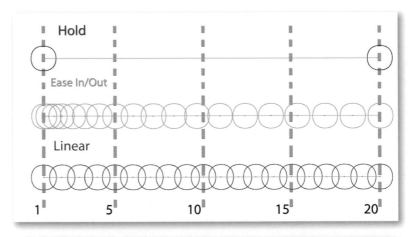

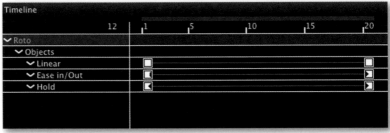

Figure 9.9

Your time would probably be better spent finding and setting the correct key frame placement rather than messing about with the curve editor.

9.2 Review

- The computer calculates the position of the individual points of a shape to interpolate the in-betweens of the shape between the user-established key frames.
- Using linear key frames gives you more control over the shapes and how they move.
- If your focus object rotates 180 degrees, be careful how you set your key frames for that focus object.

BLUR

Not all the things you'll ever roto will be crisp. Come to think about it, there is very little roto work in which at least a section of the focus object doesn't have some sort of edge blur.

Although you'll want your spline to have a blur that matches the focus object, you don't want to overdo it. When considering a focus object's blur, you want to nail down the kind of blur it is. If that object has a consistent edge blur, like a fuzzy sweater, or an element in the distance is blurred by the camera, you'll want to find a blur setting that matches that particular focus object and keep it at that amount for the duration.

A good rule of thumb is anything less than a 5 to 10 pixel blur. Whatever the mattes will eventually be used for, you should let the comper decide how much blur to apply to the mattes. As long as you keep your spline consistent with the edge of the focus object, the comper will have the ability to blur that shape to fit his or her needs.

So, let's try to isolate the gentleman in the extreme fore-ground. The focal point of the shot is the young lady, so she is crisp and clear. The man at screen left, however, is fuzzy and out of focus. To isolate him, we're going to create a shape that has the exact same blur as his edges.

Figure 10.1

Figure 10.2 Focus edge.

To start, let's create a spline for his face. Where you create this spline in reference to the edge and edge blur of the focus object is very important. Once you've found a position to place the edge of your shape, you'll be required to keep it at that same relative position for the rest of that shape's life.

This spline has been placed on the extreme edge of the blurred focus object. That means that without any blur attached to the spline, the matte would appear solid, having no gradient at its edges. From a distance this spline looks great and seemingly isolates the focus object.

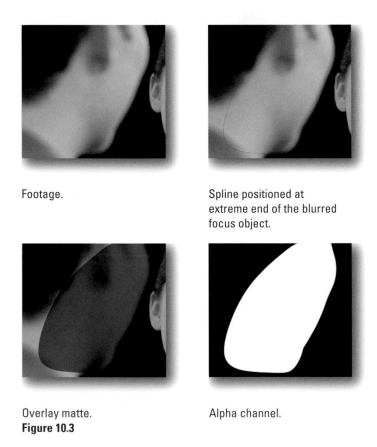

Footage.

Spline positioned at extreme end of the blurred focus object.

Overlay matte.
Figure 10.3

Alpha channel.

When we zoom in, however, the solid edge doesn't accurately portray the gradient edge of the focus object.

The spline position, in comparison to the focus object, seems to be way off the mark concerning the edge. There seems to be a huge gap between the edge of the focus object and the spline. That gap is actually the cream-colored gradient as it heads to the black-colored background.

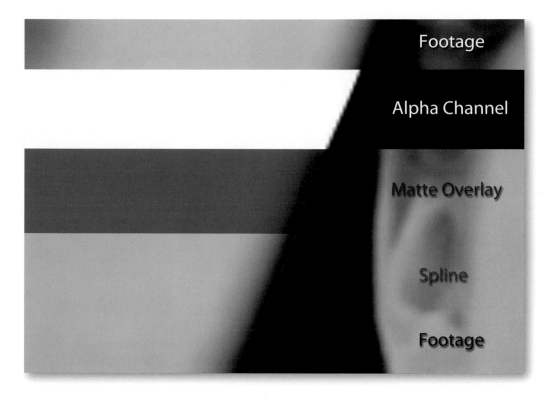

Figure 10.4

Figure 10.5

To make this matte more accurate to the edge of the focus object, let's tell our roto program to blur the edge of this spline. Since the spline was placed at the very extreme blurred edge of the focus object, we should set the blur to affect inward, on the inside of the spline.

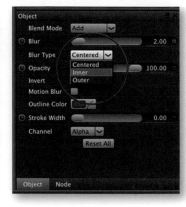

Figure 10.6

We need this spline's blur to match the gradient of the edge of the focus object. To do this, we need to compare where the gradient for the focus object starts and ends to the correlating edge gradient of the spline. Much like finding the correct values when you're color correcting an image, you want to find your values by defining the extremes. With an edge blur of 2 (Figure 10.7), the blur doesn't quite match our focus object. When we increase that value to 10, it is closer but not entirely accurate, because the gradient strays too far into our focus object (Figure 10.8). If we roughly split the difference between the two values, we'll find that this spline needs a 5-pixel blur to accurately isolate the focus object (Figure 10.9).

Figure 10.7 2 pixel inner blur.

Figure 10.8 10 pixel inner blur.

Figure 10.9 5 pixel inner blur.

Viewing your matte as a colored overlay can sometimes mislead your eye into thinking that the edge blur gradient is correct when it might be marginally off. The difference in the gradient is harder to see when the matte is viewed as a colored overlay. As you can see in Figures 10.10 through 10.12, the differences in the edge blurs aren't as clear as when we compare the alpha channel and the footage.

Figure 10.10 2 pixel inner blur.

Figure 10.11 10 pixel inner blur.

Figure 10.12 5 pixel inner blur.

A good way to check to see whether your blur is correct is to hover the pointer where the blur on the footage begins and ends and then toggle between the alpha channel and the footage. This allows you to see whether the edge blur of your matte matches the footage and makes their differences very obvious.

If your particular roto program doesn't allow you to control the direction the blur will affect the spline, you're going to have to find the spline placement that will correctly emulate the edge blur of the focus object. You'll need to figure out how your roto program of choice handles spline blur and compensate appropriately. Choosing how the blur effects the spline will seriously control how you place your spline on the blurred focus object.

The values in Figure 10.13 are pumped up to a 30-pixel blur to show the differences between the types of edge blur that can be applied to your shape.

- *Outer.* This setting will make the matte 100 percent visible starting on the outside of the spline, and then gradually, over the amount of blur setting, it will become 0 percent visible.
- *Centered.* This blur setting will keep the pixels along the spline's edge 50 percent visible.
- *Inner.* The spline will be 0 percent visible at the spline, and then the head will gradually become more visible as we go inward on the spline.

Once you've established what blur will accurately reflect the edge of the focus object, you will need to keep your spline at that same distance from the focus object edge for the life of the spline.

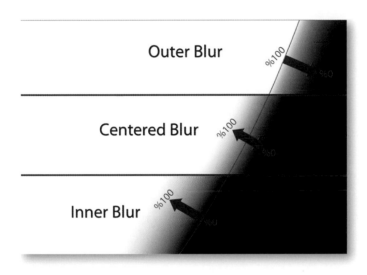

Figure 10.13

10.1 Motion Blur

You might have noticed in the pivot points discussion that the splines didn't quite match the edge shape of the young lady at the beach. Thanks for not saying anything. It's appreciated.

You would be right in thinking that the splines in Figure 10.14 and the corresponding mattes in Figure 10.15 didn't *exactly* isolate the edges of the focus object. From a strictly spline-based perspective, it wasn't accurate, but with the click of a button, these splines can be made to accurately isolate the focus object. The reason for this misappropriation of shapes was motion blur.

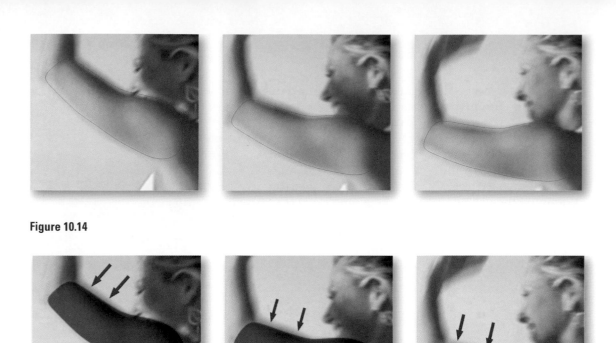

Figure 10.14

Figure 10.15

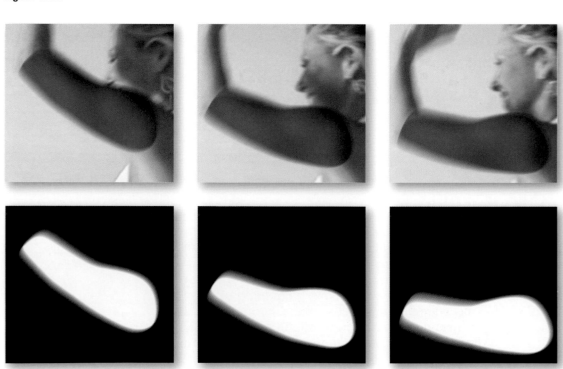

Figure 10.16 Motion blur applied to the shape.

Before we delve too deeply into that, let's take a paragraph to discuss the different types of blur the you'll be dealing with. As you might have realized, there are two reasons an element will blur. The first part of this chapter dealt with depth-of-field blur, which stems from the focal point of the camera. An element that is blurred for this reason will keep the same, even amount of blur as long as the camera keeps that particular focal length. If the focal length changes, the blur of the element will become more or less so, but at an even rate. This means that a shape created to isolate a focus object that has a depth-of-field blur should carry the same amount of blur for the whole shape edge.

Motion blur is a bit different. Motion blur occurs when a focus object moves a great distance over a short number of frames. The image blurs because the camera's shutter doesn't open and close fast enough to visually capture the moment. This results in a smearing of the image as the focus object moves.

Slow-motion footage, which is captured at a much higher number of frames per second, is generally free of motion blur because there are more frames to correctly capture the movement of the elements in the footage. This results in a much clearer image (and a more easily rotoed one, at that).

Furthermore, motion blur isn't necessarily uniform to the whole of the focus object, as a depth-of-field blur will be.

PARTIAL EDGE FEATHERING

Some programs, such as Mocha, Nuke, and Shake, give you the option to feather specific partial edges of your shapes by pulling out sections of a shape's points. This is a handy option to keep in mind, but in terms of articulate roto, you'll generally want to keep your shapes with only one point per point. Otherwise, you'll be dealing with a whole other set of variables that will have to stay consistent over that shape's life. This is not a hard-and-fast rule, but the second set of points that arise when you pull out a feathered edge will require the same attention and will need to be treated with as much care as the original points of the spline.

Applying motion blur to the mattes you create is vital if these mattes are to accurately isolate the focus object. Isolating a focus object with high motion blur without including the gradiated edges would make the mattes nearly impossible to use. This is something all roto artists must deal with on a pretty consistent basis.

In Figure 10.17, we need to isolate the orange stick protruding from the cylindrical metal handle thingy. If you think about it hard enough, you might be able to figure out why.

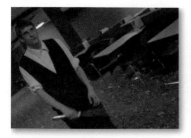

Figure 10.17

When rotoing with motion blur, keeping your shapes consistent is vitally important to creating edge-accurate mattes. If your shapes keep the contour of the focus object they were created to isolate, the motion blur applied by the roto program will be accurate, with only the mildest of tweaking.

Without motion blur, the focus object would just be a cylindrical tube, so to isolate it, we're going to treat it as such. The spline is placed where the focus object *should* be.

If you lose your focus object completely, meaning that its motion has completely obscured the edge, leaving no discernible contour on which to position your shape, move the focus object where it *should* be located, using the previous and future positions as reference. If you position your shape correctly, the motion blur should match the focus object, despite the lack of discernible shape.

Figure 10.18 Footage.

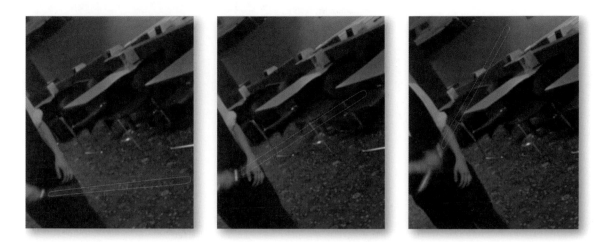

Figure 10.19 Shape.

Without motion blur applied to the shape, the matte would look much the way you'd expect. This matte does us no good at all since it doesn't isolate anything we intended. However, if we turn on motion blur, it's a whole other story.

Note how the motion blur affects different parts of the focus object. The motion blur on the shaft at the base of the saber is directly proportional to how much that part of the focus object moves. The motion blur is greater at the end of the saber because the distance the tip travels is significantly greater than the distance traveled at the base. The greater a focus object or a section of the focus object moves, the greater the element will be blurred.

This focus object has an *exceptionally high* amount of motion blur, which means that your spline is going to need more

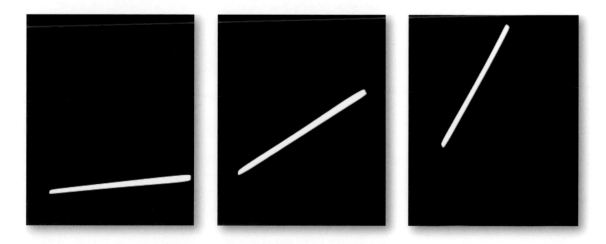

Figure 10.20 Matte without motion blur.

Figure 10.21 Matte with motion blur.

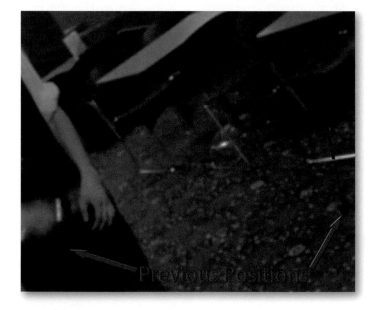

Figure 10.22

adjusting, as opposed to a focus object with just a little motion blur. You're going to find that focus objects with high motion blur are going to require a bit more finagling.

You could just straight compensate for the motion blur of the focus object; turn off the motion blur for the spline and include the blur in the mattes, physically changing the contour of your

shape. This is a perfectly acceptable way to roto—except that the natural blurring that occurs in footage when a focus object has high motion won't be reflected. If your matte is consistent, though, the comper could compensate by adding a blur to the matte in the comp, but that blur would be uniform and applied to the whole matte and not merely the sections that have a good bit of motion blur. Creating accurate, usable mattes is generally always easier when you roto with motion blur.

Silhouette Tip

When you're working with motion blur in Silhouette, you will want to do the actual roto with the motion blur settings set low. In Silhouette, the Samples in the Node window default to 16. This is a good place to leave them, since these settings don't work the computer very hard, resulting in a faster workflow. The *edges* of the blurred matte will stay accurate at a lowered setting without forcing the computer to generate a smooth, destepped blur. At the end of the shot, when the mattes are being rendered for delivery, you should increase the samples, which will result in a much smoother matte.

You'll want to leave the shutter angle and phase at 180 and –90. This is the standard default for most VFX programs.

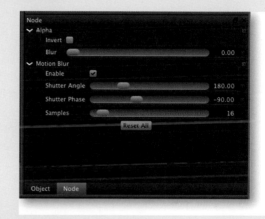

Figure 10.23

Sample setting: 16.

Sample setting: 64.

Figure 10.24

10.2 Transitioning Between Shapes with Motion Blur

Transitioning shapes with motion blur is essentially the same as transitioning without but with additional steps. To calculate motion blur correctly, the computer needs a starting and an ending position for your shape. This means that when you stop using a shape, if the motion blur is going to be calculated correctly, you need to add a position key frame after you've hidden your shape.

Figure 10.25

Figure 10.26

If we take the original transitioning shapes example, we can see that without motion blur applied to the shapes, we're going to have a hard time getting the matte to accurately isolate the focus object. Remember, the purple shape is a transition spline

between the red-and-blue shape. It is only being used as an in-between to isolate the forearm as it swings from the up-and-down position when the other two shapes don't accurately conform to the focus object.

If we apply motion blur to those shapes, the matte is close, but as you can see, we're running into problems.

These figures show us that the red and blue shapes have half correct motion blur as they approach the transitional shape, because they have position key frames up to that juncture. However, when we hid them, we didn't add a position key frame so that the motion blur could be calculated beyond the individual shapes' visibility. Not to mention that the purple, transitional shape is devoid of any motion blur because it only has the one position key frame.

Figure 10.27 Motion blur applied.

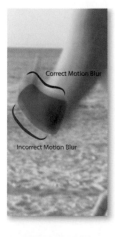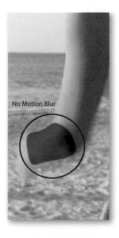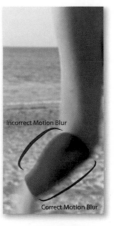

Figure 10.28

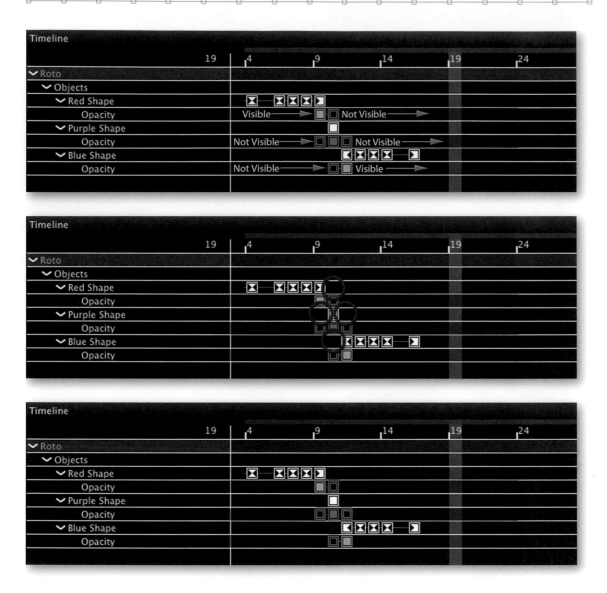

Figure 10.29 Keys need to be added for the motion blur to be accurate.

To fix this, we're going to have to add position key frames for all the shapes that correspond with the points in the timeline at which they become invisible. This solution will allow the computer to calculate the correct motion blur.

When you create position key frames when transitioning shapes with motion blur, you just want to get the shapes as close as possible. The only reason we're adding position key frames to shapes that *aren't even visible* is so that the motion blur is correct when the shape *is* visible.

Figure 10.30

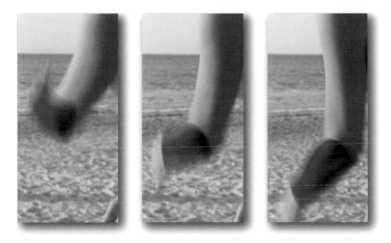

Figure 10.31 Colored overlay.

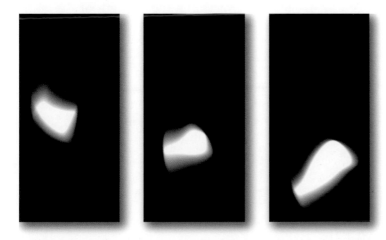

Figure 10.32 Matte.

Once you've established the new key frames, your matte will accurately isolate the focus object and its motion blur.

Just as with regular blur, a good way to check to see whether your blur is accurate is to hover the pointer over the edge of the blurred footage and then switch quickly between the matte and the footage.

Silhouette Tip

Silhouette takes the key frames of the shape into account and automatically generates the motion blur on the first and last frames of the comp. It involves using the curve of the previous one or two key frames to plot the XY movement of the shape. The slope of that curve is then extended to create the motion blur.

So, what happens when your footage has motion blur from the get-go, on frame 1? Since you need before and after key frames to accurately calculate motion blur, you'll need to create a dummy position key frame on frame 0 that accurately estimates your focus object's movement. You'll need to estimate the approximate position using the motion path of the focus object, since there isn't any actual footage at that point. If you were to create a key frame without a key frame on either side of it, the computer could only apply half of the motion blur to the focus object.

10.3 Review

- Focal blur is constant unless the focal length of the camera changes.
- Motion blur occurs when a focus object moves a great distance over a short number of frames.
- Toggling between the alpha channel and the footage is a great way to check the accuracy of a matte's blur.
- After you've hidden a shape and are transitioning to another, you must create a key frame that roughly follows the path of the focus object, so the motion blur can be calculated correctly.

10.4 Relevant CD Files

- Man_Blurred_FG
- Saber_Flip

CHECKING YOUR MATTES

After you've completed a shot, you'll always need to go back to check whether what you've done, accurately isolates the focus object. You should have been trying to keep up the quality check *while* you were rotoing, but no matter how thorough you are, you're always going to find areas of your matte that don't exactly isolate to the focus object.

Changing the way you view your rotoed footage will generally bring to light inaccuracies in your matte. Every program is slightly different, but they all generally share similar ways to view your mattes:

- Splines over footage
- Splines and colored overlay over footage
- Colored overlay over footage
- Alpha applied to footage
- Black-and-white alpha

Switching between the various views is a great way to check that your mattes are accurate. When you're working on a focus object in just one mode, you're limiting yourself to one point of view. Altering the way you view your work will greatly improve your chances of creating accurate mattes.

When you're checking your mattes, you'll want to make sure that the shape:

- Sticks to the to the edges of that focus object
- Stays the same relative distance to the edge of the focus object
- Continually isolates the same edges of the same focus object, without straying to include other edges
- Doesn't have individual shapes that are moving incongruously with the rest of the matte
- Doesn't have any holes that appear and disappear as the interior section of the splines transform

AE Tip

A great way to view your mattes as a covered overlay is to create solids on top of the footage and apply the roto to that layer. You can then take the transparency down and view the colored overlay on top of the footage.

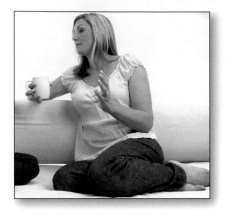

Viewing options: Footage.

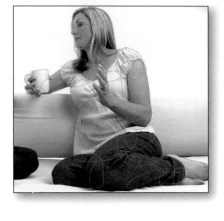

Viewing options: Shapes over footage.

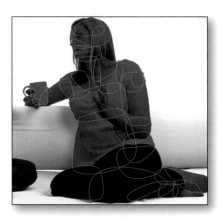

Viewing options: Shapes and colored overlay over footage.

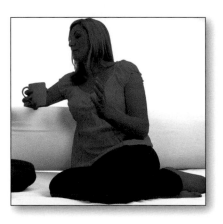

Viewing options: Colored overlay over footage.

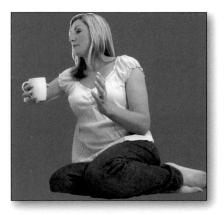

Viewing options: Matte applied to footage.
Figure 11.1

Viewing options: Black-and-white matte.

Silhouette Tip

Pressing the A key (and also Shift + A) will allow you to quickly shuffle through the various ways to view your mattes. The numbers 1–4 also allow you to switch between your various viewing options. These keyboard shortcuts give roto artists quick access to their mattes and can easily check their accuracy.

Turning your spline's visibility off and viewing your matte as a colored overlay as the shot loops in the viewer window is a great first step to checking that your matte is accurate. Doing this *while* you're doing your roto, and not just after the fact, can make subtle problems with your matte a little more obvious and can be fixed at the time rather than later. The splines themselves have an actual thickness to them and can sometimes obscure the edge accuracy.

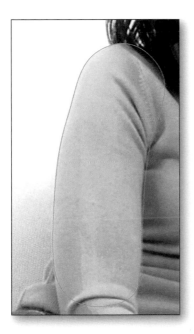 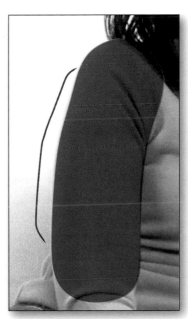

Figure 11.2

In addition, you can apply the matte to the footage and view exactly what the compositor will see when these mattes are ultimately used. This method is great for getting a quick read on what needs to be fixed and what is looking good. The only downside is that no matter how accurate your mattes, there will

always be bleed-over from the background, particularly if the background is significantly lighter than the focus object. Later, in comp, this bleed will be dealt with using color correction and edge-blending techniques, but as a roto artist, this bleed can make you pull your mattes in too tight. As long as the mattes are consistent, a good comper can fix just about anything.

Another way to check your mattes for accuracy is to simply view them as they will be delivered: as black-and-white silhouette. Although this method doesn't tell you exactly what isn't sticking, because you're not viewing the matte with the shapes, it *will* make sliding or jittering shapes very obvious. Once you've identified aberrant shapes in the alpha, go back to your footage and check to see whether the shapes you've identified are *actually* sliding or if they're accurate and merely *look* like they're sliding. Shapes do funny things when they're viewed as black-and-white mattes.

All these viewing options have strengths and weaknesses, as follows:

Shapes only:

- Viewing your matte in this manner will reveal any jitter coming from your splines and if the various shapes are moving together as one, cohesive matte. Also, any obvious edge inconsistencies can be easily spotted.
- Since the spline itself has a thickness, simply viewing your shapes over the footage will sometimes miscommunicate the accuracy of the shape.
- Also, if the focus object has any motion blur at all, this viewing option cannot relay the accurate status of the matte.

Shapes and colored overlay:

- This view very easily reveals holes in your mattes as the insides of your shapes move to compensate for the edge change of the focus object.
- It is also very easy to see when your shapes aren't overlapping correctly and create unflattering junctions as the shapes overlap.
- This is a very good way to see whether multiple shapes isolating one edge are lining up correctly and moving as one unit.
- If your focus object has small amounts of motion blur, any edge inconsistencies will be easily noticeable.
- This view isn't the best way to check on matte accuracy for focus objects with large amounts of motion blur, however.
- Inconsistencies with small details, such as hair, or partially visible elements are easily noticed in this view.
- Again, though, since the splines themselves do have a thickness to them, the edge accuracy might be obscured by this particular viewing option.

Colored overlay:

- Great for checking edge accuracy. If the edges of the shapes aren't matching up with the focus object, it is very clear if your shape is too far out or too far inside your focus object when you're viewing your mattes as a colored overlay.
- If your focus object has small amounts of motion blur, this particular viewing option is great for checking to see whether the matte is correctly communicating it accurately.
- However, if the focus object has greater amounts of motion blur, the gradiated viewing option will sometimes be misleading.
- Smaller details, such as hair, or blurry focus objects won't always give a visually accurate result.

Matte applied to the footage:

- For best results when applying the matte to your footage, make sure your background is a middle gray color. This will make the matte inconsistencies more evident than viewing it over a background that is white or black. Both of those colors can give misleading results.
- This view shows the smallest of inconsistencies in your matte. Generally, edges are clearly either right or wrong in this view.
- Viewing your matte in this manner can give you a very clear idea whether the edges of your shapes are accurately communicating the movement of the focus object.
- Great for viewing small amounts of motion blur and checking to see whether the shapes are accurately compensating for the movement of the focus object.
- When you're dealing with footage that has a high contrast in luminance between focus object and the background, this view will sometimes not give you a visually accurate representation of the final matte.
- Elements with high amounts of motion blur won't be viewed accurately.

Black-and-white matte:

- Using this view is a great way to check to see whether the starting and finishing points of your gradiated matte edges are meshing up with the motion blur of the focus object. Quickly alternating your view from base footage to alpha channel while using the mouse pointer to hover over the edges of the blurring mattes will give you the best results.
- Jitter will become very obvious in this particular view.
- If your shapes are overlapping and intersecting incorrectly and creating unpleasant edge situations, this fact will become evident. In addition, edge inconsistencies *between* shapes will be easy to spot.
- This isn't the best view for checking on total matte accuracy, meaning that minor details in your focus object cannot be easily distinguished simply because you're not viewing the footage.

Tip

If your roto program is capable, a great way to make minor adjustments to your matte is to turn the splines off, so you're only viewing the matte as a colored overlay; then, with the arrow keys, move the entire matte or selected sections to their correct place. This technique allows you to make minor adjustments to the edge of the spline without the actual splines marring your view of the edge of the focus object.

Remember, it's okay if your mattes are off as long as they are *off consistently*. If your shape consistently covers the same edge at the same distance from the edge of the focus object, the matte can be expanded or contracted afterward in comp, but if the edge changes its edge position, creating an inconsistent edge for one section of the matte, nothing can be done except to fix the roto.

If you're having trouble with a specific shape, scrub through, focusing specifically on that shape's key frames. Generally speaking, there's a keyboard shortcut that allows you to skip frames based on the selected shape's key frame placement. Using this method, you'll want to view each key frame one after another, making sure that the shape is moving correctly with the focus object.

Sequentially viewing the key frames of a shape allows you to quickly cover the key frames of the troubled shape and will allow you to make minor adjustments, most times using the nudge commands on the keyboard. When you're making corrections to a specific shape, you should try whenever possible to avoid making new key frames. Chances are, if you've estimated the key frame placement correctly, it just may be a matter of making minor changes to the position of the shape. If the shape is sliding or revealing too much of the focus object, try changing the screen position of the key frames you've already established. If this doesn't make the matte stick, you could also try moving the keys around on the timeline by small increments in either direction and adjusting the position frames accordingly. After you've exhausted all other options and there's no other choice, go back and create more key frames for the aberrational section.

(Yes, you're not supposed to move individual points of a spline, but after you've gotten some experience with roto, you're going to see when it's okay to do that and when it isn't.)

On occasion, mistakes will slip through and you'll deliver a matte that doesn't isolate the focus object to the client's wishes. When this happens, a roto artist will get notes or corrections from the supe or even directly from the client. Sometimes these are corrections for the delivered matte, or they might ask for clarification of a focus object. It happens to the best of us, so don't get too down on yourself when it happens to you.

11.1 Jitter

A consistent note a roto artist might get is that the matte has jitter. This phenomenon occurs when a point or set of points along a spline moves differently from the rest of the shape. This is a really hard and time-consuming problem to fix and should

be avoided at all costs. Interacting with your shapes as a whole rather than moving individual points is just about the best way to avoid jitter.

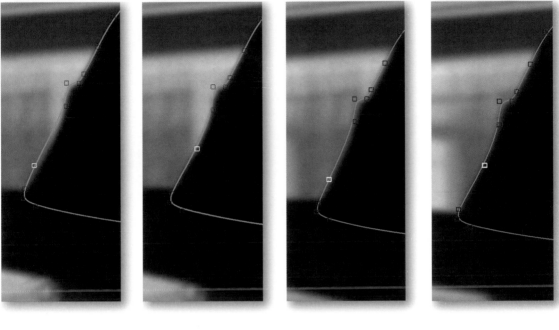

Key frame 1. Key frame 2. Key frame 3. Key frame 4.
Figure 11.3

This *can be* a really complicated problem to fix. For every key frame you've created for the entire shape, that one, single point or section of points along the spline has its own set of directives that don't mesh with the position key frames and motion of the rest of the control points. This means that for all the previously established key frames you've already created, you have to fix that one, individual point's position key frame. This is complex because you'll be focusing entirely on exactly what got you into trouble in the first place: the placement of an individual point.

In Figure 11.4, take note of the position of the highlighted point. It is changing its distance from the edge of the focus object *and* changing the position in which it lies on the hatband. In addition to all that, the difference in the point position is creating a curve that changes directions from concave to convex. Visually speaking, this will cause the matte to jitter unnaturally.

Also note the distance the point is traveling between key frames. The two surrounding points are staying the same relative distance from each other, but the jittering point is moving inconsistently *between* the surrounding points.

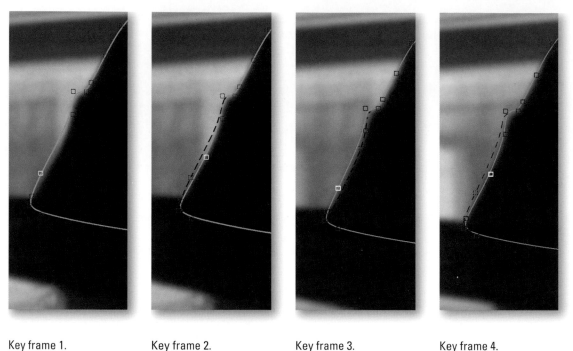

Key frame 1. Key frame 2. Key frame 3. Key frame 4.
Figure 11.4

You could fix the anomalous section of the edge by manually moving those individual points on the already established key frames for that shape, paying close attention to make sure that the relative positions of the anomalous points are accurate between the surrounding points.

This task could be problematic because you'd be doing what got you into trouble in the first place: interacting with the individual points of the spline rather than the shape as a whole. If the shape hasn't too many key frames set for it, however, this might be the way to go. When you're doing this, keep a close eye on where those aberrational points fall in relation to each other along the edge of the focus object, and try to duplicate that relationship for the rest of the key frame of those individual points. You'd have to be exacting in making those key frames, however, and might spend more time fixing the problem than you initially spent on rotoing the focus object to begin with.

Something else to consider when you're faced with a jittery matte is to delete key frames in the hope that you'll eliminate the chattering edge. This will throw off the accuracy of the shape, but if it gets rid of the jitter, you can correct the shape's placement afterward. The new key frame will be jitter free and correctly repositioned.

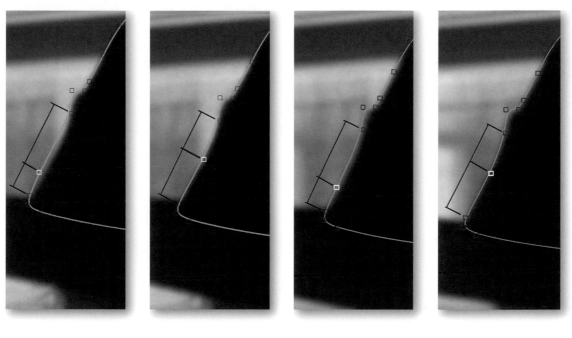

Key frame 1. Key frame 2. Key frame 3. Key frame 4.
Figure 11.5

If the section of the spline can't be saved, still having too much wobble and too many key frames, it might be more conducive to a faster workflow if you just get rid of the offending sections. However, with this option it means that for all the keys you've established for that shape, that one section will result in an inaccurate edge. If you choose this option, the shape will have an inaccurate edge section that won't match the focus object's edge, which is exactly what you don't want.

If you've chosen to delete the point (or points) of the inaccurate edge, you have a few options for fixing that section:

- After this point is deleted, you could create a new section of points exactly in the positions where the original points were. The computer will create new positions for these points that evenly move with the surrounding points. You'll still have an inaccurate edge, but the new point won't have the old point's position jitter and will move correctly with the motion of the whole shape. Although the new point won't have the jitter baggage of the deleted one, it also won't stick to the focus object and will have to be moved manually—which brings you back to the original problem, but doing it this way can give you a clean slate to accurately replicate the relationship between points from key frame to key frame.

- After the offending point is deleted, simply create another shape, compensating for the aberrant edge and overlapping the previous shape. This option is a good idea if the shape in question has been in use for a while and the only things incorrect are the few mutinous points. Keep in mind that you've already established the key frame for this focus object's motion path with the previous shape. It might be a quick fix because the key frame structure of the original shape is already determined, which means that you already have a guide for the new shape's key frames. The easiest plan of attack might be to create a new key frame for the new shape on every key frame of the previous shape. When you're creating this secondary shape that's compensating for the flattened edge of the original shape, an easy way to keep the edges of both shapes consistent is to have the points of the new shape roughly correspond with the old shape. That way, it's just a matter of going to every key frame of the previous shape and moving the new shape's corresponding points to the new position.

Silhouette Tip

Silhouette gives you the option to make adjustments across all previously set key frames or a selection of key frames with the Multiframe tool. With this option activated, you are able to alter the position and contour of your shape, which will affect all the key frames you've already established. With the new point in place, you can activate the Multiframe button, and any changes made to the spline will be applied to all the keys you've already established. This means that if, on any frame, you move the newly created point to the correct spot along the edge of the focus object, the computer will keep that point's position the same, relative to the surrounding points.

If, after spending some time trying to fix an anomalous section, you don't seem to be making any headway, your last option would be to delete the entire shape and start over again. Only consider this:

- If the shape is relatively new and hasn't many established key frames, or
- If the shape's placement is completely inaccurate and has too many incorrect key frames, or
- If the individual points of the shape move too incongruously with the rest of the key frames

If you go this route, pay close attention to your old shape, and figure out what was going wrong with it. The ways in which the old shape wasn't working might give you clues as to what *will* work with the new shape.

11.2 Review

- Toggling between the various ways to view your matte is a great way of viewing the accuracy of your mattes.
- It's okay if your mattes are inaccurate as long as they are consistently inaccurate.
- Jitter is introduced to your matte if the individual points of a spline don't move as one cohesive unit.
- Jitter is difficult to correct after the fact, so avoid manipulating your shapes on the Sub-Object level.

TRACKING AND ROTO

As a roto artist, your job is to find the quickest, most straight forward path to isolating your focus object; roto is mainly a frame-by-frame business. If there's a way to create an accurate matte without manually creating key frames for your shapes, you should try to find that method.

Tracking elements of your footage and attaching that tracking data to your shapes is one way to expedite your workload. When you track an element in a shot, the resulting track gives us the horizontal and vertical data of that element. This tracking data is then translated by the computer into XY coordinates that can be applied to a shape. Said shape will then follow the position coordinates of the tracked element. Essentially, tracking your objects is what you do when you're manually isolating the focus object, except the computer is putting in the broad strokes.

Now, this tracking data can be applied in a number of ways—position, rotation, scale, and corner pinning and stabilization—but for the moment, we'll take them one at a time. First: basic XY translation.

Let's say that we need to isolate the eyes of our scaly friend. You're going to run into this particular situation a lot. Someone will need a pair of robotic eyes inserted into the footage, or perhaps its something as simple as a color change. Either way, you're going to be creating plenty of ocular mattes.

Figure 12.1

This particular shot might be slightly challenging if done by hand, since the movement of her head and eyes are subtle as she shifts back and forth in the frame. Her eyes don't have a particular pattern to their movement. Chances are, we'd be creating a lot of key frames for our shape.

Let's see if we can't speed this process up, shall we?

To start, let's create a tracker and position it on her eye. You might be tempted to use the white glare on her eye, but since that hot point isn't really attached to anything, its movement will change with the light source and the position of her head. Tracking small reflections like this one can occasionally result in solid tracking data, but generally you should try to find a more substantive point to track.

Figure 12.2

A better choice might be her actual retina. It has consistent color and enough contrast for our tracker to stick. We'll increase the tracker size to encompass the whole of her retina, meaning that the tracker will use the entire middle ring of her eye as a tracking marker.

Take a closer look at the track created. Most of the points are centered around a small area on the screen. These small jumps signify the subtle movement of the head and the eye. Were you to try to isolate it without utilizing the tracking tools, you would be required to create key frames similar to the track.

Figure 12.3

After the tracker has done its work and created the position key frames, you'll want to apply that data to a shape. Once the data is applied, you'll see that the shape sticks to the eye, following the subtle movement as it twitches and sways.

Figure 12.4

We should discuss a bit about *how* roto programs apply tracking data to shapes. This discussion might be slightly tenuous since no one program labels its roto tools exactly the same as the others, but we'll see if we can't break the concept down into more general terms.

When you apply tracking data to shapes, the computer doesn't apply those position coordinates specifically to individual splines but to the groups or layers to which they are connected. This means that you can have numerous splines within a folder or layer that follow the set tracker you specify. This feature comes in handy when you're dealing with a shot that has significant camera movement or when your focus object has clear tracking markers, but it will force you to organize your comp into the respective subsections required by the footage.

In the previous example, the shape created to isolate her eye becomes inaccurate—not because the track is off but because her brow begins to cover her eye. It would be entirely possible to modify the eye shape to compensate for the intruding brow, but that might require meddling with the individual points of the spline and create key frames for that shape.

Since we want to make as few key frames as possible, it would be a lot simpler to create a new shape for the brow, putting that shape in the same folder or layer as the eye shape and then subtracting that shape from the eye matte.

Since the brow shape will be in the same layer or folder as the eye shape, it will use the same tracking data. Doing it this way saves you from making any extraneous position key frames for your shapes (save the initial one) and accurately isolates the

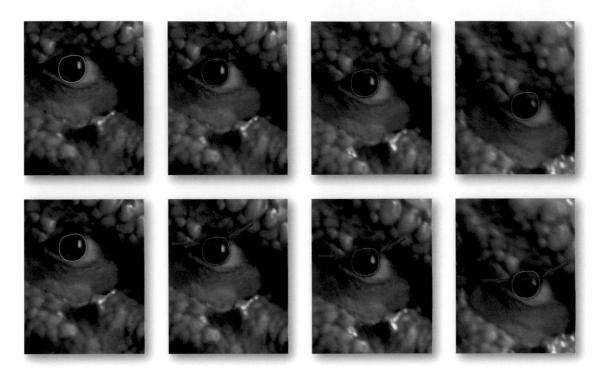

Figure 12.5

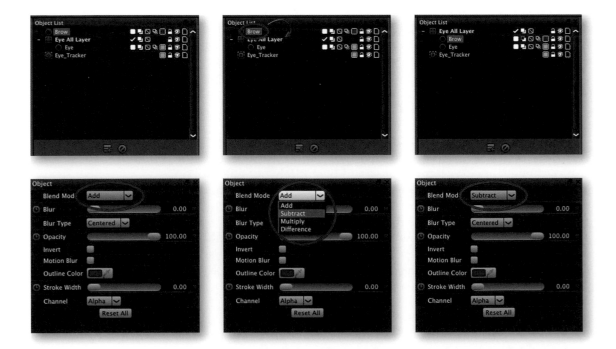

Figure 12.6

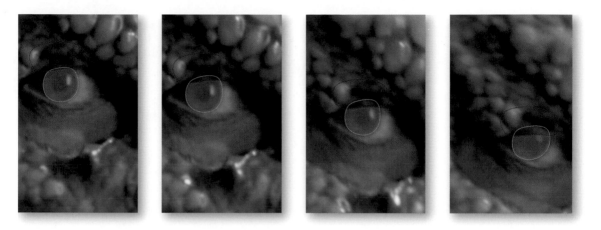

Figure 12.7 The red brow shape subtracted from the positive eye shape.

focus object. In the case of our negative brow shape, only a few key frames were necessary to accurately isolate the brow as it moved over the eye.

12.1 Tracking and Scale

Sometimes the tracking data doesn't make the allotted shape perfectly isolate the focus object. You'll find that the reasons range from a sliding track to a perspective shift in the focus object. One of the main reasons, however, is that your focus object isn't staying the same size throughout the footage.

Generally speaking, an object will change its size, growing larger or smaller if:

- The focus object is moving closer or farther away from the camera.
- The camera is moving toward or away from the focus object.
- The camera is making adjustments to the level of zoom.

The data you get when you're tracking an element in the footage is simply XY coordinates. If your focus object changes its size at any point in the footage, you're going to have to manually adjust the shape to compensate.

Before you start adjusting your shape by making new key frames, however, you could try adding another tracker. With two trackers, the computer can extrapolate scale data, which can then be applied to a shape. With the scale data applied, the shape will change its size appropriately to isolate the focus object.

In the previous example, we just applied the data as position coordinates because the focus object's scale was consistent. Now we'll not only be applying the position data but adding another tracker and applying scale data to a shape.

Figure 12.7 shows a shot of a slow zoom into the iconic Hollywood sign. Our job will be to isolate the letter *H*. With that in mind, a motion tracker has been attached to the top screen-left corner of the focus object.

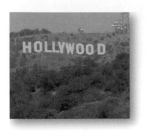 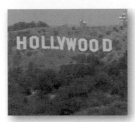 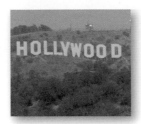

Figure 12.8

 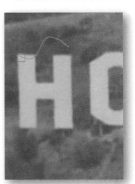

Figure 12.9

However, when a shape is created and that tracking data is applied to it, we find ourselves with a problem. The shot zooms into the sign, changing the size of the letters drastically, so the shape we created to isolate the letter *H* is only applicable as it stands for a couple of frames at the beginning. Although the position data does make the shape stick, it doesn't have enough information yet to apply the correct scale.

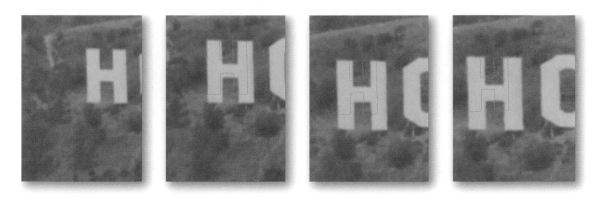

Figure 12.10

If the zoom this camera takes is perfectly consistent, meaning that it increases at the same rate for the entire shot, we could simply create a second key frame for the focus object at the end of the timeline, scaling it up to match. However, we have no way to know that this zoom was mathematically accurate, and chances are that the camera operator was human, which means it was probably done by hand. Let's see if we can't expedite things by adding another tracker.

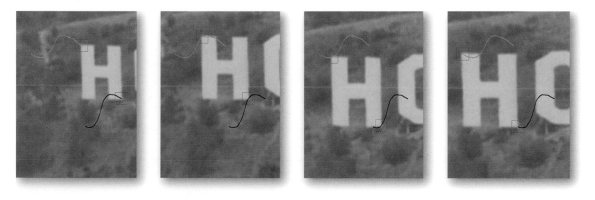

Figure 12.11

With a second tracker established on the screen right-bottom corner of the focus object, we can now apply the tracking data that will include not only position but scale data.

Figure 12.12

When you apply both position and scale tracking data to a shape, the computer is using two different sets of commands to find the correct placement for the spline:

- First, the two tracks are averaged together, creating mean position coordinates between the two trackers.
- Once the track is averaged, the computer then uses the two points as reference to apply the scale perpetrated by the focus object as related by the trackers.

Once the tracks are applied to the layer, the initial key frame on which the shape is created establishes the scale for that shape at 0 percent. The distance between the two trackers on that initial key frame is then made to equal a 0 percent scale. From that point on, any increase or decrease in the distance between those points translates as an increase or decrease in percentage of the initial 0 percent. That percentage, larger or smaller, is applied as an increase or decrease in the proportional scale of the shape as the distance between the tracker deviates from the initial 0 percent scale.

If we were to apply these trackers without using the scale data, the shape would be centered on the focus object but not scaling with it. Conversely, if you were to apply the scale data but not

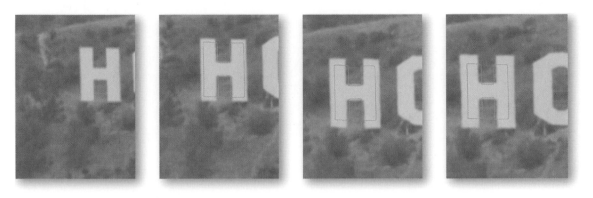

Figure 12.13 The two tracks averaged together and applied as position coordinates.

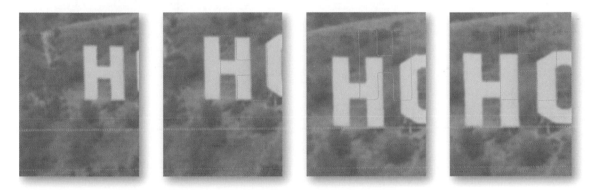

Figure 12.14 The two tracks applied only as scale.

the position data, the shape would scale correctly but would not move with the focus object.

You're not always going to be able to achieve perfect results with this technique, and some shapes might require some finagling, but you should always try to put yourself into a position where the computer will generate a majority of the key frames. Creating key frames manually will always take longer. If you can use these computer-generated scale and position key frames as a guideline, you've already cut your work in half.

12.2 Tracking and Rotation

When you apply your tracking data to shapes, there is another option in the tracking tools. Aside from basic position and scale information, you also have access to rotation data. This allows you to track two points in your footage and apply the rotation generated by those two trackers to your shapes.

Figure 12.15

Figure 12.16 Focus object.

The two points of your track create an angle at which the computer then applies to the shape as rotation data. As we mentioned initially, this is applied not to individual shapes but to the layer as a whole.

Knowing how to make rotation and tracking work for you can potentially make tough shots easy—well, easier anyway.

Let's say that our job is to isolate the entire area of the back wall. We're probably being asked to isolate this area because some new element is needed to replace the back wall. The reasons could be anything from a simple color correction to a minor graphic replacement of a specific element, or even complete and total back wall replacement. Whatever the situation, we're going to have to find a way to quickly isolate everything above the pins and below the ceiling.

The shot has many elements that make it a great candidate to use tracking and rotation to create the motion path for the

Figure 12.17

shapes. It's a handheld shot, full of jolts and jitter, plus the angle at which the camera sits changes pretty drastically from one frame to another. The most indicative point would probably be that the footage has easily trackable elements that *specifically isolate* the rotation and movement of the camera.

If we use the center isle number as a base pivot point, the rotation of the footage becomes very evident. From the following figures we can deduce that the camera is tilting quite a lot from frame to frame. That real-world tilting converts visually to our focus object having erratic rotation as well as position jumps.

When you're choosing your tracking points with the idea that those two points are going to drive the rotation of your shapes, you need to pick points in the footage that share a similar plane and will accurately reflect the rotation you need to emulate.

In the example, since the back wall is our focus object, what we're looking for are easily trackable points along that wall that will give the splines we attach to them the same rotation as the wall itself.

Our focus object is full of easily trackable points, but let's find some that will leave us with the least amount of work afterward. Since the rotation of the whole frame is so great, let's track in two

Figure 12.18 The lane numbers make excellent tracking markers.

Figure 12.19

points along the wall that exemplify the whole scope of the focus object's rotation. These two points are at the opposite ends of the frame, which will give the computer the entire range of rotation that's happening to our focus object. These two points represent the extreme rotation of our focus object.

With those two points tracked in, we can create a spline for our focus object and then apply the tracking data to that spline as position *and* rotation movement.

The rotation data we applied is just like the scale application of data, with two separate equations happening:

1. The two tracks are averaged, creating position key frames.
2. The angle between the two points is calculated and then applied to the layer that holds the shape.

Figure 12.20

Figure 12.21 Shape.

Whatever frame you initially create your spline on, the rotation applied to that layer at that frame is 0 degrees. Whenever the two tracks deviate from that initial frame, degree is applied to the layer as a rotation plus or minus the initial degree.

If the tracks stick to their elements within the footage and the spline is created accurately, you should end up with something like Figure 12.21.

12.3 Multiple Transforms

The previous two sections covered how to separately apply scale and rotation data to your shapes. As you can tell, tracking is a very powerful tool that can increase your speed and decrease the amount of work that it takes to finish a shot.

You'll find occasions, though, where focus objects don't conform to simple position/scale or position/rotation motion tracking. It is in these situations in which you'll need to apply all three different transforms (position, scale, and rotation) to your splines so that they may accurately isolate the focus object without forcing you to manually create an overabundance of key frames.

Figure 12.22 Footage.

This shot is all over the place. While our saber-wielding gentleman is preparing for battle, the camera tilts and moves with tremendous frequency. Our focus object for this example will be the screen-left door. We'll be creating a window matte for the madness that is this shot.

Figure 12.23 Focus object.

Since our focus object is the screen-left door window, conveniently enough, there are two almost perfect tracking markers in the center of the door that will create ideal tracking data. The light saber crosses in front of the trackers, so we'll have to make sure that the trackers stick to their marks on those frames.

Figure 12.24 Tracking elements.

When we track those elements, it is obvious how much movement is going on in this shot. Being what it is, jitter can severely throw off any shapes using this track to drive their transformations, so when you're planning on attaching multiple transformations to a shape, take extra care to make sure that the track is as tight as possible.

Note

These two trackers will be averaged together to find the right position data. There's more on averaging trackers a bit later on.

Figure 12.25 Tracking data.

From here we'll figure out exactly how to apply these trackers in such a way that will require the least amount of manually created key frames. We're going to find a frame where the entire door window is entirely in the shot and at a point where the corners aren't being blocked by the extreme camera movement or the actor with the light saber. With the shape for the window created, let's apply them both as position data to our shape.

Figure 12.26 The shapes deviate from the focus object with just the position data applied.

Figure 12.26 shows us that the applied motion trackers, just as position data, don't accurately isolate the focus object. It's not even close, really. There's a scale generated by the camera move for which the position data alone isn't compensating. With that in mind, let's see if we can't make this shape more accurate by applying scale as well as position data to our shape, using both trackers as reference for the scale deviations. This is a static object, meaning that aside from perspective shifts, the individual parts of this focus object will keep the same proportion relationship to each other. This makes them ideal tracking markers to use to apply a position *and* scale transform.

Figure 12.27 A position/scale track is applied to the layer, and the shape still doesn't stick to the focus object.

Applying position and scale data to our shapes definitely brings us closer to our goal. The shape scales up proportionally to the shifting size of our focus objects, but now the rotation in the camera movement becomes more apparent, which, as we only used position and scale to drive the movements of the focus objects, the shape isn't compensating for the rotation of the trackers.

Where does that leave us? If the position and scale tracking data isn't enough to isolate our focus objects, we're left with one more option before we are forced to manually create key frames for these shapes: adding rotation data to the mix. With the two trackers as they are, they should accurately compensate for the rotation of the focus object.

Now, obviously, the matte isn't complete. You'll have to create a negative matte to subtract the gentleman with the light saber, but we'll get to that soon.

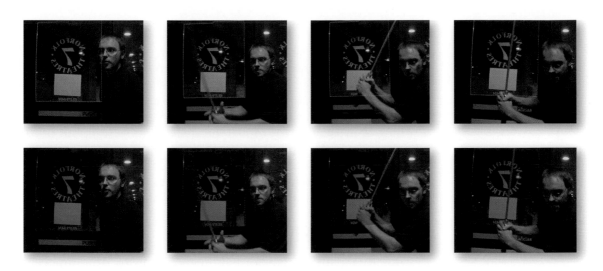

Figure 12.28 The shape sticks to the focus object with position, scale, and rotation tracking data applied.

Whenever you use motion tracking to define the position, scale, and/or rotation of a shape, you're embedding a lot of transform information into the movement of that shape. Keep this in mind when you apply more than just position trackers, because if any of the trackers is even a pixel or two off, you're going to have to compensate for that by:

• Readjusting the trackers for the deviant frames or
• Creating position key frames for the shape

Very rarely do the stars align and create such a perfect configuration that will result in a perfect position/scale/rotation track. More often than not, using trackers to drive the transformation of your shapes will get you most of the way to a shot's completion but will generally require you to modify the shapes in some way, so they will accurately reflect the edge and motion path of your focus objects.

In the example, when the tracking data was used to manipulate the position, scale, and rotation of the shapes, the resulting tracking coordinates brought us closest to isolating our focus object, requiring only a few additional key frames here and there.

When you're adding key frames to layers with tracking data applied to them, you need to isolate the area in the timeline so that they *accurately* stick to the focus object. Generally speaking, the track is only off for a frame or two and is accurate for a majority of the shot. Once you identify where the track is accurate and where it begins to drift, you need to create key frames for the shapes on the accurate frames *without* actually changing anything about their contour or position. This means that if you merely add key frames where the shape begins to drift, *without adding key frames to indicate where the track was accurate*, you'll be throwing the entire track. The tracking data has given us a

mostly accurate shape placement, so when you add key frames for this shape, you'll be throwing off the shape on the frames that *do* work if you don't establish key frames on the accurate frames.

Although it is sometimes a good idea to use trackers to move your shapes, subtle changes in perspective or scale can throw off the calculations and make the shape move erratically. Though the computer is a great tool, it still is just a computer, without reasoning or artistry. Learn to use the tracking tools well, but don't become dependent on them. Used correctly, they are a wonderful time-saving option, but if the tracks aren't dead on, you might spend more time fighting with the tracking data applications than it would have taken simply to do it by hand.

12.4 Corner Pinning

Another type of transformation tool used to drive tracker-based roto is most employed for screen replacements. If you've got a blank screen in a military control room or alien command center that needs to be isolated, *corner pinning* is the way to go about doing it.

Corner pinning takes four motion trackers and uses their resulting coordinates to apply a nonuniform transform to the shape to which they're applied.

This differs from applying position/rotation/scale tracking transformations, because when those are applied to a shape, the resulting transforms stay proportional and translate uniformly. Corner pinning is used when elements shift perspective to such an extent that simple position/rotation/scale transformations don't accurately compensate. In addition to position/rotation/scale transforms, corner pinning applies shearing to a shape that will distort it appropriately to match the focus object, using the four trackers as reference.

Now we're going to isolate the front side of the fountain shown in Figure 12.29.

Figure 12.29

Figure 12.30 Focus object.

Just to be safe, let's check to see whether we can track in the diagonal corners of the fountain and apply a position/rotation/scale transform to our shape. Creating accurate trackers might take time, so if we can get our shape to stick using only two motion trackers, we've saved ourselves the time it takes to make two additional trackers.

Figure 12.31

When we apply the tracking data as a position/rotation/scale transform, the shape starts off on the right track (it had been a while since the last pun—I was jonesing!) but loses its accuracy as the fountain shifts perspective. The two corners of the shape connected to the tracking markers stick to their respective positions on the focus object, but the shifting perspective requires the shape to shift nonuniformly to its initial contour. Using this position/rotation/scale tracking data to drive our shape's motion would require us to manually create key frames on the inaccurate sections of the footage. And who wants to *manually* create key frames when the computer can do it for you?

Figure 12.32 The shape with position/rotation/scale data applied doesn't accurately isolate the focus object.

To start corner pinning this shape, we'll add two additional trackers, located at the other corners of our focus object. As you can see in Figure 12.33, we now have a total of four trackers, one at each corner of our focus object. These trackers will drive the nonuniform transform of our shape and will hopefully make it accurately isolate the focus object without manually creating key frames.

Figure 12.33 All four trackers.

After we apply these trackers as corner-pinning data to our shape, you'll see that our focus object is being isolated accurately. The shape stays accurate to the perspective shift of the focus object for the range of our frames.

Figure 12.34 Corner pinning did the trick.

12.5 Averaging Tracks

For motion tracking to be a viable option while rotoscoping, the tracking data you create will need to be consistent with the focus object and have as little jitter to it as possible. It isn't always possible to get tracks that exactly stick with the focus object, however. If these tracks don't stick, they can't be used.

One way to improve the consistency of your track is to average several together. This process generally gets rid of anomalous key frames within your position data.

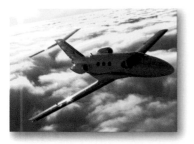 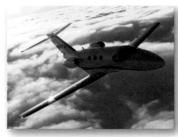 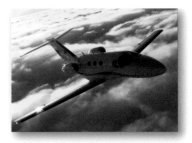

Figure 12.35

Let's take the example of the jittery plane footage. If you were to roto a shot like this, without utilizing your tracking tools, it would probably be monumentally complex. Though the plane itself isn't moving to any great extent, the camera is jumping a great deal but only marginally from frame to frame. You would need to create many, many key frames to accurately isolate this focus object, without incorporating tracking into your workflow.

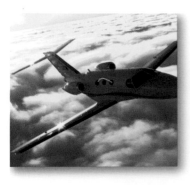

Figure 12.36 Screen-right window.

In Figure 12.36 the front round window on the body of the plane has been tracked, creating position keys that, ideally, stick to the focus object. The track seems to be accurate, but the position key frames are very jittery. This could be a bad track, or it just might be the footage. The large direction jumps between key frames are particularly troubling.

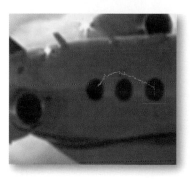 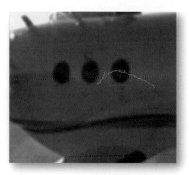

Figure 12.37

To test this, we're going to track another window, this time using the back one. In theory, these tracking objects should have a similar motion path, since they're attached to the same object, which is solid and static in the footage. We're tracking the other window to see whether the initial track wasn't sticking or if this footage happens to be very jittery.

Figure 12.38 Secondary track added.

The secondary track does indeed have the same jittery movement as the first track. The two share similar peaks and position jumps from frame to frame, which is particularly obvious around the more extreme key frames.

Figure 12.39

This means that our first track was accurate and the footage is once again established to be very jittery. However, there are subtle differences in the position data between tracks. To be sure, let's average the tracks and see if we can even out the motion a bit. The way you do this varies from software to software, but the math is all the same.

When you average trackers together, the computer adds the X and Y coordinates of the trackers and then divides their sum by however many trackers you're averaging together. In the example we're only doing two, but generally speaking you can average however many you like. When the trackers are averaged, the computer will find the exact middle point between the trackers.

Figure 12.40 The middle track accurately falls within the center of the middle window.

Since the tracks are at the center of the two outside windows, if our tracks are accurate, the averaged track should represent the center of the middle window.

Let's double check our averaged track by creating a shape for the window and attaching it to the averaged track. When the shape is attached, it appears to isolate the middle window without problem.

Figure 12.41 The shape attached to the averaged track sticks to the focus object.

As we mentioned, you can average however many tracks that you feel is necessary. In the example we only needed two, but if you're having trouble finding a decent track for a focus object, you can always track multiple elements on the focus object and average them all together to find the most stable track.

12.6 Stabilizing Footage

There's nothing worse than a shot that would otherwise be very simple were it not for the obvious and hard-to-avoid movements of the camera. As roto artists, we tend to like locked-off cameras (and bald actors who don't move around much, but we'll get into that later). Shots with locked-off cameras are infinitely easier to work with because the resulting shots allow us to easily identify and isolate the motion path of our focus object without also having to compensate for the additional movement of the camera.

Figure 12.42 Footage.

When the camera is still, we are only responsible for the movements of our focus object. When the camera is moving about in the hands of an overcaffeinated camera operator, the movement of the focus object is lost among a sea of motion that's hard to nail down and almost impossible to predict.

There is no definable pattern to the motion path of a focus object that is moving *while in a shot* that is moving. The two motion paths aren't related in any way, so you'll be fighting to establish a key framing pattern that doesn't involve lots and lots of key frames.

A very popular way around this problem (besides serving decaf and distributing tripods to all camera operators) is to stabilize the movement of your shot using motion tracking. Stabilizing your footage negates the camera movement and makes the motion path of your focus object the only movement for which you'll need to compensate.

In Figure 12.42 we have our original footage, which is in desperate need of some stabilization if we're going to be able to easily isolate any of the elements in the shot.

If our focus object is any of the figures walking on the beach, this shot brings up some interesting challenges:

- Our potential focus objects are elements that will require multiple shapes, all of which will move, rotate, scale, and shift perspectives completely separate from each other.
- Not only are our focus objects complex, but each represents a varying scale as it moves closer to the camera while the camera operator moves backward. This means that the individual figures as a whole will have minor shifts in scale and position.
- The camera movement is completely unrelated to the movement of the focus objects.

Overall, were we to isolate the these focus objects without using tracking data to stabilize the shot, we'd be stuck in front of our machines for a very long time, which should be avoided.

To stabilize our image, we're going to use the building set way in the far background.

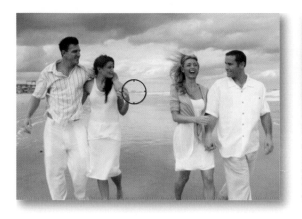

Figure 12.43 Tracking element.

When we attach a tracking marker to the building in the distance, you can see how drastically the shot moves. This tracker is following a stable, unmoving element in the background of the shot. Yes, it's moving in reference to our camera, but the building isn't physically changing its position on the horizon line. Remember, the beach isn't moving; the camera is.

Using this as our stabilization point will allow us to negate the movement of the camera and limit our focus to the movement of the focus object.

Figure 12.44 Tracking coordinates.

Figure 12.45 The footage now sticks to our tracker.

All that's left to do is apply that tracker as stabilization coordinates and our extremely complex shot has become, well, less complex.

A distinction needs to be made about tracking and stabilization at this point while we tackle how to stabilize footage correctly. Motion tracking and stabilization use the same tracking data. Both take information gathered from tracking elements within the footage and then use that data to motivate the transforms of the established shapes. The difference isn't in their input but in their output.

When you apply tracking data to a shape, you're telling the computer that you want *that* shape to follow *that* element in the footage. When you apply that same tracking data as stabilization, you're telling the computer that the footage needs to use that tracker as its anchor point. A track applied as a stabilization

Figure 12.46 The track without stabilization.

Figure 12.47 The track with stabilization.

merely inverts the track so that instead of your shape following the tracker, the footage will appear to be stable, with the tracking point being the center of the stabilization and everything else moving around it. The footage is pinned to the tracking marker, keeping that point at the same XY coordinates at which it started.

When you compare Figures 12.44 and 12.45, you'll see that without the track applied as stabilization, the tracker merely follows the tracked-in element without affecting the footage. But the track applied as stabilization pins the footage to the tracker, using it as the anchor point.

In the case of our couples on the beach, stabilizing the footage allows you to focus on the movement of the individual focus objects and their multiple motion paths rather than trying to compensate for the movement of the camera *plus* the movement of the focus objects.

Once you've finished isolating the focus object on a stabilized plate, you need to go back in and take out the stabilization. You'll need to deliver mattes that accurately isolate the focus objects without the stabilization applied to the footage. Once you've removed the stabilization from your plate, you must then apply the tracking data that was originally used to stabilize the footage

to your various shapes so that they will stay with the original footage that wasn't stabilized. When you apply tracking data as a stabilization transform, you're inverting the track, so *that same tracker* used as a regular transform, without inverting it, will apply the correct movement to your shapes.

Tip

Although most programs make a distinction between tracks applied as transforms and tracks applied as stabilizations, Silhouette has a button that can make your selected track appear to be a stabilized one. This feature is great because you don't have to worry about putting the tracking data back into your shot once you've finished rotoing a stabilized shot. Mocha also has this viewing option.

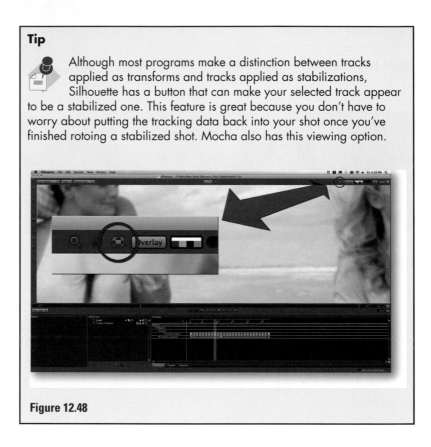

Figure 12.48

12.7 Review

- Tracking elements of your footage and attaching that tracking data to your shapes is one way to expedite your workload.
- Tracking data can be applied in a number of ways: position, rotation, scale, corner pinning, and stabilization.
- Tracking reflections doesn't always result in accurate tracking data.
- When you're choosing trackers to apply rotation data to a shape, pick ones that give the widest and most accurate account of the rotation.
- Applying multiple transforms from tracking data will get your shape close but will often require manually established key frames.

- When adding key frames to a shape with tracking data applied, you first must isolate the areas in the timeline where the track is accurate and establish key frames as such.
- Corner pinning applies a nonuniform transform.
- Stabilizing your footage will negate the movement of the camera and create an ideal situation in which you can simply focus on the motion path of the focus object.
- After you've stabilized footage, you must reapply the tracking data as a positive transform.

12.8 Relevant CD Files

- Bowling_Lanes
- Couples_Beach
- Determined_Saber_Guy
- Girl_Fountain
- Girl_Mask
- Hollywood_Sign
- Plane

13

ROTO AND THE HUMAN FIGURE

A good portion of a roto artist's day is spent isolating human figures. The reasons vary quite often, but in most cases your focus object (or objects) will be human beings for which mattes must be created that isolate them from the rest of the shot. And not necessarily even a whole human figure. Sometimes it's as simple as sky replacement. This happens frequently. A director will stipulate that the actors' performances are wonderful but that he dislikes the cloud formations in the sky or the secondary actions happening in the background. Often a plane will inconveniently fly into the shot, which will require a matte for everything under the horizon line.

Whatever the case, you'll find yourself having to roto human figures, and you'll need to do so quickly and accurately.

Humans represent a good many of the previously covered topics, but the catch is they represent those topics all at once. One

Figure 13.1 Creating mattes for everything *but* the sky is a common task for a roto artist.

human figure with minimal movement over a short number of frames can represent a shot with numerous shapes, all transitioning and moving separately from one another and all having different pivot points and key framing patterns. At first glance a shot like that can appear a bit overwhelming, but with the right perspective, there's a good chance we can overcome anything they throw at us.

First off, humans don't move in a linear fashion. The species in general can be quite graceful at times, but most of the time our fluidity and grace get lost in the code. Most human movement can be broken down into curves, which, by their very definition, aren't straight lines. Roto programs are designed around logic and even linear movements, but humans very rarely move in such a strict and limited fashion. From the start, we have a difference in perspectives, but it's one that can be overcome with time and practice and technique.

Humans also represent a multitude of *different* shapes that will ultimately be the matte. Bodies are segmented and sectioned off into multiple smaller shapes, all of which move differently from one another despite being connected to the same whole figure.

You also might have trouble finding a standard, definable key frame pattern for each of these subsections of the focus object, since they can, and often do, move differently from one another quite easily. These smaller shapes, designated to isolate a specific area on your human focus object, will also rotate and scale differently from one another.

Perspective is a problem, too. A focus object that's changing its position and rotating and scaling, all while shifting its perspective, can be a bit of a hassle to isolate, but it's not impossible.

These smaller subshapes also represent different edges of the focus object and might require multiple different shapes to isolate the specific edges that appear and disappear with the movement of the focus object.

The first step to tackling the seemingly random human figure is to step back and compartmentalize your focus object. Don't focus on the whole figure at once. Break down the whole focus object into the smaller shapes that we roto artists have been trained to see. Take a motion or a specific subsection of the focus object and start there.

13.1 Remember Your Anatomy

When you're starting a shot for which your focus object is a human being of some sort, right off the bat you need to watch the footage and let it loop. While it's looping, take a look at the footage, making mental notes as to the focus object's shapes and moving parts. The next step is defining the motion path of each individual subshape. You don't have to do this all at once, particularly if the focus object has multiple shapes.

Figure 13.2

Figure 13.3 Focus object.

Our job for this shot will be to isolate the girl at screen left. For now we'll ignore her hair and just focus on her arms and torso.

Our footage is of two young ladies speeding along in some flashy convertible (as attractive, bikini-clad women so often do). All of her body is in constant motion. Her arms are waving happily while her torso is twisting, changing the edge and contour of our focus object. This means that to correctly isolate this focus object, we'll need to create many individual shapes.

Breaking down your focus object into smaller shapes is particularly important when you're rotoing humans. The human body is full of easily identifiable, eminently usable shapes that, if defined and created correctly, will require little by way of transforms except some position and perspective-based scaling. Remember, roto is about edge and shape, but the most important thing about your matte is its edge. Shapes are just a convenient medium we use to accurately isolate an edge. Let's just take it slow and define some edges of our focus object that need isolating.

Figure 13.4 Focus edges.

Figure 13.4 shows us the edges of our focus object. Let's focus on her screen-left edges.

This footage is great because it clearly isolates the specific sections of our focus object. The bikini top creates a natural segmentation that you can use to create the shapes that will isolate the entire focus object.

Her body is broken up into edges that essentially stay the same throughout the shot. Though they vary slightly and might require some minor manipulation, ultimately her screen-left edges can be broken down into the shapes shown in Figure 13.5.

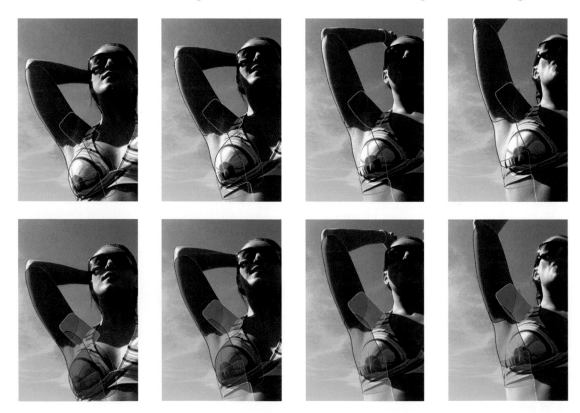

Figure 13.5 Shape breakdown.

Each shape is dedicated to isolating a specific edge of our focus object:

- Upper arm
- Upper shoulder
- Lower shoulder/armpit
- Breast
- Bikini band
- Stomach

Take one edge/shape at a time. You can't roto everything all at once, so don't try. Define one edge and follow that edge until it changes shapes drastically or stops being an edge.

Once this specific shape is finished, move on to another shape on a connected edge and isolate that edge completely. The order is generally of no consequence. Just find an edge and stick with it until it's completely isolated.

After her screen-left edges are completed, take what you learned about her shape distribution and movement and apply that to the other side of our focus object. The same shape distribution applies.

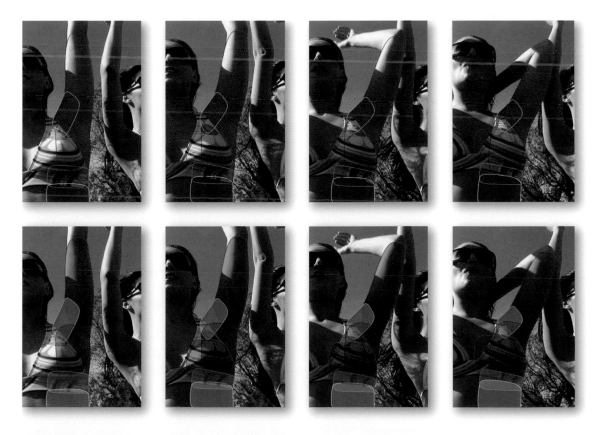

Figure 13.6 Shape breakdown for her screen-right edges has a similar breakdown as her screen-left edges.

With both sides of our focus object finished, all that remains is a shape to connect them that covers her midsection, and we've successfully isolated the focus object.

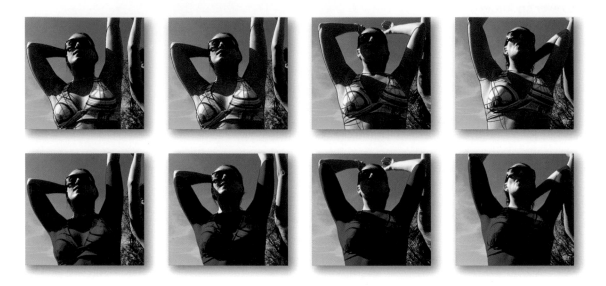

Figure 13.7 Shape for the center of her body, connecting both sides of our shapes and creating a whole matte.

Not moving individual points of a spline can be particularly challenging when you're isolating a focus object that has many rotating extremities. You're going to find that the crossing point of these splines will often require a lot a noodling when you're trying to get the seams of your shapes to match up. If you don't use shapes that can easily be manipulated *without* making modifications at the Sub-Object level, you'll find yourself making many tiny alterations to your shapes, which, as we've mentioned once or twice, takes time.

You'll want to remember how human bodies work. Bones don't bend at their center but at the joints, where they meet other bones. Muscles will follow the bones, squashing and stretching as the bones they are attached to extend, contract, and rotate. The shapes you create to isolate these focus objects will have pivot points that correlate with the pivot points of the body. When two parts of a body are pressed together, the contact point between them will expand as the skin and muscles are forced apart.

The human body is chock-full of easily definable shapes that don't alter much on the whole; this is all dependent on the motion of the focus object in question, of course, but ultimately, if you have a strong general idea about the basics of human movement and anatomy, isolating human focus objects will quickly become an easy task.

None of the following shapes is set in stone; there is always an exception to the rules of roto. These are merely suggestions for shape distinctions that generally work when isolating the human figure.

13.1.1 Isolating Extremities

When you're dealing with the human figure, you'll generally be asked to isolate various limbs and whatnot. Whether your focus objects are arms, legs, feet, or hands, the constant thing to remember is the way these objects are constructed and where they rotate from.

Arms and legs only have two pivot points relative to their construction. Arms pivot at the shoulder and elbow. Legs bend at the hip and knee. This means that the focus objects *between* these two pivot points won't alter much to any great extent. Shapes created to isolate these various limbs should then not be designed to have pivot points anywhere other than the previously stated positions.

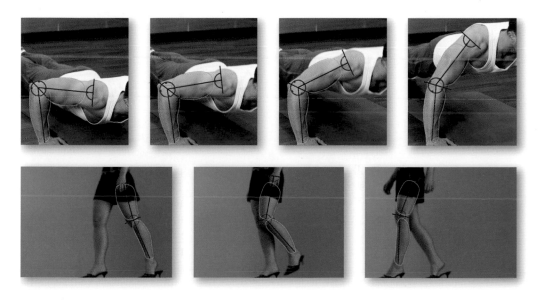

Figure 13.8

This is important to note because of *how* you'll be required to animate these shapes. Knowing that the pivot point of your calf shape only rotates at the knee will give you advanced knowledge of how that shape will move, which will then dictate the fastest way to create a key frame and position structure for that shape that requires the least number of key frames and shape alterations.

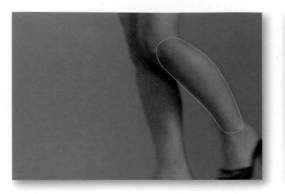

Figure 13.9

Just as we discussed in Chapter 8, you'll want to move your shape over the pivot point at which the focus object is rotating. Once there, you'll establish an appropriate pivot point for the shape that correlates with the focus object.

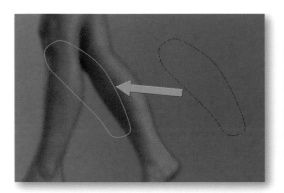 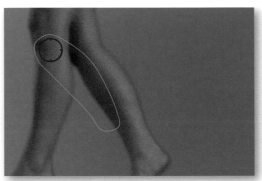

Figure 13.10

With the pivot point established, you simply need to rotate the shape to the appropriate angle. Rotating your shape from the pivot point of the focus object, particularly when you're dealing with human limbs, is a great way to quickly establish new key frame positions for your shape and limit the amount of Sub-Object manipulation.

Whenever you're working with human extremities, knowing where they rotate from gives you a starting point for every key frame you'll create for that shape. You won't have to figure out the best pivot point every time because you'll know that it's always going to rotate from the same point. And if the focus object keeps the same perspective or doesn't turn to any great extent, you'll be able to get a lot of miles out of that shape.

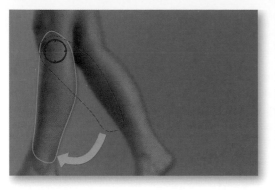

Figure 13.11

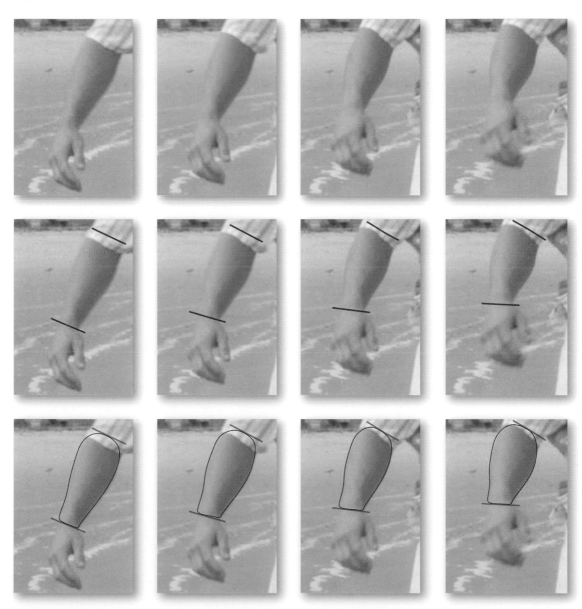

Figure 13.12

However, it is humanity's nature to be contrary, and very rarely do you find a focus object that doesn't rotate or shift perspectives in some way. When you're dealing with something like a forearm or calf that is changing perspective, you must keep that shape's edges at the same point for the life of that shape. Keeping the shape's position consistent will allow you to use that shape for a longer period of time. If your shape starts to expand, covering areas of the focus object that it wasn't created to isolate, that shape will require manipulation on the Sub-Object level.

An easy way to keep your shapes consistent is to pay attention not only to where your shape falls within the focus object but where certain points fall *along the edge* of that focus object, and keep those points placed at the same point along the edge.

When a limb turns or changes perspective drastically, the contour of the edge will shift, becoming something entirely new. In these cases, sometimes you'll be required to create a new shape (or shapes) that reflects the new edge shape and transition from the previous shape.

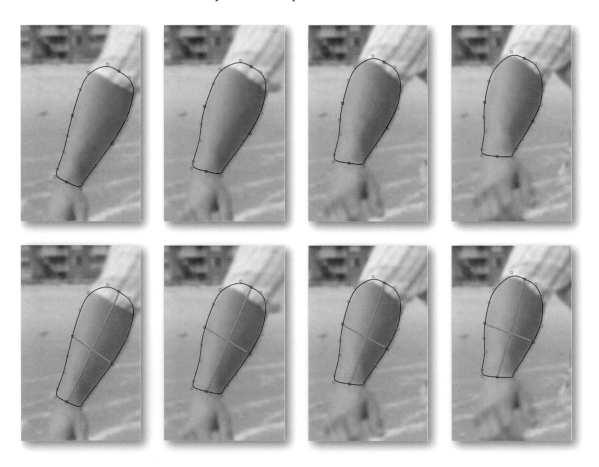

Figure 13.13 The points should keep their same relative position to the focus object as long as that shape is in use.

Our focus object is the screen-left leg in the following example.

In Figure 13.14, the foot is pointed toward the camera. Then it turns to point toward screen left, giving us a front and side view of the lower leg.

Figure 13.14

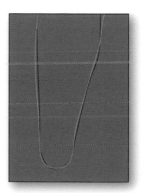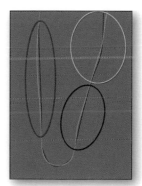

Front view. Side view.
Figure 13.15

As you can see in Figure 13.15, the front view of our focus object is pretty different from the side view. Before and after the leg rotates, the shape is pretty constant, but the frame between those two points is too different for just one shape to isolate it without manipulating a shape on the Sub-Object level. Had the differences been only one of the highlighted frames in the last image of Figure 13.5, it would have probably time conscious to alter the spline's points individually, but the shapes just aren't similar enough to justify it.

So, we've got two shapes that accurately isolate the focus object, but there is a good chunk of frames between them that we don't.

Figure 13.16

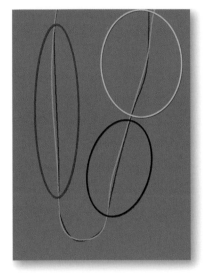

Figure 13.17 Front-view shape compared to the side-view shape.

A good majority of the time you can get away with just one shape for the leg below the knee and above the ankle knob, but in this case we're going to need to break up the focus object into more shapes that accurately isolate the changing edges of the lower leg while it rotates to point the other way. These shapes must reflect the edge as it transitions from front view to side view. A great place to start is to create new shapes based on the differences between the beginning and end shapes. Take another gander at the differences between the front- and side-view shapes.

The lead edge of the focus object can be isolated if we create a shape that will *just* isolate that front edge. The contour isn't so drastic if we limit our shape to isolate this edge alone.

Remember, in situations like this, you find a consistent edge and stick with that edge until it stops being an edge or the shape no longer accurately isolates that edge. From here, let's focus on the next area of the spline that differs

Figure 13.18

the most. And when that section is isolated, you move on to the remaining edge.

Figure 13.19

 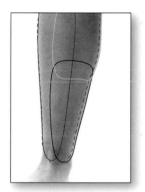 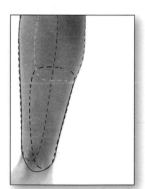

Figure 13.20

When you're transitioning between shapes on limbs, you must be careful to shape the contour of the new shape to match the old one seamlessly. If the transition between shapes is too distinctive, your matte won't look accurate. It might require some Sub-Object manipulation, but that should be kept to a bare minimum.

Finally we'll end up with a matte that accurately isolates the focus object.

Although the example only covered the lower leg, the principles are the same for all rotating limbs. Forearms, shoulders, and biceps all look subtly different from every angle. The key is to know how the various limbs are constructed and how they move. With this knowledge, flailing limbs become a thing of joy to roto.

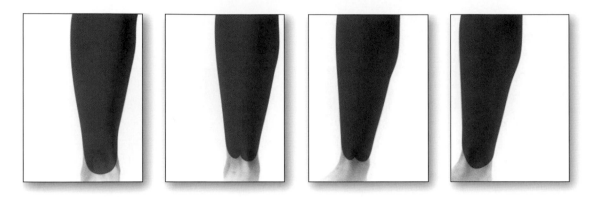

Figure 13.21 Final matte.

13.1.2 Hands

You'll be asked to isolate a significant number of hands in your time spent as a roto artist. Directors won't like the guns that the police are holding and will want them replaced with entirely believable flashlights. The sponsor of the show will change and all the product-placed cans of cola will need to have the logo altered in post. Or perhaps some computer-generated monkey will have to be inserted into the hero's gentle grasp.

So yes, you'll be asked to roto a lot of hands.

And hands can be complex to isolate. They're full of digits and moving parts with multiple pivot points, all curling and shifting perspectives. They also tend to wiggle, all the digits moving in different directions simultaneously. Sometimes they can be quite a handful (that pun was *just awful*).

Hands represent a pretty tough focus object because of their complexity. Legs and arms only have two pivot points, but a single hand has significantly more. Each individual finger has three, as does the thumb. Then there's the hand itself, which technically only has one but really has two. The wrist is the main pivot joint of the palm, which allows the hand to rotate up and down, but the elbow gives a further dimension to the pivot joint, allowing the hand to rotate side to side.

Then there's the perspective issue. For a finger that curls forward while facing the camera, the movement itself is pretty straightforward, but the changes in the edges of the finger itself will be pretty significant.

Overall, the process for isolating hands can be quite involved. On the bright side, however, hands are really easy to break down into subsections. Yes, they do have lots of pivot points, but those pivot points are all connected to oval-shaped bits that have very distinctive motion patterns and always, always, pivot from the same spot. Knowledge of the anatomy of the hand and how that

anatomy works is key for correctly breaking down the hand. The joints of the fingers make for excellent separation points.

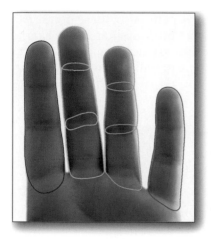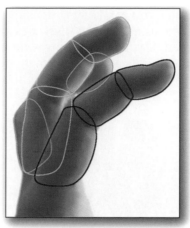

Figure 13.22

Although it is possible, even likely, that you'll be able to use one shape to encompass one finger, you have to be careful to note how that digit moves. The complexity and multiple pivot joints of a finger can make even the smallest movement a huge change in contour.

The palm is a slightly different story. The diversity of the palm's arrangement and movements makes it a bit complicated to speculate on a specific shape breakdown that applies in every situation. Just use your instincts and shape knowledge to guide you to the shape placement. A starting point to split up the palm is to create separate shapes for:

- The palm itself
- The meaty bit connected to the thumb

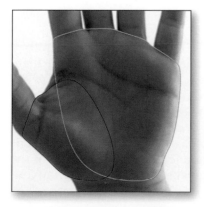

Figure 13.23

Point placement is very important in creating your hand shapes. If you keep a point at the base of each finger when you're making a palm shape, those points will be excellent markers at which you can keep your shape consistent. Also, these points can serve as a guide to marking exactly how long that shape can be used. If you're spending a lot of time trying to make the finger base points accurate, it might be time to rethink your shape strategy and create some new splines.

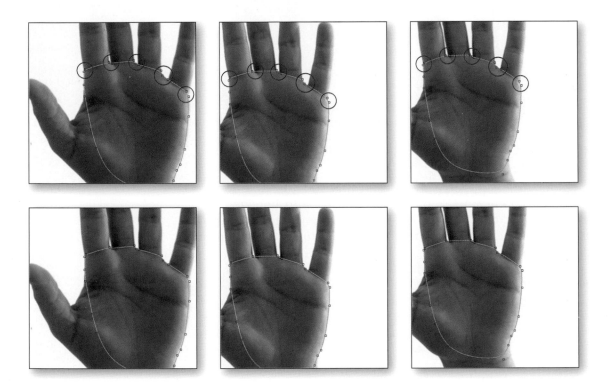

Figure 13.24

In these figures, the points at the base of the fingers keep their relative position with respect to their relevant fingers as the hand moves about. If you create your shapes correctly and with foresight, you can use that shape's points as reference to keep your shapes correctly isolating the same edges of the focus object and avoid manipulating that shape in a Sub-Object level. Referencing point location is particularly helpful when you're isolating hands because it provides an easy visual reference. The sections of the hands as they meet the palm are great spots to mark the way your focus object is moving.

 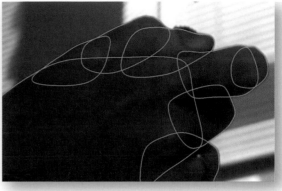

Figure 13.25

Hand movement varies greatly from shot to shot, and every minor hand movement can generate a completely different set of edges, that only differ from the previous edges in a minor way. If you're lucky, you'll get a hand that might move a lot but keeps the same general shape for the duration. Although these are considerably easier than a shot full of flailing fingers, you have to watch for subtle bends and turns of the wrist. They're not obvious, but these small modifications to the positioning of the hand can change the contour of the shape without being very noticeable or distinctive.

Even if your focus object seems to keep the same contour, the hand with all its many pivot points and separate parts will still move, changing the edge and shape to a very minor degree. If a hand shape does have a similar contour for the duration, it's still suggested that you break up the focus object into smaller parts, paying close attention to keeping the edges consistent as the focus object makes its minor shifts and changes.

With hands, as with limbs, you find an edge and stick with it until it is no longer an edge or necessitates the creation of another shape.

It *is* completely acceptable to use one spline to group several fingers into one shape, but the same rules apply. Subtle movement might change the finger shape so that you'll be forced to alter that shape on the Sub-Object level. When you're grouping several fingers into one shape, take careful note that holes between the fingers don't appear as the fingers move. In these cases, you might be forced to transition the group of finger shapes into their separate digit shapes.

Figure 13.26

If you do group several fingers together, remember: that's a lot of edges for one shape to compensate for. Chances are you'll have to manipulate the shape on a Sub-Object level if you choose this route. There's no hard-and-fast, absolute rule at this point, though. The best way to do it is the way you get it done the quickest and with the highest quality.

If your focus object hand has a lot of movement and a large number of contour distinctions, you're going to find yourself creating a lot of different shapes. The contour of a hand can change drastically from position to position. If a hand is turning a lot, creating many different shapes for short periods of time, there's no way around it.

Figure 13.27

As you can tell, there's a lot happening in this shot. The hand turning as it is creates numerous edge changes. If we choose our shapes carefully, however, some of them can be used for the entire range of frames.

Let's focus on the palm to start. The screen-right edge of the palm stays pretty consistent throughout the entire shot. If we create a shape on the last frame where the palm is at its widest and most easily identifiable and then move backward in the timeline,

keeping that shape screen-right edge, we can get a lot of use out of the one shape.

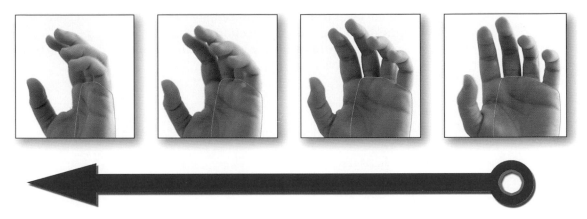

Figure 13.28

With hands, as with limbs, you should find an edge and stick with it, until it is no longer an edge or necessitates the creation of another shape.

The only thing that was done to this shape was a bit of scaling. Our focus was only the screen-right edge and the bits of the palm between the fingers, but check out where the shape ended inside the shape (Figure 13.28). Keeping the inner relationships of the spline consistent allows the shape to scale and rotate correctly, which will allow you to use the shape for the length of the shot.

Next there's the chucky bit below the thumb that creates such a perfect contour for a shape, but that contour changes pretty drastically on the last two figures, which will require a transition between two shapes.

Figure 13.29

As large as the shapes were, they were only responsible for a small section of the overall edge shape. This shape was chosen

because it required little by way of Sub-Object manipulation and only required one transition. Shapes that isolate small sections of your edge but don't require you to manipulate them on a Sub-Object level work well because they can be key framed easily and quickly isolate that edge section.

The palm beneath the pointer finger can be isolated just as quickly in this manner.

 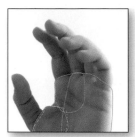 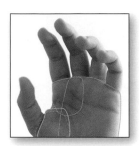 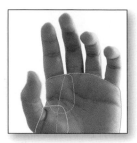

Figure 13.30

That leaves the little section of palm between those two shapes (Figure 13.31). This was left until last because of the straight line created between the two surrounding shapes and creates a very easily definable area that only requires one shape.

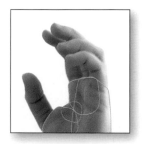 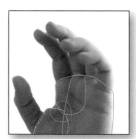 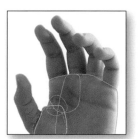 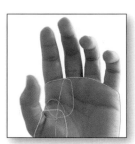

Figure 13.31

That isolates a good majority of the palm, with only a few little edges that need isolating for brief periods of time. For the moment, however, let's focus on the thumb.

The creases in the thumb, created by the way the skin on the digit creases, create very distinctive shapes that can be used for the entire shot with little by way of Sub-Object manipulation. If you use the creases as dividers, the shapes essentially create

themselves, even as the contour of the thumb changes. The only wrinkle is that the top of the thumb will require one transition shape because of *how* drastically it changes.

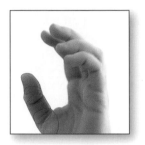

Figure 13.32

With the thumb and palm mostly isolated, let's check out one of the fingers. Just like the screen-right side of the palm, we're going to find shapes that are distinct on those frames. The pointer finger is very distinctive on the last frame. In theory, we could create one shape for the entire finger, but it would only be good to us on the last frame and would require us to transition. With that in mind, let's create a shape for the base section of the digit and work backward from there. With the base isolated, create a shape—again, on the last frame—for the middle section and work backward.

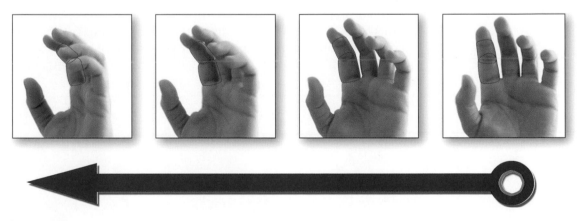

Figure 13.33

Both the base and the middle shapes easily isolate their assigned sections. Since fingers are essentially cylinders, you

won't have too much change for the lower two sections of the finger, but owing to a fingernail and the fact that it's the top of a column, the upper section is going to generally require a bit more noodling than its subordinates below. This specific case will require a bit more attention also because of the drastic shift in perspective and the difference in the contour on the first and end frames of the focus object.

The first shape will cover the base of the top section of the finger, covering the joint as it moves into the middle digit section, and it will end at the point at which the nail sits on top of the pointer finger.

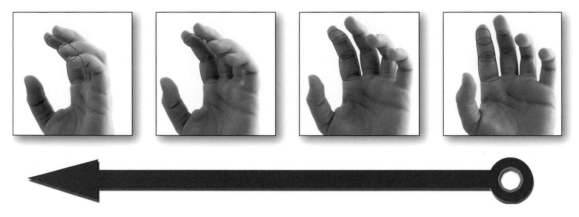

Figure 13.34

That leaves the very tip of the finger, which is changing its contour pretty significantly. The tip was broken up into two sections because of how drastically the shape of the top section was changing from frame to frame. Had we used one shape to isolate the entire top of the finger, we would have had to transition

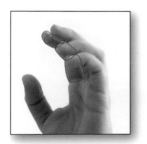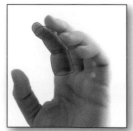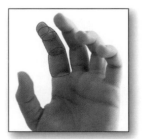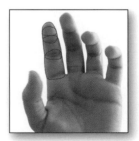

Figure 13.35

between several shapes or manipulate the shapes on a Sub-Object level. When we split it into two parts, the top shape to isolate the remaining top of the digit, which will cover the tip, pad, and nail of the finger, we will only have to manipulate the shape a very little.

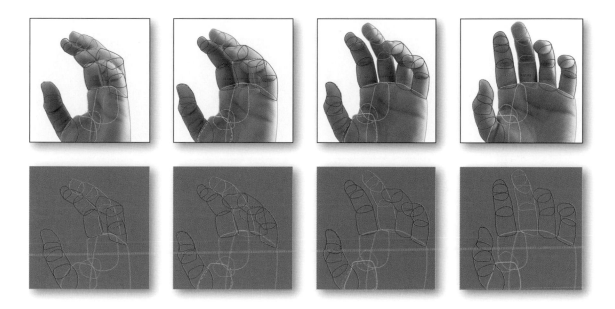

Figure 13.36

If you follow this pattern for the rest of the fingers, you'll end up with something that looks like Figure 13.36. Look at the sheer number of splines created when we isolate one hand.

A focus object of this complexity requires you to create almost as many shapes as for an entire human body. Hands are often a very imposing focus object which requires a roto artist to actively plan the placement of the shapes so as not to create more than the great number that are already necessary. Also, with great spline comes great organizational abilities. If you weren't organized with your comp when you started, this shot could have gotten out of control very quickly.

And that number still doesn't include the joint splines. What are joint splines, you ask?

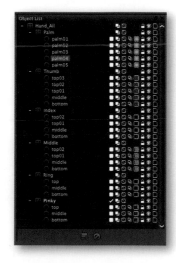

Figure 13.37

13.2 Joints

You might have noticed a pattern in which the shapes for the extremities were being roughed out. Most of the shapes established while isolating a human figure and its various parts and extensions began and ended around their respective pivot points. So, if we've got the forearm and the bicep covered, there seems to be a distinctive whole in the methodology or at least in the matte.

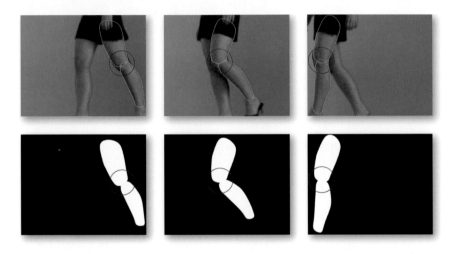

Figure 13.38

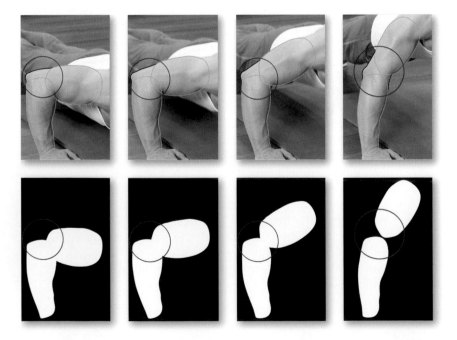

Figure 13.39

These joints can't be treated the same way as an arm or leg because their function is to bend, distort, and rotate. These joints give versatility to human movement and allow a wide range of motion. The shape of these joints changes pretty drastically because as the limbs and fingers bend, the skin around them expands and contracts, compensating for the movement of the surrounding bones and muscles.

Joints often require you to break down the shape further into smaller shapes that isolate smaller bits of edges. Though yes, you are creating *more* shapes, doing so will save you from manipulating those shapes in Sub-Object mode. This idea will ultimately save you time and frustration.

Let's take a look at the gentleman and his push-ups. We've got his upper arm and forearm shapes established already, but the joints between them need to be isolated as well. Using just one shape to isolate the area between the established shapes would require a veritable plethora of Sub-Object manipulation. The shape changes far too much for one shape to be a viable option for a timely isolation.

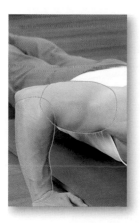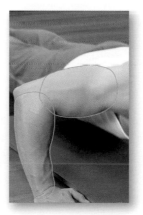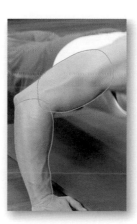

Figure 13.40

Nothing about this shape stayed the same for long enough to manipulate it on an Object level. The edges and contours shift too much over the range of frames. Every change that would need to be made would have to be done by manipulating the individual points of the spline.

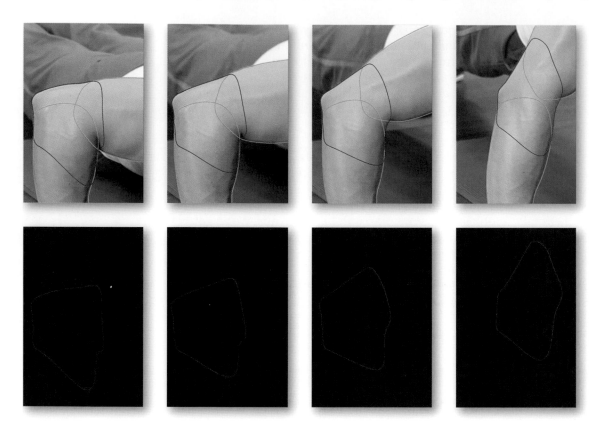

Figure 13.41 One shape just won't cut it.

Remember, you've got to compartmentalize your roto into easily identifiable edges that can quickly be isolated. Breaking down the joint shapes into smaller, single-edge-based shapes is the best way to isolate these bending sections.

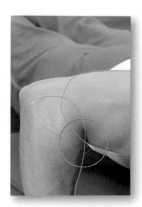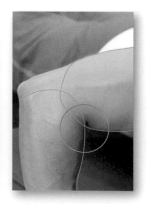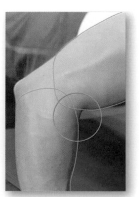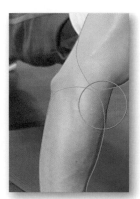

Figure 13.42 Focus edge.

We're going to create a shape that specifically isolates just that edge section of the arm between the forearm and bicep in Figure 13.42.

If you start at the end of the footage, where the edge is clear, this edge of our focus object is pretty small and one shape easily isolates it. It only requires a bit of position and scale manipulation for accurate isolation and even disappeared (i.e., ceased being an edge) as the bicep and forearm met.

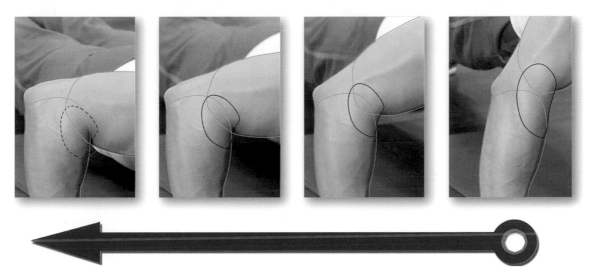

Figure 13.43 Shape.

The next edge we'll focus on will be the back of the arm as it moves into the elbow. We ended this shape at the elbow because that square-looking bit sticking out at the end is actually bone and won't change its shape to any great extent. However, the muscles leading into the elbow from the upper arm do stretch quite a bit.

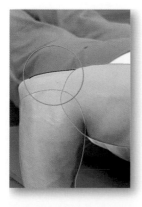

Figure 13.44 Focus edge.

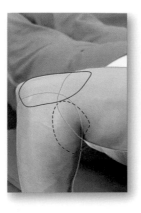

Figure 13.45 Shape.

The last edge is the aforementioned elbow bone, which keeps its general shape until the bitter end.

 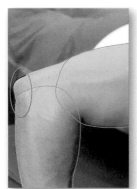 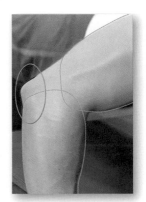 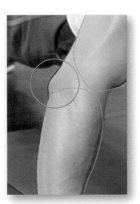

Figure 13.46 Edge.

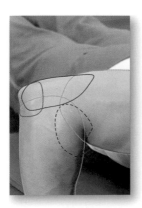

Figure 13.47 Shape.

Where joints are concerned, don't try to isolate too much with too few shapes. It is the nature of joints to bend, and that will require more shapes to compensate for. These edges were chosen because they were simplistic and easy to compensate for as the focus object moves. They don't change much, and those changes can be achieved by applying simple Object mode transformations to the shapes created to isolate them.

When we compare the elbow shapes, nothing changes in their edge shape, but their constructions were extremely different. Isolating that focus object with just one shape required heavy Sub-Object manipulation and took a considerable amount of time, but when we broke down the edges into smaller shapes, the job became significantly easier.

Figure 13.48

When you break up your joints into smaller pieces, though, you've got to make sure that the shapes cover the entire focus object and cover it consistently.

13.2.1 Overlap

The shapes you use to isolate the various joints that connect the limbs and digits of human beings have several purposes where roto is concerned.

The first and foremost is accurate edges. This is by far the most important thing a shape can do. This means that when you're creating these joint shapes, you need to make sure that they flow seamlessly into the surrounding shapes. To accomplish this goal, these shapes need to overlap each other at consistent angles.

These figures show that the edges of the triangular outcroppings at the base of the calf are indeed isolated, but the transition from

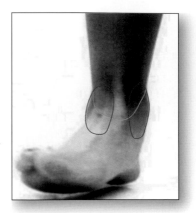 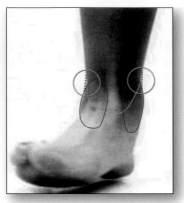 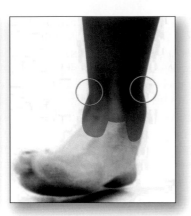

Figure 13.49

calf into ankle isn't accurately portrayed. This shape placement will not create an ideal matte for the joint section.

You could go back in and add shapes to compensate for the aberrational areas, but it's much easier to create the joint shapes with edges that slope correctly in the angle of the surrounding shapes.

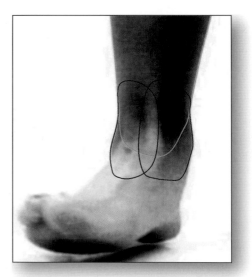

Figure 13.50

This might require a bit of Sub-Object noodling, owing to the fact that joints can have a great deal of motion and contour changes. These shapes need to accurately convey the edges of these joints as they flow into the surrounding shapes.

The second function of these joint shapes is to fill the matte in these areas so that it is solid and without holes. The problem with holes is that they aren't obvious until you actually turn the matte on. When you're looking at a bunch of splines, all moving and shifting as the focus object moves, the holes don't seem apparent.

The inconsistencies become far more obvious when you view the matte as a colored overlay, however.

Figure 13.51

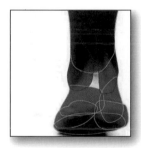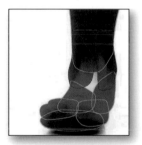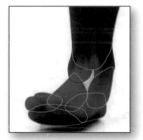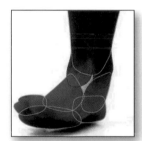

Figure 13.52

With all the movement, scaling, and rotation that joint shapes do, you're going to find that holes can appear between key frames as they transition from key frame to key frame. This can happen frequently when a focus object is turning and/or rapidly changing its contour.

The solution to this problem is to create your joint shapes large enough so that they will overlap the surrounding shapes, thus eliminating the holes in the matte. Remember, we don't care about the inner edges or how they move as long as they completely cover the inner part of the focus object.

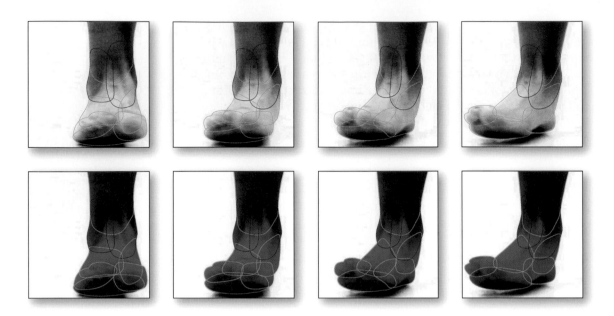

Figure 13.53

If you don't initially create them correctly, you'll find yourself going back and altering the individual points of the joint shapes to cover the holes or creating a new shape that doesn't isolate any edges and just fills in the gaps between shapes. Both these methods are completely acceptable when you're going back to fix your matte, but if you can avoid the extra steps by doing things correctly the first time around, you've saved yourself a considerable amount of time and haven't created any extraneous splines.

Overlapping your splines to keep the matte solid is good technique for *any* shape you create, not just joint shapes, but the shapes that we create to isolate joint areas are particularly tricky because of the range of motion they have and their constantly changing edge shape.

13.2.2 Fixer Shapes

When you're breaking down a focus object with high numbers of changes in the edges, you're going to find that even if you choose the correct placement for your shapes, you're not going to be able to isolate every bit of that focus object with elegant shapes that can be used for a significant number of frames. There will always be edges that don't fall neatly into the shape breakdown you've created for your focus objects. In those cases, you're going to need shapes that don't necessarily have a larger purpose other than a few frames as your focus object turns or shifts in perspective.

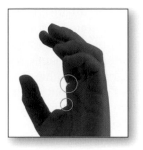 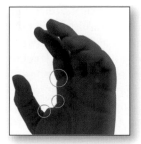 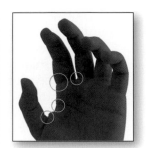 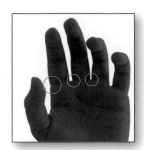

Figure 13.54

These "fixer" shapes won't have a long screen life, gener-
ally speaking, and they might require heavy transitions between
shapes or manipulation on the Sub-Object level. Sometimes
there isn't any way around Sub-Object manipulation. At times,
Roto can come off as a bit passive aggressive, but don't fret. She
loves you nonetheless.

These areas will generally fall at the joints of your human focus
objects. They're located there because these areas have the great-
est movement and edge change, compared with the surrounding
shapes.

In the example, the edges of our focus object that deviate the
most from our established shapes are the parts of the hand that
have the greatest malleability. The purpose of the skin and mus-
cle between the index finger and thumb is specifically to stretch
and will tend to bunch in odd ways. The same goes for the base of
the fingers. These parts of the hand enable the fingers and palm
to move with great versatility.

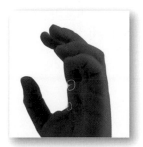 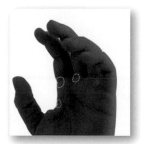 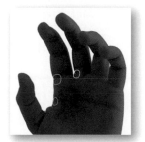

Figure 13.55

Even when your joint shapes are created and animated cor-
rectly, there isn't always a seamless transition. That's why it's a good
idea to end your shapes around joints. The natural curves of the
focus object create the breaks in the edge, without you having to

manipulate any individual points. As long as your shapes are consistent, the intersection of the splines will create an accurate contour.

It becomes a question of choice between manipulating the established joint shapes on a Sub-Object level or creating new shapes, for a short period of time, that meld the edge shapes into each other.

If you can easily manipulate the joint shapes' individual points without creating jitter or taking too much time to do so, Sub-Object manipulation on the established shapes might be the way to go.

However, if you feel that going through the whole shot and hammering out the main shapes of your focus object can save that time, then do it. Keep mental notes (or physical ones, for that matter) on where you see the focus object stop adhering to the main shapes you're creating. Once you've finished with the main shapes, go back in and add the fixer shapes to your matte while you're doing quality control and checking your matte. All shots are different and will require different solutions.

13.3 Review

- Humans don't move in a linear fashion.
- The human body generally represents a straightforward shape breakdown.
- Work one edge at a time.
- If a shape breakdown works for one side of the body, it will generally work for the other.
- The edge of a hand can change very drastically with very little movement.
- It will generally take more shapes to break down human joints.
- Rotate limb shapes from the pivot point of the focus object limb; it will save you from overmanipulating the shape.
- Fixer shapes are used to isolate the areas of your focus object that don't have simple and straightforward shape breakdowns.
- Make sure that your joint shapes flow seamlessly into the surrounding shapes.

13.4 Relevant CD Files

- Feet_Turning
- Girl_Green_Screen
- Girls_Dancing_Bikinis
- Hands_Turning
- Man_Pushup

FACES AND HEADS

Although you do need to make sure that all your mattes accurately isolate your focus objects, faces may require an extra bit of attention. This is generally where the audience will be focusing its attention, which means that the person double-checking your mattes will probably be looking in the same area as well. If you miss a frame or two of sliding in the bottom screen-left corner of your matte, it might not be a huge deal. However, if the matte on our hero's square jaw is a fraction of a pixel off its mark, it's a good bet that there will be an issue that will require a bit more of your attention.

Faces are complex because they are *physically complex* in their construction. They have exceptionally complicated dimensions compared with the relatively cylindrical extremities of finger, arm, or leg. The differences in edges between a face's front, three-quarter, and side views are worlds apart.

Figure 14.1 is just one head turn. It is one of the simplest motions a head can do, and yet it creates a massive overabundance of edge changes.

Side view.
Figure 14.1

Three-quarter view.

Front view.

Side view edge.
Figure 14.1 (Continued)

Three-quarter view edge.

Front view edge.

The solution is just the same as everything else: breaking down the focus object into easily definable edges. But faces might require a bit more shape deconstruction than you are accustomed to at this point. The ridges and angles created by a face represent a multitude of easily identifiable shapes and edges. There are loads of them just floating about. Let's focus on one edge and see where it takes us.

Figure 14.2 Footage.

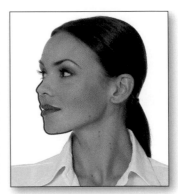

Figure 14.3 Focus edge.

To start, there's a lot of change in this edge. As the woman turns her head, edges that were once prevalent begin to disappear, and previously hidden ridges of her facial structure become the dominant contour.

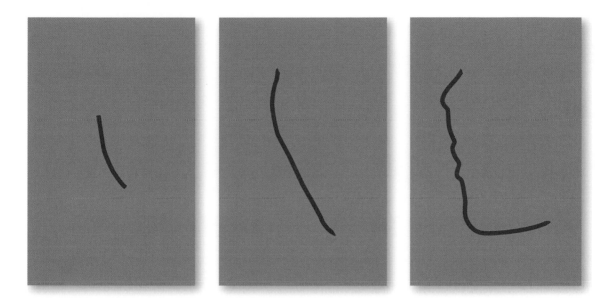

Figure 14.4

First, let's nail down the more solid bits of her facial structure (Figure 14.5). The cheekbone is just that—a bone—so chances are it's going to stay the same general shape for a good bit. There is so much going on to the edge of our focus object that we shouldn't get too attached to the shapes we create. With such a flux of edge change, our shapes are not going to have a long shelf life as her head transitions from front view to side view.

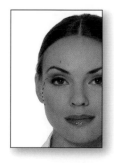

Figure 14.5 Cheekbone focus edge.

The blue shape for her cheekbone was created on the middle of the frame range and then animated in both directions (Figure 14.6). The middle frame represented the best point at which to create the shape because that's where it was most distinctive. It stops being a prevalent edge on the first frame, though.

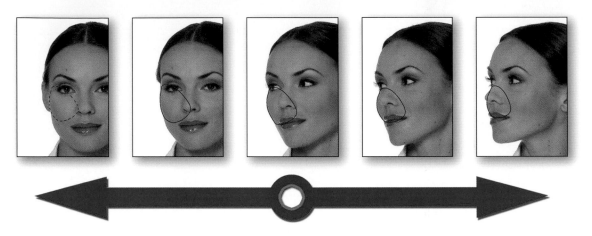

Figure 14.6 Cheekbone shape.

The next solid bit of her face is her chin. The focus edge is the tip of her jaw, which, like her upper cheek, is a bone and won't have drastic changes to its contour.

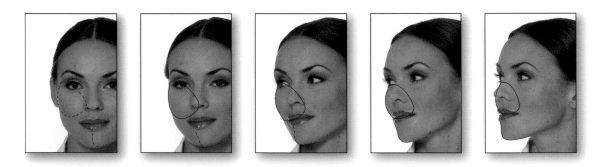

Figure 14.7 Chin edge.

We're going to create the green chin shape on the very last frame, when her face is completely in profile, and work our way forward. Again, we aren't able to use this shape for the entire frame range; its usefulness peters out as her chin gradually becomes less prominent and the edge melts into the jawline.

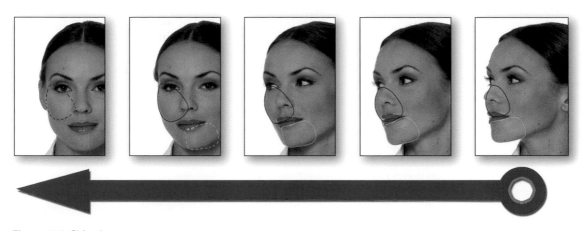

Figure 14.8 Chin shape.

With the surrounding bits done, we've put ourselves in a position where the focus edge sits between two established splines. With this edge, though, having a significant amount of change in its contour, it is possible to manipulate a shape originally created for her entire jaw and apply that shape as the edge changes throughout the shot.

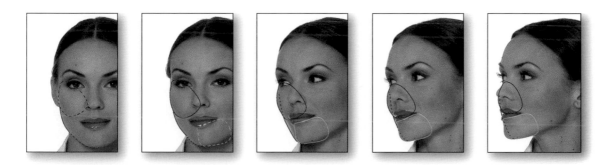

Figure 14.9 Remaining edge.

This edge could be a bit tricky. Technically speaking, the remaining bit isn't exactly one edge. It starts out as her jaw between her neck and ear, but as she turns, that jaw edge disappears and becomes an edge representing her cheek between the cheekbone and the tip of her chin.

If you noticed, there's been a theme about consistency of edge and shape placement throughout these pages. If we were to follow the established rules, it would require several shapes to correctly isolate the remaining edge, but the good part about knowing the rules is knowing when to break them.

Technically speaking, the pink shape does not follow the same focus edge. When it was created on the first frame, it was created to encompass far more than the edge would have required at that point in the timeline. It was created like that because her jawline is only an edge for a short period of time, but if we create a shape that extends farther along the edge, we can use that shape to isolate the remaining edge between the established shapes. By the end of the shot, that shape, which started out as a pretty significant bit of edge, ended up only isolating a fraction of the focus edge.

Figure 14.10 Shape.

Also take note where the internal part of that last shape falls within our focus object. As her head turns, that shape sticks to the same part of her face and scales with it as the contour changes.

The only remaining edges are her lips and nose, which don't appear until the tail end of the head turn.

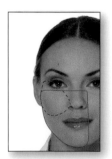 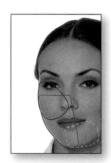 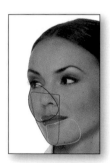 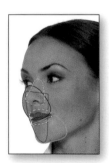

Figure 14.11 Nose and lip shapes.

Which brings us to an interesting segue: The face is a very complex object with edges that seem to change significantly from frame to frame. These complex edges can be simplified, though, if you keep in mind that even when an shape isn't an edge, it still exists.

Figure 14.12

If you take a closer look at the gentleman's ear, it isn't always an edge, but as his head turns, it eventually becomes an edge. If you create a shape for it *before* it becomes an edge, isolating that ear becomes a very simple set of transforms.

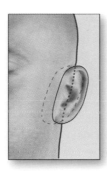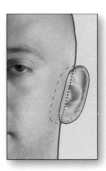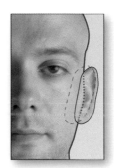

Figure 14.13

This shape was created when this object wasn't an edge but was at its most distinctive point in its shape. It was isolated very easily with one shape, a few scale transforms, and some very minor Sub-Object manipulation. The ear essentially held the same contour that it had when it wasn't specifically an edge.

The same idea applies in reverse as well. A facial shape can begin as an edge; then, as the focus object moves, it can cease its role as an edge but keep its general form as it recedes.

Figure 14.14 Nose shape.

If you keep that shape in the same place relative to where the edge would be, were it visible as an edge, you'll be able to get a great deal more life from your shapes. This principle will also allow you to easily plan your focus object breakdown and will save you from making excess numbers of shapes.

Figure 14.15 Neck.

For example, if you know that his Adam's apple is going to disappear as the head turns toward the camera, you can make a neck shape that bypasses it and only isolates the surrounding edges.

Once that's established, you find the frame where the Adam's apple is most prominent, create a shape for it, and then animate that shape accordingly. Knowing how your edges are going to react is a wonderful way to streamline your workflow.

Figure 14.16 Neck shape minus the Adam's apple.

Figure 14.17 Adam's apple shape.

While isolating focus objects above the neck, something else to consider is that these parts of a human won't have movements that will vary to any great extent. The only joint connected to the head is the neck, and though it does give a wide range of movement, the head and face won't deform much with that movement. Aside from some wiggling ears, stretching cheeks, and furrowed brows, a human face will essentially keep the same general shape. All you have to worry about are turns and perspective shifts.

Often you'll find that when a head has an extensive amount of movement, you're going to be able to reuse your shapes. The first example in this chapter featured a woman turning her head to the left, creating a profile.

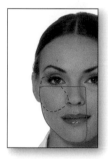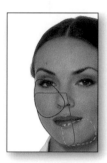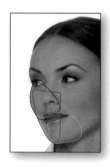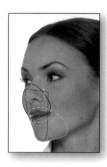

Figure 14.18 Head turning left with shapes.

Farther up the timeline, she turns her head back toward the camera. The shapes we used to isolate her edges as she turned her head to the left can now be used in reverse order to isolate the edges as she turns back the other way.

Figure 14.19 Head turning back to the right.

Obviously, the timing and positions will vary slightly, but the lessons learned while we established the initial head turn can be applied as she turns back toward the camera. You should always look for shortcuts that minimize the time a shot takes to complete. If you can reuse key frames, shapes, or key framing methods from a previous section of the shot to help speed along another part of the shot, by all means use every tool in your arsenal to get that shot finished.

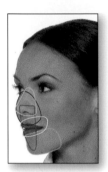 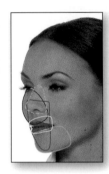 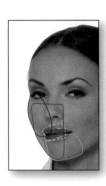

Figure 14.20 Reusing the shapes, but in the other direction.

14.1 Review

- Faces are physically complex in their construction and will require more shapes that vary a great deal.
- Work one edge at a time.
- Just because a shape isn't an edge doesn't mean it isn't there.
- If a motion is similar to one from a previous part in the focus object's movement, you can reuse the shapes from the previous bit.

14.2 Relevant CD Files

- Bald_Guy
- Girl_Head_Turn

15

HAIR (OR: BALD PEOPLE ARE GREAT)

Just step back and put this book down for a moment. If you're new to roto, revel for a moment in the fact that you don't know what's coming. Cherish this time, because your life is about to change.

Over the course of your experience as a roto artist, you might start gradually seeing mattes in everyday events. It's to be expected. Isolating mattes in the digital world will subtly alter your perception in the real one. Isolating hair is no exception.

The tops of human heads represent a huge speed bump in a roto artist's life. Hair is small, it's blurry, and the slightest head rotation can completely change everything about your edge. Though hair is victim of physics (and gobs of hair gel, if you're lucky), it will often not fall into any definable pattern. It's flaky, visually inconsistent, clumpy, mostly transparent, and a huge pain in the *tuchus*. Hair is like thousands of tiny, boneless limbs that have no uniform movement and fall prey to the slightest of breezes.

The numerous multitudes of hairstyles, lengths, and accessories make the process of isolating hair complicated. Humans in general have a similar muscle and bone structure, which lends itself to a easy, consistent breakdown pattern across the board, but their hair can vary to many degrees—so many that no one hard-and-fast rule can apply to every situation.

Isolating hair will require great attention to detail. It does have a definable movement, but because the individual hairs will sometimes seem to disappear and reappear at will, defining that motion can be something of a challenge.

And depending on the complexity of the focus object in question, you might be required to create numerous shapes that are only applicable for a short amount of time.

No roto artist really enjoys creating mattes for complex hair movement, but at the end of it all, the black-and-white matte you create is a thing of joy to watch, knowing that the chaos that is

hair isolation was tamed with some dedication, focus, and more splines than you can shake a stick at.

15.1 Base Shapes

This woman's head has numerous little hairs all floating about. For the purpose of establishing the base shapes, we'll focus on the upper screen-left edges of her hair.

Figure 15.1

The first step is to identify and isolate the sections of hair that won't require too much fiddling. These will be edge sections that appear whole and have definable edges that can be isolated with shapes that won't shift their contour to any great extent. These shapes will comprise the main, mostly solid bit of your hair matte.

Figure 15.2 Focus edges.

Figure 15.3 Base shapes.

Isolating hair isn't an exact science. You're going to be making a lot of judgment calls as to what constitutes an edge. A partial transparency might appear in an edge you've been treating as solid, and it is your decision to change the shape or keep the partially transparent edge as solid and hope for the best.

Figure 15.4 Is that a hole or a highlight?

Situations like this are a frequent occurrence when you're trying to isolate hair. A solid edge will vary from frame to frame and can significantly change, depending on the movement and position of the hair edge. Whatever method you choose, be consistent. If you decide to isolate a slightly transparent edge with a solid shape, you've got to keep it that way for the life of that shape or until the status of that specific edge changes to something else.

Once the larger edge shapes have been roughed in, it's a good idea to go back in and adjust these shapes on a Sub-Object level. Shape consistency is important, as always, but with hair, an edge will make almost unperceivable shifts as the head moves, which means that you'll be forced to manipulate that shape on a Sub-Object level. Just keep the general shape consistent, with a minimum of traveling points. If you were to try to create shapes for every different edge variant and transition between them, you'd be creating dozens of shapes that were only relevant for a frame or two. It doesn't happen often, but sometimes working in Sub-Object mode is faster. Just be careful not to introduce jitter into your matte.

Furthermore, don't get overzealous trying to cover everything at once with these base shapes. There will be time later to add fixer shapes at the end of everything. You don't need to isolate everything at once with initial shapes.

These shapes might need a certain amount of edge blur applied to them because the nature of hair is generally to be not crisp. Adding a small amount of blur can really give a hair matte an extra bit of accuracy. Don't go overboard, however. A little shape blur can go a long way.

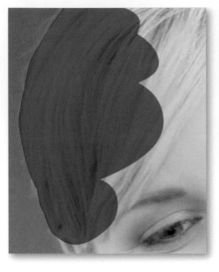

No blur applied to the matte. 2 pixel blur applied.

Figure 15.5 Colored overlay.

No blur applied to the matte. 2 pixel blur applied to the matte.

Figure 15.6 Alpha channel.

15.2 Standouts

We're going to switch sides of her head while we focus on the small stragglers that aren't easily covered by the initial base shapes.

Now that you've got the solid edges of your focus object in place, the next step is to identify the errant strands of hair that didn't fit neatly into the base shapes. These shapes will vary in

Figure 15.7

Figure 15.8 Base shapes established.

their shape and movement. There could also be a lot of them, depending on the shot, of course.

A good way to check what individual hairs are important in a shot is to view it from afar. Take in the whole shot and identify the individual tufts and strands that appear distinctive from a distance. When the shot is viewed from close up, you can see too much detail and the individual strands of hair don't seem as clear. Making a distinction on which hairs are important and which aren't can be tough.

These hairs are clearer when viewed from this distance . . .

. . . rather than zooming in to this level.

Figure 15.9

The hairs are very distinctive when they're viewed from a distance, but zoomed in the contrast between the hairs, the background, and the various compression artifacts and/or grain make identifying individual hairs all the tougher.

Start with the easily definable stragglers. These will be the ones that keep their specific shapes for a good majority of the time and have movements that are easy to figure out. As you can see from Figure 15.11, there are a lot of these little buggers. At this stage, you just want to identify the main stragglers.

Figure 15.10

With a rough idea of what strands you're planning to isolate, pick one and stick with it until:

- The frames run out, or
- It disappears into a base shape, or
- It stops being an edge

These little strands will generally require some attention. In some cases, you're going to have to manipulate the individual points of these shapes. These isolated strands of hair might not have a long frame life; they might only exist for one or two frames at a time, if that. The slightest turn of a head can bring previously hidden hairs onto the edge and then back into the crowd on a second's notice. It is entirely possible to create several shapes for individual strands of hair and transition between their various states, but that will effectively double or even triple the number

Figure 15.11 Focus edge.

Figure 15.12 Shape.

of shapes, positions, and transparency key frames you're going to be establishing. As with the base shapes, avoid that if possible, but sometimes there just isn't any way around Sub-Object manipulation.

Also, if the standout hairs continue to be edges, you absolutely must keep that specific shape with that specific hair. It will become very obvious in the finished matte if the standout shapes stick with their allotted focus objects.

Individual hairs are going to react differently to the varying conditions of lighting, movement, and background information that occur from shot to shot. The strand in Figure 15.14 is solid for a majority of its movement but disappears for a bit toward the end. This is the nature of hair.

Fine . . . Fine . . . What the?! Fine . . .

Figure 15.13

A situation like this has no easy answers, and every situation is different. Were you to try to accurately animate varying levels of transparency for the troublesome focus object, the resulting matte would appear incorrect, despite the fact that it visually might be correct.

The best bet would probably be to keep that shape visible on the frames on which the hair disappears and treat it as though it was always there. This will keep your matte consistent.

Fine . . . Fine . . . Let's pretend . . . Fine . . .

Figure 15.14

This sort of thing will happen frequently when you're isolating individual hairs. The status and visibility can shift on a per-frame basis. In some situations, you might need to animate the transparency or even in some cases actually paint the hair back in for those frames in which it goes missing. (*That* is a whole other nightmare) Use your best judgment and get some outside input. Another opinion or two can't hurt. There are lots of gray areas when it comes to hair. (Was that a pun? I can't tell anymore.)

Once you've established a few standout shapes, they (alongside the established base shapes) can be used as reference for placement of new shape positions. These little grouping of hairs will stick together, keeping the same relative placement with each other unless the edge changes too much. A group of hairs that are physically close together will generally move together, having a similar motion path and secondary motion. This isn't always the case, because occasionally a group of hairs will *appear* to be in the same place on the focus object but are actually in a completely different place on the head.

Occasionally, you won't necessarily need a whole, *closed* spline to isolate individual hairs. It is completely acceptable to use an open spline to isolate the movements of these standout hairs. Once they're isolated, you then apply a stroke to the spline, using the thickness of the focus object as a guide to indicate how much it will need to accurately isolate the edge.

Figure 15.15 Open spline without stroke applied.

Figure 15.16 Open spline after the stroke is applied.

Isolating individual strands this way is great because you're not dealing with a whole shape, so the subtle changes to their curvature become a little easier to compensate for.

The only problem with stroking your splines is that hair doesn't always have a consistent thickness for the entirety of the clump. Often the base of the stragglers will be significantly thicker than the very tip, so applying a stroke to an open spline won't always be the fastest route.

While you're isolating the standout hairs, you're going to find out if, when, and where your base shapes were inaccurate. When you initially created the base shapes, you were just trying to establish the core edge of your matte, so minor detail changes weren't painfully obvious. But now that your focus has changed to the extraneous stragglers, the inconsistencies in your base mattes might become more noticeable.

Silhouette Tip

The nonuniform transform in Silhouette is tremendously helpful when you're manipulating these little buggers. It allows you to significantly modify the general contour of the shape without being forced to deal with the individual points.

A great way to check to see whether your edge shapes are accurate is to view your matte as a colored overlay. Anomalous edge sections aren't necessarily that obvious when you're just viewing the shapes over the footage. In the case of hair, our focus objects have about the same thickness as a spline, so shifting your view to a colored overlay and turning off the visibility of the shapes will bring inaccurate sections of your matte to light.

Figure 15.17 Shapes turned on.

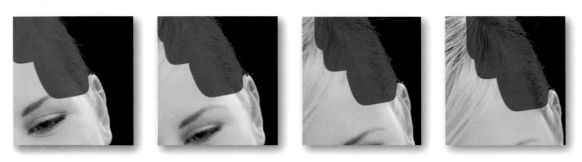

Figure 15.18 The edge becomes clearer when viewed as a colored overlay.

These individual shapes are almost definitely going to require some small amount of blur as well. Don't overdo it, though. These shapes are pretty thin as is, so, as with the base shapes, a little blur goes a long way.

Organization is a must at this point. When you're dealing with such a large number of shapes, all of which essentially isolate the same kind of thing, naming the individual shapes can get a little redundant. In lieu of individual names, you will need to make sure that these numerous shapes are at least grouped together in the same folder. Things could get very out of control very quickly if you aren't organized from the start.

So, you've continued the isolation process and gotten what you think are the remaining standout hairs. This would be a great time to figure out exactly what level of detail is necessary for the completion of this matte.

15.3 Minimum Level of Detail

The level of necessary matte detail is different for every shot, particularly when it comes to isolating hair. If your instructions are to roto someone's hand, there probably won't be any questions about the edge of *that* focus object. But hair, in its infinite

complexity, can vary a great deal. The level of detail, as it pertains to hair, can depend on:

- What the matte is going to be used for
- How much time can be spent on the shot
- Where the hair is in reference to the focal point of the shot
- What hairs are visible in the surrounding shots in the sequence

If you ask your supervisor about the level of necessary detail at the beginning of a shot, chances are you'll probably get a vague "As much as you can" or "The big ones" sort of answer. Your supervisor isn't being insensitive or callous, but hair is a tricky beast. It's not something that can be generalized without looking at the specific shot, and even then it's not always evident.

When a roto house works on a sequence involving different shots of the same character, they'll sometimes specify individual hair breakdowns so that the delivered mattes have continuity between the separate shots. The hair mattes for the sequence will need to at least appear somewhat similar and have all the same standout hairs and general head shapes from shot to shot.

The purpose of your mattes is vitally important, particularly when it comes to isolating hair. If it's a sky replacement of similar colors, a matte might not have to be as detailed as for, say, a day-for-night shot.

A *day for night* is when a scene is shot in the daylight and, for whatever reason, the time of day needs to be changed significantly. That means that the background behind the tiny strands of hair that currently have a bright, whitish blue color around them will have a significantly darker color inserted behind them. The stark difference in the background color will make inconsistencies in your matte very obvious, so the level of detail will need to be specific and exacting.

In the case of hair mattes, a great time to ask about the level of detail is when you've isolated a good majority of the obvious stragglers. When you look for clarification at this point (Pun #125) in the process, you can give the supervisor a frame of reference (Pun #126) from which he or she can easily point (Pun #127) out which strands should be included in the matte and which ones can be omitted.

At some point, you *must* ask about the level of detail for the shot. Hair is the sort of focus object that can be fiddled with endlessly. A complicated hair shot could theoretically go on forever. Don't let that happen; that way lies madness.

If your matte is looking like it's entering the last 20 percent of completion, you might want to pull your supervisor over to see which of the remaining hairs he or she feels need to be isolated.

And just as with compositors, the last 10 to 20 percent might take the same amount of time that it took you to get that far. This is the juncture at which you begin to narrow your focus and start

> **Note**
>
> These are not the actual numbers of puns included in this text. I'm just being silly.

putting in the final matte details. You'll be adding fixer shapes galore and modifying the established hair shape a pixel at a time.

15.4 Motion Paths and Motion Blur

This particular shot might be a bit complicated. The hair, our focus object, shifts shape, position, and transparency without any care for the poor roto artist being asked to isolate it. Fear not. There is a way.

Where hair is concerned, what constitutes a base shape and a standout isn't always so black and white. The edges surrounding a bunch of hair can change significantly, so what once was a base shape may transition into a dozen or so individual stragglers and then back into a base shape. There is no order when you're isolating hair.

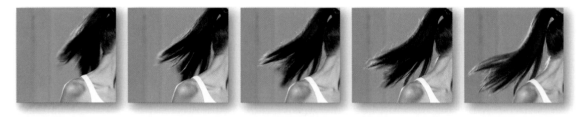

Figure 15.19

However, it is a roto artist's job to impose a sense of structure on a seemingly chaotic situation. And though it isn't always easy, with the right mindset and solid shape breakdown any wildly out-of-control hair can be tamed. It might take more than a couple of splines to do so, but hey, this is what we do.

The shapes required to isolate our ponytailed figure will require our shapes to blur. When hair blurs, the pixel-thin focus objects becomes a smudge of almost indefinable color. Situations like this might require you to animate the level and type of blur.

A better solution, however, might be to isolate this focus object with motion blur. Motion blur can be something of a godsend when it comes to isolating hair. As you well know, hair is composed of thousands of tiny pixel-thin strands that can appear and disappear at will. Capturing accurate hair with all its per-frame blurs and subtle gradients can at times be a very daunting task.

To start, you need to isolate the areas of the hair that have very little contour change or transparency. The hair is solid toward the ponytail, which makes sense because its movement and ability to separate into smaller sections is limited the closer you get

to that fixed point. The movement, motion blur, and shape deviation are going to increase the farther away the hair goes from that fixed point. So it stands to reason that you're going to find more consistent, solid shapes at the base of the fixed point.

Now comes the hard part. The rest of the hair will require a bit more planning.

If you choose to roto with motion blur, it is vitally important to keep the contour and position of your shape consistent with what it was created to isolate. This isn't always an easy task when it comes to hair because of the constant state of flux that high-movement hair generates. Keeping a shape consistent with specific hairs is almost impossible. They aren't individually labeled or color coded; it's just a mass of brownish pixels with varying degrees of transparency, blur, and shape.

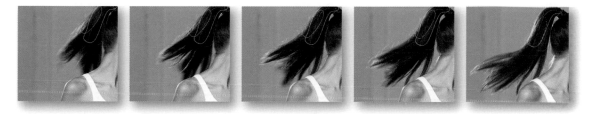

Figure 15.20 Ponytail shapes.

To keep your motion blur consistent, you'll need to keep your shapes on the same general place as the hair moves, but as we stated, there's no convenient labeling system for these hairs.

What you're looking for is clumps of hair that, even for a short time, have a definable set of edges. Just like everything else roto, you'll want to create these shapes at the point in the footage that they become the most distinct and easily definable. The trick is to accurately place these shapes *after* their distinctiveness disappears.

Let's focus on some of the strands by her neck. We're going to create a pink shape for this clump at its most definable position and work outward from that point (Figure 15.23). This clump of hair doesn't deviate much from its initial position. The shape stays in close relative proximity to the shapes that form the base of the ponytail, and it keeps its same general form.

Whether or not to compensate for the transparency in the middle of this clump is up in the air at this point. We can always add negative shapes later, as the holes appear. For now, your job is simply to isolate the big shapes of hair that can easily be defined without too much fuss.

Figure 15.21 Focus edge.

Figure 15.22 Shape.

As you animate this shape, you need to keep your eyes on the edges that define this shape from frame to frame. They aren't always clear. In the last frame, this clump joins another clump, becoming one larger clump. Resist the urge to alter this shape to isolate the whole larger clump. If you do, the motion blur won't match up. We're going to create another shape for this secondary clump at the point where it's separate and then combine them.

Figure 15.23 Focus edge.

Figure 15.24 Shape.

Let's shift our focus to the hairs farthest away from the neck. These are the ones that have a greater velocity than the hairs at the base of the neck. This means that their motion path is going to be slightly different. And it is this motion path that is going to be key in finding major clumps of hair and ways to define them.

The motion path of the outer hair starts low and moves up, around, and then down as the woman turns her head. This particular motion path will vary from clump to clump, but they will all follow a very similar set of movements.

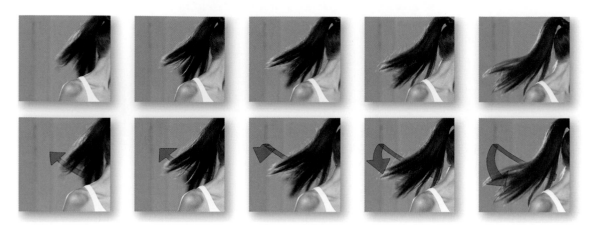

Figure 15.25 Motion path.

Shape breakdowns, hair in particular, will vary significantly among roto artists. You might be surprised how differently two different roto artists will break down the same shot.

Let's take this one as an example.

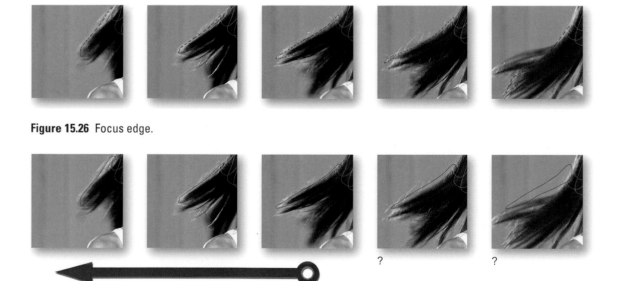

Figure 15.26 Focus edge.

Figure 15.27 The shape becomes indistinct.

Starting is the same: We find where the hair is at its most easily definable and make a key for it there. This clump's definability starts strong in the center of the arc, and finding its motion path, moving backward is easy. It melts into a larger clump at the beginning of the arc.

Its shape moving forward from the initial key frame is a slightly different story. When your hair shape inevitably disappears into another mass of hair, you should take into account where that shape would have been, had it stayed completely visible. The rule applies doubly when you're applying motion blur to your shapes. As was mentioned in the chapter about faces, an edge still exists despite the fact that it isn't necessarily visible.

On the frames following the initial key frame, the hair stops being defined as an edge and melts into the chaos, mostly disappearing as the hair swings forward. And we could just make that frame its final visible frame, but if we use the motion path to figure out where that specific clump of hair would go, were it distinguishable, we can continue using that shape.

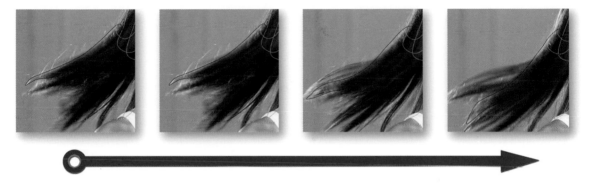

Figure 15.28 The shape's path on the bottom of the arc.

Keeping your shapes consistent with the way hair clumps move despite the fact that they aren't necessarily a definable shape will allow you to reuse your shapes and keep the motion blur consistent.

When using motion blur, you have to be consistent with the motion of the focus object in general, not necessarily the specific edges that the various shapes were initially created to isolate. We want the motion blur consistent because when we continue isolating hair clumps, adding shapes that move with the motion path of the focus object, the overlap of the shapes will create the subtle transparency that accurately communicates the varying degrees of transparency and blur of the focus object.

Once you nail down the motion path for an initial shape or two, the following shapes become easier to isolate because you've created a reference point from which to base the remaining shapes. The initial few shapes act as a guide for the rest of the hair strands. You'll start to see relationships between the sections of hair and the way they interact with each other. As you continue

to isolate sections of the moving hair, you'll find that you'll need the shapes for fewer and fewer frames. By isolating the hair clumps individually using their motion path as your guide for their positions, the matte will start to build up its visibility as you put more individual shapes into the mix. That's why *how* these shapes overlap from frame to frame is so important.

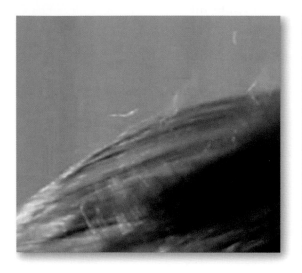

Footage.

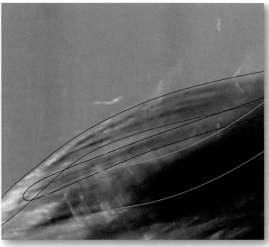

Shapes.

Overlay.
Figure 15.29

Matte.

When overlapping these hair shapes, you want to keep the subtle breaks consistent because the motion blur of both shapes is going to mix, communicating the minor transparencies of the focus object. These breaks represent the most solid, easily definable edges as the hairs shift.

With motion blur applied to your shapes, the subtle transparency between the hairs as they blur can be communicated by your matte.

Motion blur is a great way to give your hair mattes that last bit of total accuracy without having to manually animate the amount of blur per individual splines.

With a shot like this example, getting the minimum level of detail is pretty important. Achieving the subtle and varying transparency of this matte will be a time-consuming process, so if you don't need it, you shouldn't spend time trying to be that intricate with your shapes.

With a shot like this, after you've isolated the base shapes, in this case the ponytail, you might want to pull over your supervisor and ask specifics about the shot, taking care to point out the specific areas within her hair that have a slight transparency and see if they're really necessary to include in the matte.

Ultimately, the matte you deliver needs to be perfect for whatever specific purpose it will be used for. Every shot is different and will require a separate set of variables.

15.5 Review

- Hair can represent a tough focus object.
- Breaking down your hair shapes into "base" and "standout" shapes is a great way to create hair mattes.
- Applying a blur to your hair shapes should be done sparingly.
- Altering the gamma setting in your viewer can make hair detail easier to distinguish.
- If a hair disappears and reappears, generally you'll want to treat it as though it was always there, using the surrounding positions to estimate where it should be.
- Getting a minimum level of detail is vitally important where hair is concerned.
- In using motion blur to isolate hair, it is vital that you keep the positions of your shapes consistent, even when that shape no longer represents a specific bit of hair.
- Create your shapes at the point in the timeline that they are at their clearest and most easily definable.

15.6 Relevant CD Files

- Girl_Ponytail
- Girls_Computer

16

HUMAN MOVEMENT

Human beings are very graceful creatures at times. The complexity and elegance of their movements are often a joy to behold.

However, people don't move in straight, even lines; in respect to isolating the human figures for roto work, this can create something of a hassle. There is very little economy of movement where humans are concerned, and basic human gestures rarely conform to the linear in-betweens generated by a computer.

Generally speaking, you can break human movement into easily definable stopping points and direction changes, which would imply that motion-based key framing is the way to go. However, the complexity and subtle movement that drive the human body can be hard to nail down. No one key framing technique can apply to every shot featuring human movement.

When we take a relatively simple motion such as taking a step and break it down into its base movements, on the surface it's a pretty straightforward key framing structure.

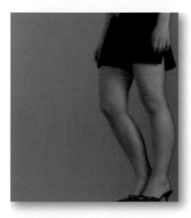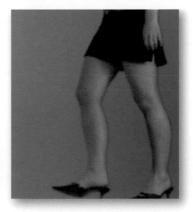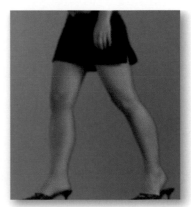

Figure 16.1

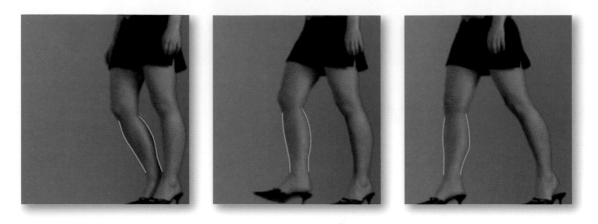

Figure 16.2 Focus edge.

To start isolating our figure's leading leg, we're going to base our key framing structure on her motion and create key frames at points in the timeline that correspond with its stopping points and/or direction changes. Let's nail down exactly what the calf shape is doing and see if we can isolate a motion path for it.

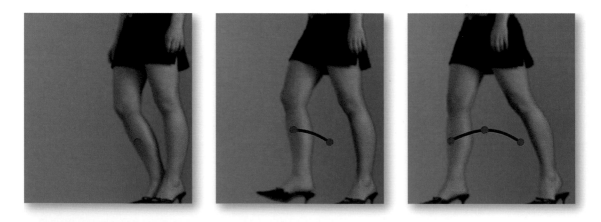

Figure 16.3 The arc of the focus object.

The lower leg starts at the beginning of the arc, moves up and over, and then back down as she plants her foot.

With a rough motion path established, we can create three key frames for our focus object using this arc as the basis for their placement within the timeline. These key frames will represent the three points of the arc that we can clearly define.

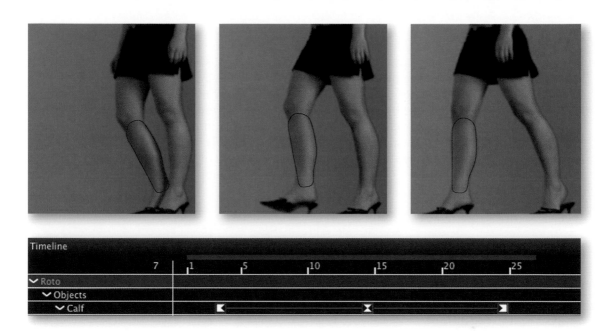

Figure 16.4 Key frames representing the arc of the focus object.

When we look at the in-between positions generated by the computer, however, you can see that although the motion is close, it is by no means accurate.

The computer is calculating the distance between key frames and applying the distance traveled equally between the key frames; essentially it's generating straight lines when the focus object is actually traveling with a curved motion path. Another problem with the computer-generated in-betweens is that although the knee and ankle share a similar motion path, the rate at which they travel on that motion path is completely different.

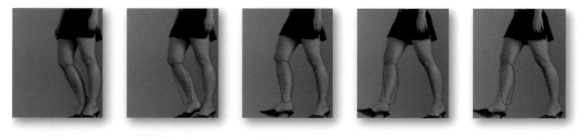

Key frame. Key frame. Key frame.

Figure 16.5

The calf is surrounded on its top and bottom by the knee and ankle. Those two points have two *completely* different motion paths. The knee travels a relatively short distance compared with the distance traveled by the ankle. Also take a look at the ankle's motion path. It starts small, barely moving, and easing out of the starting position. As it swings forward, however, it begins to travel a greater distance over a shorter time, but as it reaches the final position, the rate at which it travels begins to gradually slow and eventually it eases into the bottom of the arc.

This particular ease in/out motion path is classically how humans move.

Figure 16.6 Motion paths of the knee and ankle.

You could continue with motion-based key framing, trying to deduce exactly how and where the shape deviates from the initial key frames, but a simpler solution might be to apply a bifurcation mindset to the already established key frames.

We know that on the three frames we've already established, the shape accurately isolates the focus object. With that in mind, we can check the timeline between the motion-based key frames and insert new key frames for our focus object at the center point (or some variation) between them.

The key framing pattern that arises from this perspective becomes something between motion-based key framing and bifurcation. You establish the initial key frames based on the stopping points and direction changes of a focus object and then use a variation of bifurcation by checking the frames between the initial keys to see where it deviates. When you look at the key frame structure in Figure 16.7, a noticeable pattern arises that loosely fits bifurcation and motion-based key framing.

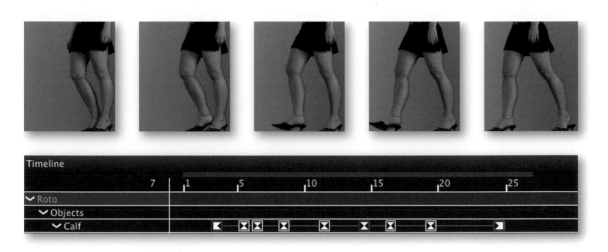

Figure 16.7 Initial motion-based key frames with bifurcation supplements.

It isn't exactly bifurcation because you're not looking to base these key frames strictly on the position of the surrounding key frames within the timeline. But it isn't strictly motion-based key framing, either, because although there are specific points in the focus object's motion that lend themselves to easy identification of motion-based key frames, narrowing down the specific and subtle direction changes isn't a straightforward task; human motion will rarely fall into strict compliance with one key framing method.

Something else humans do well is repetition. Repeating shapes was covered in Chapter 4, but the idea is exceptionally applicable when you're isolating a human figure. If you've got a figure doing roughly the same motions over a period of frames, once you get the pattern set for one go-round of the motion, a similar key frame structure and shape position can be applied to the subsequent repetitions.

If we take a look at the motion of this focus object (Figure 16.8), it is obviously repetitive. The arm starts low, pushes up, sits at the top fully extended, and returns to the ground in a position similar to the initial pose.

Just taking the base movements into account, we'll have a rough position structure that is similar at four points in the timeline:

- The starting down position
- The initial up position
- The second up position
- The final down position.

Figure 16.8

The shape position and key frames can be reused at these points in our focus object's motion. Granted, it won't be as simple as setting four key frames, but with the breakdown of the movement defined in these terms, we can apply the position of the shapes and the position of the key frames for those shapes repetitively. In addition, not all shapes within this focus object will share the exact key framing pattern, but they will conform to some variation of this down, up, up, down pattern.

Once you've got the shapes in a good place for the trip up, you can apply the basic position key frames to his figure on the way down. After you've manipulated the shapes from the down to up positions, there will be some noticeable distinctions to the shape when you compare their starting and ending positions. The focus object, however, will share similar contours when you compare the start and end positions. On the initial frame you created a shape that accurately isolated the shape at that point in the timeline. Now that that shape has returned to an almost identical position and contour, you can simply copy and paste the initial key frame when that focus object returns to its starting position.

Obviously, this process isn't going to be exact and will require some minor manipulation, but if you've already done the work, there's no need to reinvent the spline.

16.1 Big Human Movements

It is surprising to note that the grander, over-the-top movements of a human focus object can be easier to isolate. The motions are defined by their large movements and direction changes, which, on the surface, create an ideal situation in some cases for motion-based key framing.

Whatever the motion is, whether jumping, throwing, punching, or dancing, there's always a way in which humans move. We don't move in a linear sense, meaning that though you can define where the large movements begin and end, human beings aren't

going to move the distance from those two points in evenly measured distances.

Figure 16.9

Initially, let's focus on the forearm. When we look at the motion path her arm takes, this situation would seemingly lend itself to motion-based key framing, but take a closer look at the distance her forearm travels in relation to the curve created by the motion path.

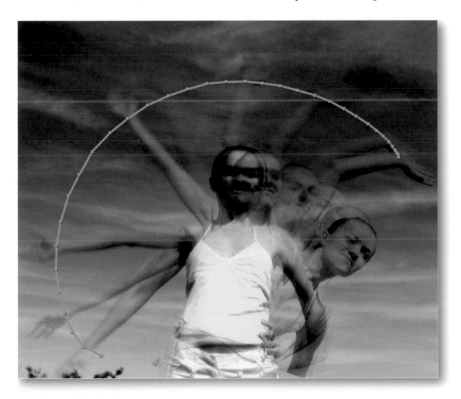

Figure 16.10 Motion path.

The rate at which the forearm moves is in a constant state of flux. Her forearm doesn't quite stick to evenly spaced distances of travel for long enough to justify using motion-based key framing.

Were we to use motion-based key framing, we would have a tough time establishing the exact stopping points or direction changes because of the simple fact that her arm is traveling in an arc. And the rate in which her arm travels that arc isn't consistent long enough to establish a usable pattern.

We would also be fighting the nature of point movement as the computer interpolates the movement between key frames. As the focus object rotates, were we to establish key frames at intervals defined by motion-based key framing, the in-betweens generated would contract in on themselves as they traveled between key frames. In Figure 16.11, the key frames were made at very large intervals as her arm moved in the circular arc. Owing to the linear interpolation of spline movements, the computer-generated in-betweens don't follow the prescribed arc. Fixing this issue would be a problem because the rotation of the focus object is going to cause the shape to contract inward as it moves between key frames. As it is, our key frames will contract on themselves anyway, but if the key frames are set closer together in the timeline, the malformed in-betweens will be manageable.

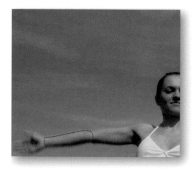 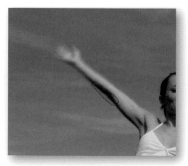

Figure 16.11

We've already established the motion path of her forearm, so what can we learn from that motion path? The solution here is to use incremental key frames but not use the same increments for the entire arm movement. The motion path of her arm indicates that we'll have more key frames at the beginning and end of the arc and fewer key frames at the top as the arm travels between the beginning and the end. Areas where your focus object is moving shorter distances over a short amount of time will require more key frames than when it is moving greater distances over a longer amount of time.

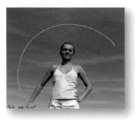 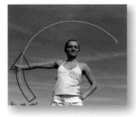 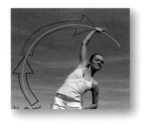

More key frames closer together.

Fewer key frames farther apart.

Then gradually back to more key frames closer together.

Figure 16.12

With that in mind, we'll use increments of 2 for the initial leg of the arc (not a pun; just an accident—really). As the arm speeds up, heading for the top part of the movement, we'll shift our increments to 4 until the arm hits the tail end of the arc. When the arm begins to slow as it reaches its final destination, we'll shift back to using increments of 2.

Increment shifts: By 2s.

Increment shifts: By 2s.

Increment shifts: By 4s.

Increment shifts: By 4s.

Increment shifts: By 2s.

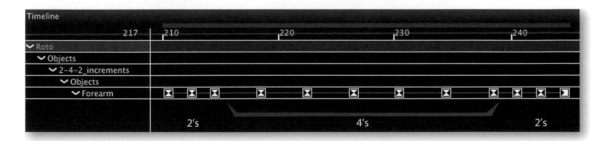

Figure 16.13 Incremental shifts.

Yes, we could have used increments of 2 for the entire movement, but we don't want to create an excess of key frames. This pattern of shifting increments is just to establish a base set of key frames from which we can isolate the minimum number of key frames necessary to isolate this particular focus object.

With the key frames set using the varied increments, we're obviously going to check where the shape isn't exactly accurate for this specific focus object. And we're going to use the motion path of the object to narrow down where precisely the incremental key framing didn't exactly work.

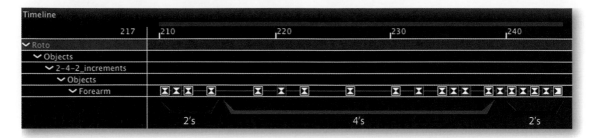

Figure 16.14 Additional key frames.

We know we're going to need more key frames in the beginning and the end of the movement because of the ease-in and ease-out motion generally perpetuated by human beings.

So we've isolated the forearm by adding a couple of key frames between the initial 2-4-2 incremental shifts. These additional key frames conform to the pattern we established by isolating the motion path of the focus object. More keys were required at the beginning and the end of the motion than in the middle arc.

Figure 16.15 Upper-arm motion path.

When we shift our focus to the middle of the arm, there will be some minor variation to the incremental key framing pattern. The arc created by the middle of the arm will be slightly less pronounced than the forearm/wrist. So that means that when we create key frames for the middle arm, we're going to have to keep at the increments of 2 a bit longer at the beginning and the end of the motion. There will still be fewer key frames in the center of the arc, but the section of timeline that we shift to increments of 4 will be shorter than the forearm.

Upper-arm incremental shifts: By 2s.

Upper-arm incremental shifts: By 2s.

Upper-arm incremental shifts: By 4s.

Upper-arm incremental shifts: By 2s.

Upper-arm incremental shifts: By 2s.

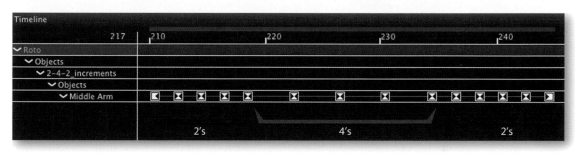

Figure 16.16

Again, once we've established the key framing pattern at increments, we'll go back and add keys where the shape needs it. And again, the pattern holds steady: more key frames at the beginning and the end, with the middle needing fewer.

Figure 16.17 Upper-arm additional key frames.

Now, as we move onto the shoulder, we're going to apply what we learned from isolating the fore- and middle-arm sections to establishing a key framing pattern that will accurately isolate the shoulder with as few keys as possible.

The section of the arc requiring us to use incremental key frames on 4s is slowly getting less and less. The forearm is

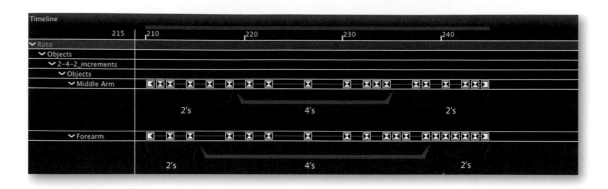

Figure 16.18 Comparing the forearm and upper-arm key framing pattern reveals our next strategy.

traveling a greater distance than the shoulder, which means that although the forearm did conform to the 2-4-2 incremental shift, the shoulder will need more key frames because it is traveling a significantly shorter distance over the same number of frames. The shoulder is also creating a far shallower arc than the forearm. The farther away the section of the arm is from the initial arc, the more key frames it will require to isolate it.

Since the section of the arc that allows us to key frame on 4s is quickly disappearing, the shoulder will probably require its entire movement to be key framed at 2s.

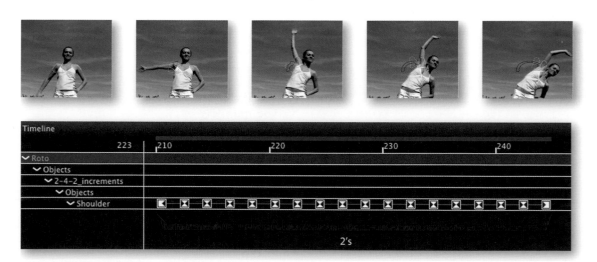

Figure 16.19 Shoulder at 2s.

It would have been perfectly acceptable to just use incremental key framing for the entirety of the shot, but that would have inevitably created a bunch of key frames that you didn't necessarily need. Incremental key framing is great because it allows you to

quickly set up a key framing structure that accurately isolates the focus object, but the downside to its method is that it does generate a lot of key frames.

However, when you adapt your incremental key framing based on the motion of the focus object, you're taking the best of both motion-based key framing and incremental key framing and creating the bare minimum of key frames necessary for accurately isolating the focus object in a fast and accurate way.

Human motion will often require you to alter your perspective on key framing methods because they very rarely will confine themselves to any one pattern. Being unrestricted with your key framing method will allow you to find the fastest way to isolate the human figure and with the fewest key frames possible.

16.2 Subtle Human Movement

After having covered the grander, expansive movements that human beings are capable of, it's now time to get into a slightly more involved, albeit less complex, form of human movement.

Of all the human roto, the minor, subtle shifting of a being at rest is often the hardest to isolate. It's complex because there isn't any pattern to the movement. An actor, merely emoting, filling in the space of the frame, isn't really being still. People shift their hips, turn their shoulders a minor degree, turn hands, flex fingers, stretch necks, and the list goes on. Very rarely is a person actually still. Except perhaps Samuel L. Jackson; that man doesn't move except when necessary and generally only in straight lines. And he often shaves his head. Creating mattes for Mr. Jackson is a pretty straightforward task.

The problem with subtle human movement is that there aren't any definitive moments in the shot that stand out and present a clear and precise point at which you can create a key frame for your shapes. All the movements blend together into an amalgam of minor turns and shifting joints and small, imprecise shifts in stance and posture—all of which create such minor changes in your focus object that they can barely be considered movement at all.

But these small, minuscule shifts in the edge of your focus object will definitely need to be compensated for. With big human motions, if the shape on a swinging arm is a pixel or two off, chances are that the motion blur applied to the matte will compensate and not leave it with any noticeable problems.

But if a figure, standing mostly still, turns his or her head a fraction of a degree and the shapes don't move with the focus object, the inaccuracy will be noticed.

If you were asked to create a matte for the young man in Figure 16.20, it wouldn't seem like too much work: a couple of head turns, some shapes for his shirt and hand. Even his spiky

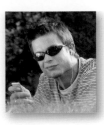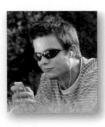

Figure 16.20

hair isn't all that complex (though roto artists in general dislike that hairstyle—not as a fashion choice, mind, but more along the lines of we don't want to roto your hair; put a hat on). Overall, this shot doesn't seem to present anything too overly complex.

Except that those five figures are representative of a shot that contains over 230 frames.

That's the other problem about subtle human movement. The quiet shifting of a seemingly still figure will often span a great number of frames. That means that though the movement itself doesn't create a huge shift in contour, any minor inaccuracy between the shape and the focus object will be extremely noticeable.

When you're considering a shot containing subtle human movement, your first instinct might be to use any of the timeline-based key framing techniques. Incremental key framing or bifurcation would definitely create an accurate key frame pattern for your focus object. Both of these techniques do lend themselves to isolating focus objects that don't seem to have a noticeable pattern to their movement. However, they both potentially create a significant number of key frames.

A better perspective might be to use motion-based key framing to isolate the movements in our spiky-haired friend. Yes, this technique is based on stopping points or direction changes, so why would you choose to employ a technique like that on a shot where the focus object doesn't seem to have any definable movement?

Motion-based key framing is ideal for a shot like this because of the subtlety of movement of the focus object. When you create a shape that won't shift its contour much and will only change position a little, the differences between the movements are very obvious and distinctive.

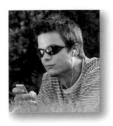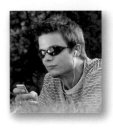

Figure 16.21

The difference between the focus objects in these figures isn't very big. It's just a quiet little head move that doesn't change the edge to any great degree.

When you create a shape to isolate an edge for a move like this, the movement is so minor that the difference in position is very obvious when you use the spline's initial position to motivate the position and shape of the next key frame.

Figure 16.22

When we create a shape on the initial key frame, the subtle movement becomes obvious. The difference between where the focus object started and where it ended up is easily distinguishable when you compare the movement of the focus object with the static position of the shape.

And that pattern begins to build on itself. Once you've isolated the movement based on the position of the initial key frame, you can create another position for that key frame. Then, based on the position of the new key frame, you're able to isolate the position and timing of the next key frame—and on and on until you've established a very subtle movement for your shape without simply creating arbitrary key frames based on the timeline.

When you see this sort of movement, though, you can't just make a new key frame for the new position of the shape. This shape was accurate for a number of frames before the focus object moved. It was correctly placed for the frames coming up to that point, so if you simply create a new key frame, the shape will be inaccurate on the frames where it was previously spot on.

You have to create a key frame establishing that the shape hasn't moved. You're not actually creating a new position key frame for the shape; you're merely indicating to the computer that the shape needs to stay in the same position between the initial key frames before the focus object moved. It's generally enough to press the up arrow and then the down arrow in quick succession. The position hasn't changed, but the computer knows that between those two key frames, the shape isn't to change position.

And the ease in/out rule still applies. Once you've defined a subtle movement, though the motion is slow, it will still not be entirely linear and will require a few extra key frames as the figure changes positions.

Isolating subtle human movement will allow you to get away with manipulating the shape on a Sub-Object level. The differences between key frames is so minor and happens over such a long range of frames that, if you're careful to keep the general contour of the shape consistent, you'll be able to modify the shape's individual points without creating jitter. This will keep you from creating an overabundance of shapes.

For subtle human movement over a long range of frames, before you jump in and try to define a usable key framing pattern, you might consider using tracking to minimize the workload.

16.3 Tracking and the Human Figure

Freckles are great. And moles, too. We love these things about the human body. There is definitely a shortage of freckled, bald people on film. Roto artists love minor, highly trackable, always visible blemishes on the human body. We love these things because they make our job infinitely more manageable.

Capturing the subtlety of movement perpetuated by the human body isn't always a simple task. Limbs turn and heads rotate, causing such minor changes to the edge that defining a usable key framing pattern isn't always a cut-and-dried task. You should consider anything you can do to automate the roto process.

Using tracking in respect to the human body is one way to speed up the process of matte creation. In the case of subtle human movement, if you can find a tracking marker from which you can drive the transforms of your shape without having to manually nail down the key framing structure, you've just found a way to create key frames for a shape without having to do it manually. Automation is generally better when it comes to roto, even if it is a rarity.

In terms of subtle movements, our friend lazily listening to music in the field has several facial elements that would make the roto task significantly easier. The highlighted elements represent a tremendous shortcut that would speed up the process of isolating his face, because they accurately correspond to the subtle movements of his head and face that are happening over a great number of frames. Tracking these elements and using that tracking data to motivate the movements of your shapes would significantly shorten the amount of time that this shot would take to roto.

Mocha Tip

 Mocha's planar tracking is excellent for tracking in specific parts of the human body and applying the planar tracking data as XY coordinate transforms in other software.

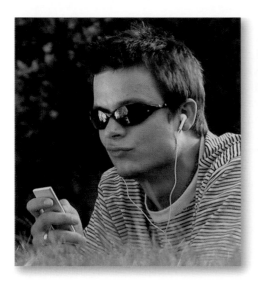 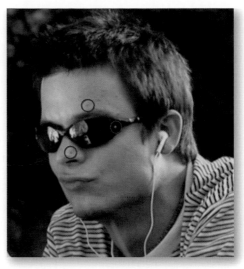

Figure 16.23

Tracking can be used to quickly establish a motion path for a particular shape, or, in some cases, it can be used to isolate complex movements.

We have our well-muscled gentleman doing his pushups with vigor and focus. His motion, though repetitive, isn't simple. There are many little twitches and minor rotations to his limbs that might force you to add significant key frames.

 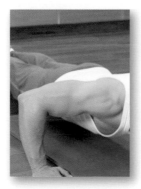 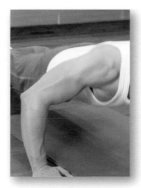 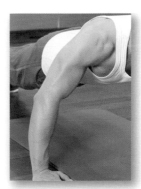

Figure 16.24

However, there are also a couple of easily trackable points that will make the process of isolating his screen-left arm go a lot quicker.

In a situation like this, you'll want to think like an animator, or more specifically, like a rigger. In the animation world, once the character has been designed and modeled in 3D, the model is then given to a rigger, who will set up a series of joints and controls that will allow the animator to breathe life into that character by adding realistic movement.

That idea applies specifically to roto in some respects. We're going to isolate this gentleman's arm. To do so, we'll need points along his body that correspond with the movements of his arms. Back in Chapter 13, there was significant discussion about limb joints. In that section, it was posited that these joints represent the pivot points of these focus objects, and they should be used to create the rotation necessary for accurate limb isolation. The same ideas should be applied when you're using tracking to isolate the human figure.

If we want tracking markers that correlate with the movement of our focus object—in this case, his arm—we should look to his joints. The joints are exactly what their name implies: a pivot point between limb sections that move together but don't share the same motion path.

Luckily, our exercising friend has a freckle that almost exactly sits on the dead center of his elbow joint. Ideally speaking, you'll

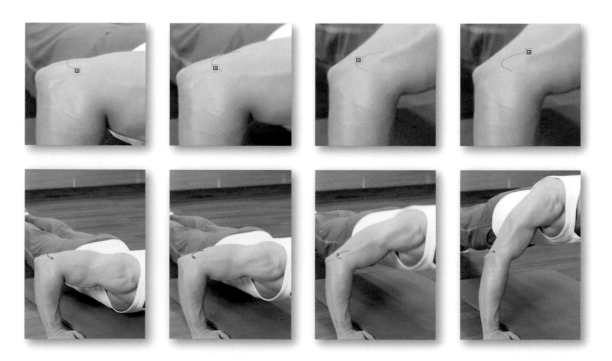

Figure 16.25 Elbow trackers.

want to track points in his arm that exactly correspond with the center of the relative pivot points. Realistically speaking, however, rarely are the stars going to align in such a convenient manner, so you'll find yourself in situations where the trackers are close but not exact. In this case, had the tracker been more centered at the exact point that his elbow ends rather than slightly up his arm, the tracking transforms would be more precise and would require fewer manual key frames.

Figure 16.26 Ideal tracker position versus actual tracker position.

Next, we'll need one for his wrist; conveniently, there is a scar on the base of his wrist, directly above the hand. Again, this tracking marker isn't exactly in an ideal position, but it will serve our purpose.

Figure 16.27 Wrist trackers.

These trackers need to be as close as possible with the least amount of jitter. Any amount of minor jitter will throw off the transform data and force you to compensate by manipulating the shape, which is what we're trying to avoid. When you use tracking markers that are on the skin, though, you've got to make sure that the tracking marker doesn't move from its starting position. When muscles flex, they can change the position of the tracking object without actually changing the shape of the focus object. Just make sure to double check your tracks when you're tracking anything sitting on the skin.

Figure 16.28 Both trackers.

With trackers at the respective pivot points of our focus object, we'll want to apply this tracking information as position and rotation transforms. Including scale will throw off the accuracy because what the computer would apply as scale transforms is actually just the limbs and joints stretching to compensate for the movement of our focus object.

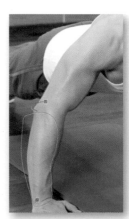

Figure 16.29 Shape with position/rotation transforms applied. No manually set key frames.

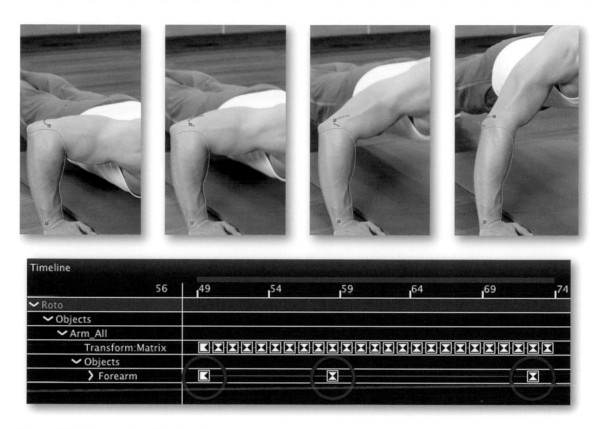

Figure 16.30 Shape with position/rotation transforms applied and only three manually set key frames.

As you can tell, it isn't exactly right. As the arm goes into full extension, the edges change pretty drastically from the initial shape, but the position and rotation are otherwise manageable. This sort of tracking application will always require a little bit of fiddling, but with correct application of the tracking data, we've taken a complex movement and cut out all the heavy lifting.

If tracking can get you to a point where the movement is close, you're in a good place. Taking out the manual part of key framing is generally a good idea. Fixing this shape with respect to its focus object took only three key frames. That number would have been significantly higher had we chosen to isolate this focus object without using tracking.

16.4 Review

- Human beings very rarely move in a linear fashion, so you'll have to vary your key framing strategy to compensate.
- Combining key framing strategies is a great way to isolate human movement without creating too many key frames.

- There is a natural, ease-in/ease-out movement that is indicative of all human movement.
- Humans often display repetitive movements, so in some cases previously hidden shapes can be reused.
- Rarely will you find a person who is actually still. Pay close attention to subtle movements because they can be more complicated than they look.
- Tracking elements of the human body to motivate the translation of your shapes is a solid time saver.

16.5 Relevant CD Files

- Girl_Green_Screen
- Girl_Stretching
- Man_mp3_Field
- Man_Pushup

CLOTHING

Unfortunately, not all your focus objects will be scantily clad. Sometimes this is a good thing and sometimes not, but not for the reasons you might be thinking.

Generally speaking, clothing reacts with the human body that's inside of it and moves naturally with the flow of the clothed individual. Pants can be isolated the way that legs and shirts can be rotoed like arms. The same general principles apply across the board where humans and clothing are concerned. Overall, clothing doesn't represent an overly tough focus object to isolate. It follows the laws of nature to the best of its ability and generally conforms to a consistent pattern of movement—generally speaking.

Like limbs, clothing will require more shapes around the joint areas or, more specifically, any place where the body bends. The nature of clothing is to bunch up and condense in and around places that bend. The good thing is that it will generally bunch the same way, so once you've isolated one set of bunches, you'll find that the next set will move in a similar fashion as well as having a similar shape breakdown.

17.1 Shape Breakdown

When clothing bunches, generally these bunches will keep their shape throughout the movement of the focus object. They will probably get smaller and closer together and sometimes disappear completely, but if you plan your shapes correctly, you can get a lot of use from those shapes and keep your matted edge consistent.

The edge in Figure 17.3 does seem to change a lot from frame to frame as our focus object bends. However, with the right shape breakdown, this edge in flux can be isolated easily, with little trouble.

Start as you always do and find an easy edge; stick with that edge until it stops being an edge or changes its shape so drastically it would require another shape. With bunching clothing, though,

Figure 17.1 Footage.

Figure 17.2 Focus edge.

Figure 17.3 Edge.

you'll find that you won't need as many transitions as you might think. Find edges that stay consistent, and isolate those edges first. Afterward, once you've isolated all the edges that don't change shape too much, your job is to go in and isolate the remaining edges that might not have a particular pattern or consistent shape.

Let's start with an easy edge.

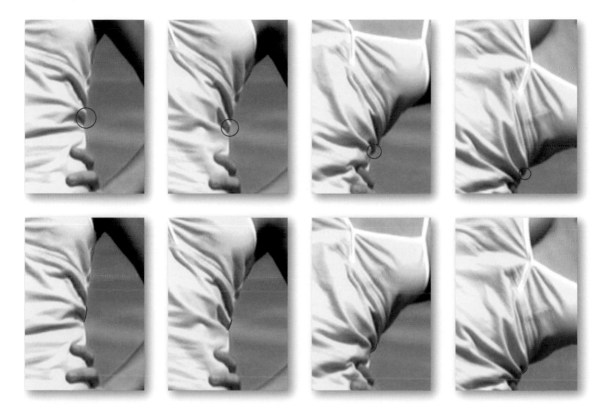

Figure 17.4 Focus edge.

The highlighted edge moves with our focus object and keeps its position relative to the surrounding shape for the duration of the move. Also note that the area of edge that the shape isolates at the beginning becomes significantly smaller as the figure bends.

Just like everything else, you'll want to create your shapes at the point where the focus object is clearest and most distinctive. In the case of our stretching woman, the best creation point is at the top of the movement, before the shirt begins to crunch in on itself. Creating shapes for clothing at the correct point in the footage can really extend the use of those shapes.

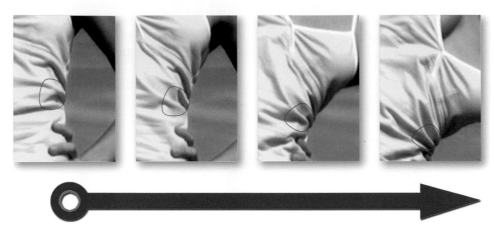

Figure 17.5 Shape.

This bunch of clothing, though moving and scaling with the rest of the focus object, keeps its general shape and relative position to the surrounding bunches. So the shape we used to isolate it didn't need too much manipulation.

Had we created the shape at the bottom of the movement, when the shape was condensed, we probably couldn't have used it for the duration of the movement without manipulating that shape's individual points. *When* you create your shapes with concern to clothing is very important. From here, we'll move on to an edge adjacent to the shape.

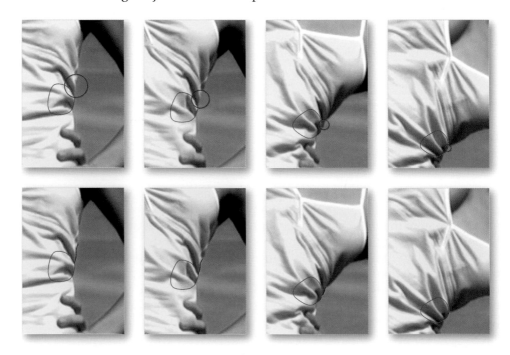

Figure 17.6 Focus edge.

This edge will include two ridges. When you combine folds, it is imperative that you keep the contour consistent with the ridges. Notice that by the end of the movements, this edge has nearly disappeared; the ridges melt into the rest of the folds.

Figure 17.7 Shape.

The green shape isolating this edge reacted the same way as the initial shape, changing its contour very little and keeping the same position relative to the surrounding bunches. When you use one shape to include multiple folds, you must keep the relative low and high points consistent. In some cases, keeping the shape consistent might require a bit of Sub-Object manipulation, but if it's kept to a minimum, the resulting matte won't have any jitter.

You might be wondering how these edges are being defined. The highlighted edges are being isolated by how and what the previous edge is isolating. Using your established shapes as reference for the surrounding shapes is a great way to establish a breakdown for your focus object.

The next edge overlaps the previous one a great deal. You'll find that when you're isolating bunching clothing, the shapes are going to overlap and, depending on the movement, these shapes might not always isolate as much as they did initially.

The bunch that started out as its own edge at the beginning of the movement melded into the fold underneath it, creating two shapes that end up isolating a similar edge. This will happen frequently as clothing bends, bunches, and folds. Remember, just because an edge stops being an edge, that doesn't mean it isn't there.

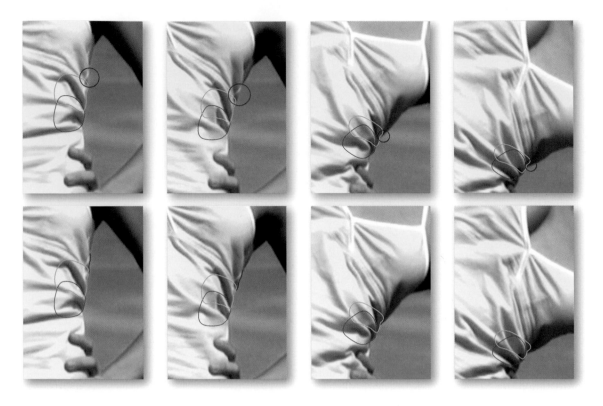

Figure 17.8 Focus edge.

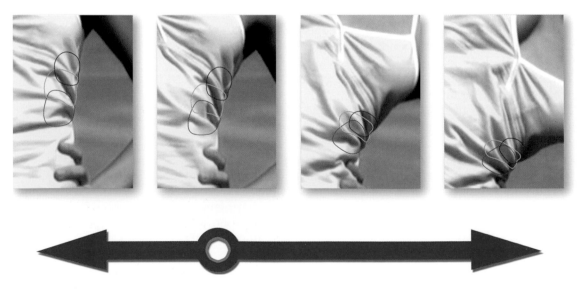

Figure 17.9 Shape.

This blue shape was created at the point at which its focus object was at its clearest and most distinct. That's why the edge seemed to overlap so much initially. When the edge was at its clearest, they were exactly that—edges. But as they moved, they gradually became less distinct; their actual edge, in relation to the whole edge, became smaller as the movement came to an end and the shirt condensed in on itself, creating folds.

Clothing shapes will overlap a lot, particularly if the article of clothing goes from a stretched position, resulting in a relatively straight edge that becomes a condensed edge with many bunches. The way these shapes intersect is key to communicating a believable and accurate edge. When you break down the edge of a clothing focus object, you'll want to end your shapes so that the adjacent shape will create a pleasing intersection between shapes. The intersection between shapes will create an accurate edge without the need for Sub-Object manipulation. Keeping your shapes consistent with their allotted edge is key to a consistent matte edge.

Look at the overall movement of the shapes as they compare with the movement of the focus object. The shapes themselves move, scale, and rotate like the edge of the focus object that they were created to isolate.

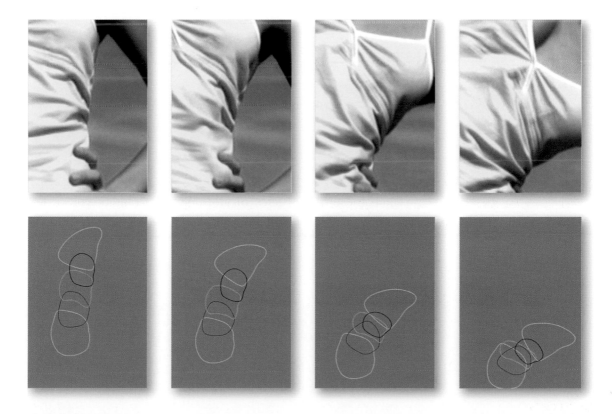

Figure 17.10

As you can tell, clothing as it bunches creates an ideal situation for easy shape breakdown.

Even in situations where there's no bunching to be had, the way clothing sits and hangs on the human figure creates perfectly distinguishable shapes that easily and accurately isolate the focus object.

Figure 17.11

As the woman moves, the clothing creates an ideal situation for your shape breakdown. The top around her midsection stays the same general shape, as do her pants.

Figure 17.12 Focus edge.

Once these two articles of clothing are isolated, you've left yourself her stomach, which can easily be defined by a shape that only needs to isolate the edge between her shirt and pants.

Figure 17.13

And if clothing bunches, it's a good bet that the human wearing that clothing is going to be doing that motion repetitively, so the shapes you used to isolate the bend one way can be used in reverse to isolate on the way back. Repeating shapes run rampant when it comes to isolating a clothed figure.

17.2 Consistent Point Placement

To create a shape that accurately isolates an edge of a ridged area of clothing, and that area, as is wont to happen, changes when the figure moves, you must keep the shapes consistent with the ridges that they were created to isolate from the get-go. If you create a shape that changes its position on the edge, moving to isolate another fold or bunch, the resulting matte will appear to slide, thus breaking your matte.

Clothing, like hair, can change its contour at the drop of a hat. Whether that motion is a big sweeping movement or a small, little-noticed gesture, the edge of your focus object is going to change, and your shapes are going to have to accurately isolate that rapidly changing edge.

Figure 17.14

Our well-dressed gentleman is putting his hand over his chest and in doing so has significantly altered the edge of his shoulder and sleeve. We're going to focus on his upper screen-left shoulder and sleeve for the moment.

Figure 17.15 Edge distortion.

This edge distortion is common enough in sturdy fabrics. The simple motion of moving his hand from his side to his chest has just wreaked havoc with the edges of his suit, which of course is our focus object.

There is a pattern to this movement, however. The key to creating a usable matte for this shot is to keep note of where the various folds and ridges appear and what they ultimately turn into.

In the first example, though there was significant edge change, the bunches were generally consistent and always visible as distinct edges. The indications of the various bunches and ridges in our current focus object are far less obvious.

To drive this point home, let's focus on one of the folds around the shoulder area.

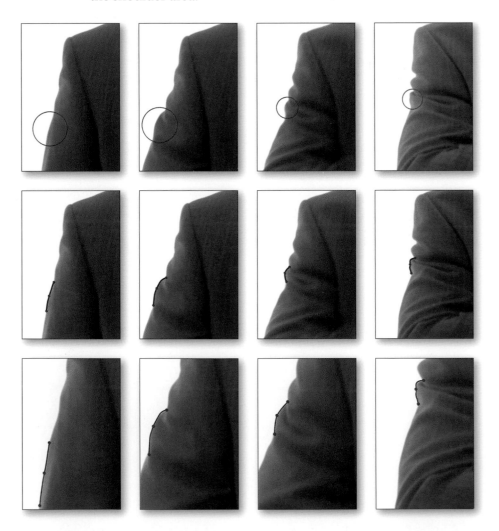

Figure 17.16 Focus edge.

This bunch starts out nearly straight, with only the mildest of indications that it will become a bunch. But as the shoulder and arm move, this mostly straight edge eventually becomes a very distinctive bit of edge that looks nothing like its original form. In addition to the very distinctive edge change, it has also forgone a significant position change as well. And the size of the edge in question shrinks considerably over time.

Furthermore, the final position of the bunch might be a bit tricky. For a majority of the frames, the edge section has a nice smooth curve as the focus object goes through the motion, but on the last frame it makes a drastic change in contour. What started out as very curved edge eventually becomes a shape with a significantly more complex contour.

When you create a shape to compensate for an edge like this, the best frame for the initial shape, generally created when that shape is at its most distinctive, is far too distinctive. We're talking about an edge that goes from one extreme to another. Were you to create the shape on the first frame, the shape would be flat and would require you to significantly alter the shape on a Sub-Object level. And creating the shape on the other extreme creates the same issue.

The best way around this particular situation would be to create the shape on the frame where the contour best represents the middle of the two extremes.

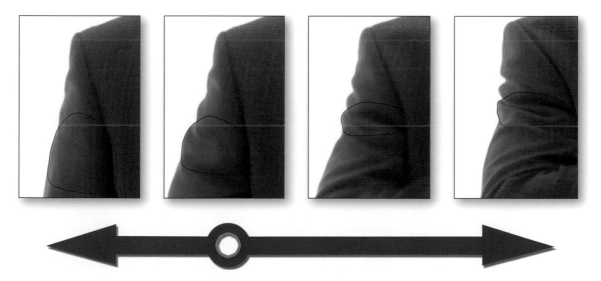

Figure 17.17 Shape.

When we create the shape on this frame, the contour of the shape is somewhere between both extreme positions, thus enabling us to manipulate that shape to compensate for both the extreme flat and extreme curve that the shape undergoes.

Keep in mind, though, a shape that changes its edges this much is going to require some amount of Sub-Object manipulation, but we're trying to isolate this edge with as little of it as possible.

Keeping your point locations consistent on clothing is very important. Clothing bunches and folds in all sorts of ways, but one of the most important things about clothing is that it bunches and folds consistently. When a bunch of clothing sits along a particular place along an edge, when that edge moves, chances are that the specific bunch is either going to flatten out or increase its bunchiness at the same place it was along the edge.

In the case of our suited fellow, the points that sit at the various creases and ridges along the edge of the focus object must always stay in their relative position to that focus object's edge, even if that edge changes as drastically as this one is.

Figure 17.18 Point placement.

Figure 17.19 Points at the base of the bunch.

In Figure 17.19, you can see that the points of this shape stay at their relative positions to the ridge's base, and it is key that they do (another pun; what a surprise).

Figure 17.20 Points at the top of the bunch.

Take note of the placement of the points on top of the ridge in Figure 17.20. The red highlighted point represents the top of the ridge. Even when that ridge becomes convex on the final position of the bunch, it still keeps its position as center point between the points at the base of the fold. The lighter points surrounding the red point also keep their position as in-between points between the top and base points.

If the points of spline don't stay with their respective edge junctions, the resulting matte will have "traveling" points, meaning that as the computer generates the in-betweens for your key frames, the ridges and hollows of the shape will move inconsistently and appear to travel along the edge of the focus object. Suffice it to say, this is bad.

You might be thinking that there are an awful lot of points at the edge of this spline, and you would be correct in thinking so. At the point in the timeline at which this shape was created, a seeming overabundance of control points was placed at the edge of this focus object. The extra points, though not exactly necessary on this shape's inception, are entirely necessary on the shape's final position. The edge changes so drastically for the final movements that the extra points serve to give us more control over the shape, keeping it consistent with the focus object, and allow the shape to be more malleable.

It would be entirely possible to create several different shapes and then transition between them to isolate this particular fold, but with the complexity of shape and fluidity of movement, you probably would have spent just as much time getting the shapes to match as they transitioned to the next.

The rest of the folds will follow suit (sigh). All the individual edges will keep their relative proportions and position to one another. When you're working on clothed edges that change their

shape with such frequency and degree, you must keep the shapes consistent with the edges they were originally created to isolate.

17.3 Secondary Motion

In animation terms, secondary motion is a movement that is triggered by another, primary movement. Any animator can tell you that accurately creating believable secondary motion is no simple task. There are all sorts of factors that, if handled incorrectly, will keep the animation from selling the realism.

The same is true for rotoscoping. We're simply mimicking the movement of our focus objects, so our task is infinitely easier in one sense. But there is a trick to it, particularly with clothing.

You'll find all sorts of secondary motion when you're creating mattes for a clothed figure. Most of it will be small shifts as the clothing moves and settles around the limb it's covering. Sometimes, however, you'll find that the clothing moves with a motion path that does mimic the body part inside but, given the loose nature of some clothing, doesn't follow the same key framing structure.

When rotoing a figure with loose clothing, start with an established part of the body that the clothing is on. For example, if a woman is wearing a flowing pair of pants, start with the foot. Once the foot is rotoed, you can use the foot key frames as a guide to establish a loose set of key frames for the loose part of the pants. With a rough idea of the major keys, all you have to do is establish the secondary keys for the secondary motion, which will have placement around the keys you've already established for the foot.

Let's take a look at some striped socks, shall we? For this exercise we're going to focus on her screen-right leg.

Figure 17.21

In a situation like this, you'll want to first isolate the part of the focus object that is the most easily identifiable, which in this case is the foot. The striped sock on the foot is more or less skin tight, so the motion of this focus object won't differ any from the limb that it's covering, which means that this particular section of the focus object won't have any secondary motion.

Figure 17.22 Foot/ankle shapes.

The jeans cuffs, however, are a different story. The cuffed bottom starts essentially settled, hanging without motion over the striped sock. As the leg moves, the jeans move with it, but at a slightly delayed response. When the foot and ankle reach their stopping points, the cuffs are still a frame or two behind the movement and continue to move, despite that fact that the limb inside them has ceased to move. The cuff eventually settles into what essentially was their starting position at the beginning of the movement, but it did so at a completely different rate from the socked foot.

Figure 17.23 Cuff motion.

That's why we started by isolating the foot. The key framing pattern established by the foot can serve as a guide to the shapes that we'll use to isolate the lower pant. We know that when the foot stops, the cuffed jeans bottom will continue to move. If we establish the stopping point of the foot, we've established a rough idea of where the cuff will stop. At whatever point the foot stops, the cuff will generally be a few frames behind it.

Foot stopping
point.

Cuff stopping
point.

Figure 17.24

When the foot/ankle stops, the jeans continue to move forward until they hit the ankle inside them. Then they spend the next few frames settling into place, eventually coming to a stop.

Furthermore, the sections of the jeans are all moving differently. As the leg moves, the jeans are reacting to the movement of the leg inside them, but not all the sections of jeans are reacting in the same manner. The top of the jeans, around the thigh area, isn't going to have as much secondary motion, because it's traveling a far less distance and doesn't have as much room to shift around the leg as the cuff does.

When you're isolating an article of clothing that has this sort of secondary motion, you have to take into account the limb inside that article, even if that limb doesn't represent any real edge as it relates to the matte.

17.4 Review

- Clothing will require more shapes around areas of the body that bend.
- Isolate the areas of clothing that will require the least amount of work first, and then move on to steadily more complex shapes.
- Clothing represents a focus object with a relatively straightforward shape breakdown.
- Just like everything else, you'll want to create the shapes on frames where they are most easily distinguishable.
- When you're isolating clothing that bunches, you must keep your shapes consistent with what they were originally created to isolate. This will avoid traveling points.
- Bunches of clothing will often only scale and move with the clothed person and not alter its general shape to any great extent.
- Referencing point placement is a particularly effective tool for creating clothing mattes quickly.

- Correctly overlapping your shapes will lead to accurate clothing mattes.
- Use the body part occupying the article of clothing to define an appropriate key framing pattern. This is particularly useful when the clothing has significant amounts of secondary motion.

17.5 Relevant CD Files

- Girl_Stretching
- Man_in_Suit

18

KEEPING FOCUS AND
GETTING WORK

There is a truly satisfying sense of completion when you finish a particularly tough shot. After time spent hunting for the fastest way to a completed task, you'll find yourself in a very centered place, knowing that you accurately isolated a complex focus object.

But before you can complete a shot, you've got to start it. Every final matte has been started with a single spline. When you're first starting out on a shot, you'll gradually find yourself slowly tuning out the outside noises; then, without realizing it, you've quite unexpectedly entered a mental state referred to as *the Zone*. In this frame of mind, all other things are far away and the only thing in your world are the mattes in front of you.

This mental perspective can be hard to achieve, but given the correct tools and the right amount of introspection, consistently entering this place becomes something of an easy habit.

There's no one way to narrow a person's focus; everyone is different.

Listening to music is a great way to bring down the outside distractions. Another auditory means of focus roto artists often use is audio books.

But these things can also be a distraction, too, so when choosing a selection of music or an audio book to aid you in your workday, make sure it's something you're familiar with. You'll want to find something that will be running in the background essentially; not something that will continually cause your focus to drift from the work at hand.

Don't listen to a new band that you've just discovered. Though you might learn to enjoy their music, it's new to you, so it might pull your focus away from your shapes and key frames while you discover a new favorite band. A better choice would be a selection of bands and artists that you know well and have heard before. Your old favorites will serve as perfect background noise and enable you to focus on what's in front of you.

Or pick a favorite book, one you've read a dozen times and can quote from without thinking, and get the audio version of it.

It will keep you focused because you know the innermost details of this book and don't have to necessarily pay proper attention to it. And since it's your favorite book, it will keep you amused while you're creating mattes. That's another great thing about audio books; a good one will last for days.

Whatever you choose, you need to know what environmental stimuli, or lack thereof, will create the best situation in which you will be able to keep focus on what you're doing for the longest amount of time. Dissect your work habits, experiment with different work environments, and get to know yourself and how your mind works. Knowing how you work and what things will keep you working is vital to becoming a reliable professional.

Everyone works differently. The key to becoming a solid roto artist is distinguishing between what motivates you to work faster and what is distracts you from accomplishing your goals.

At the beginning of your tenure in the roto world, you might find that as you're learning the ins and outs of the basics, you might not want to have any sort of background noise. But as you gradually become more accustomed to the principles and techniques of roto, you'll find that you can gradually increase the level of outside distraction. Once you've got a solid grasp of this art form, you won't find it necessary to limit the amount of stimuli with which you surround yourself while you create mattes.

18.1 Bad Habits

No matter how long you've been creating mattes, at some point you're going to realize that you've fallen into work habits that don't necessarily lend themselves to the fastest route to speedy matte creation.

One day you realize that you've been overmanipulating your shapes on the Sub-Object level, or the shapes you've been using have far too many points on them. It happens to everyone at some point or another. The point is that you *need to realize* you've fallen into these habits. If you continue working inefficiently, you're not going to improve. And not fixing these habits might have a more dire effect: You might actually become slower.

So, when you come to the realization that you've started creating your shapes on the most inconvenient frames or you've become lazy with your edge detail, stop and look at what you're doing. Then ask yourself why that particular habit is wrong and why it isn't the best way to go about doing things.

Once you've answered those questions and found ways to improve, you should then think back to why you started down this road in the first place and make choices that will actively prevent you from falling back into these bad habits.

But it does happen to everyone, so don't get too down on yourself. Everyone from first-year VFX students to seasoned professionals falls into roto habits that don't lend themselves to a quick and accurate pace.

18.2 Estimating a Job

Way back in Chapter 4 we mentioned projecting how much time a shot is going to take. It was just a tiny paragraph that didn't draw any attention to itself or distinguish itself in any way. It was a sleeper paragraph that has just been activated.

Projecting how long a shot is going to take is a particularly important aspect of a roto artist's life. Now that you've had a chance to see what sorts of focus objects and motions will take a bit longer than others, it's time we got into the specifics of projecting how long a shot will take. There are several things to consider when someone asks how long it will take you to do a particular shot.

First and foremost, you need to nail down exactly how many frames make up the shot. Rotoscoping is largely a frame-by-frame business, and though there are ways around working on a shot on a per-frame basis, sometimes a shot will require you to make key frames on every frame. It's just the nature of some shots. As we've mentioned, sometimes there isn't an elegant solution; you just need to hunker down and make the key frames. Getting specifics about the frame count is a must when you're projecting a timeframe for the completion of a shot.

Next, you need to get specific about what exactly you're being asked to isolate. The focus object will need to be explicitly detailed to you if you're going to give an accurate account of the time a particular shot will take you. You'll need to ask questions like:

- "When you say you want the man isolated, do you mean all of him, including his cape, antennae, and the flecks of hair that are protruding from his shoulders?"
- "Do you need a matte for the whole goat or just the bits of it that rise above the horizon line?"

And what is that focus object doing? If you're being asked to isolate a person, is that person standing still, or is that person jumping around without any noticeable pattern? A focus object that is following a set pattern of movement, or at least an easily definable one, is going to take less time than one that is moving at random.

In addition, a human figure, no matter how still or unmoving it seems to be, will always have some bit of minor movement. That minor movement will generally always take longer to isolate

than, say, a bunch of buildings on a skyline. Unless the camera has an inordinate amount of movement, the buildings will always keep the same shape they began with, versus humans, with their multijointed, multisegmented, ever-moving bodies.

The matter of defining the specifics of your focus object is probably the most important thing to nail down. A focus object, like a ball or an airplane, can be broken down very easily into simple shapes that very probably won't change much over time. However, a focus object with flailing limbs mixed randomly with sudden moments of subtle movement is going to require a more complex shape breakdown.

Here's a simple rule: The greater number of shapes a focus object will require, the longer it's going to take to isolate.

How much your focus object's edges change over the course of the shot is a huge factor. Something like hair or bunching clothing can shift its edge very quickly, which will require you to transition between many shapes or manipulate those shapes on a Sub-Object level, both of which take time. In the hair chapter, you saw the amount of time and effort a complex hair shot can take, so when you're handed a shot where the focus object has a full head of complex and breeze-ridden hair, you might want to get the minimum level of detail required for the final matte.

Minimum level of detail doesn't only apply to hair. On occasion, you'll run into a situation where the tiny holes that appear as fingers flex and move don't necessarily need to be compensated for. Instead of creating a bunch of separate shapes for that hand, you'll be able to create one large shape that encompasses the whole hand.

Or how about an article of clothing with fine ridges on its edge? You'll need to specify whether you can keep the edge general or if those ridges need to be accounted for individually. Finding out this sort of thing beforehand can really help when it comes to projecting a timeline.

Which leads us to the next item of detail: What exactly will the matte be used for?

If the matte is just being used as a minor color correction to a specific area of the shot, chances are the matte doesn't have to be as detailed as a matte being used to isolate an actor for an entire background replacement. Some items in the matte might require more detail than others. For instance, you should probably spend more time on the matte for a character in the center of the frame versus one in the far background behind an out-of-focus tree.

A locked-off shot is significantly easier to roto than one with camera pivots and tilts. And if the shot has a lot of complex camera movement, you need to find out whether there are elements in that footage that can be stabilized. Or in a shot with a moving camera, you'll need to know whether the focus objects within

that shot have a lot of movement. Chances are, the motion generated by a jittery shot won't have any linkable reference to the figures moving within that shot. A shot with a moving camera that is following people who are also moving can represent a pretty tough matte to create.

Something else to be aware of when projecting your timeline for shot completion is where you'll be doing the work and with what software. If the job is freelance, most times you'll be at home in your pajamas, working on your own system, using software with which you're intimately familiar.

If, however, you're being pulled on site, working at a company's facilities, you might be required to work with unfamiliar proprietary software, which would definitely increase the amount of time a shot (or shots) will take. Luckily the tools for roto don't vary much from software to software, so the learning curve for each one won't be enormous, but you've got to take this sort of thing into account when you're figuring out how long a shot is going to take.

After finding out all this information, you need to measure your skill level versus the complexity of the shot. This is particularly tough when you're just starting out, because you haven't anything to use as a reference. In the beginning of your rotoscoping education, you might just want to double whatever your initial estimate is. There's no shame in being honest about a shot, particularly if you're just starting out.

You'll also need to consider your strengths. People have different levels of expertise and areas in which they excel and others where they might need some time to hone their skills. You'll need to know what you do well and what you don't, if you're going to give accurate accounts of your time.

If you've handled something with similar issues in the past, you can use the lessons learned from that experience to project the amount of time that shot might take you. If you handled the previous shot in 5 hours and you feel that the new shot is similar in content and will require a similar workflow, committing to 5 hours is a completely logical thing to do.

If you've never dealt with a particular element or technique in a professional sense, you definitely want to factor that into the estimate of time that shot is going to take.

If a shot contains unknown variables, you'll want to pad the estimate a bit—not to any great extent but enough where when something comes up that you didn't foresee as a problem, you'd have a few spare hours to handle the issue.

Yet another factor is when the actual matte is due. Generally speaking, when you get a shot, the deadline is a fixed thing, without much room for negotiation. When you accept a shot with a fixed deadline, you're committing to completing that shot in that allotted amount of time.

This is why knowing how long a shot will take is so important. The worst thing a roto artist can do is take longer than was projected. It's the sort of thing that will be tolerated once, or maybe twice, but consistently underestimating the time a shot will take will cost you work.

If you don't think you can do the shot in the amount of time that the deadline will permit, say so. Depending on the manner and complexity of the particular shot, it might just be a matter of splitting up the focus objects among a few artists, or dividing up the frames, or even splitting up a single focus object into separate parts.

If you're given 10 hours to complete a shot, you need to be able to complete that shot within the deadline. If you don't think that it's possible, explain why.

The "why" is very important. If you simply say that you can't do it and leave it at that, the perception might be that you have no idea what you're talking about. However, if you explain why you don't think it's possible, and you do so in a professional and straightforward manner, you're saying that you can't finish the shot under these time constraints and circumstances but that it isn't your personal skill level that is lacking; rather, it is that the client-projected deadline was perhaps a bit unrealistic.

Take careful note of how you phrase that last bit. Politely telling a client why the deadline isn't realistic is a lot different from saying you lack the ability and skill level to complete the shot within the suggested timeframe. Remember, you want these people to keep sending you work.

18.3 Pacing Yourself

Don't get overly cerebral with your matte creation. You do want to find way around working with the footage on a per-frame basis, but you don't want to spend half the allotted time piddling away at a clever technique that won't ultimately get the job done.

It is absolutely suggested that you spend a short amount of time at the beginning of a shot to see whether you can pull a luminance key from the sky or if the limbs of a spastic human figure can be tracked into a shot, but don't spend an inordinate amount of time doing these tasks. If no shortcuts are available, you've got to know when it's time to buckle down and start making shapes.

A great way to find an even pace at which you can complete a shot in the allotted time is to divide your frame ranges into sections that directly correlate with how much time you've got to finish the shot.

Let's say that you've got 8 hours to finish 100 frames of articulate roto. Right off the bat, you know that when you divide 100 by

8 you'll get 12.5. That means that you'll have to complete around 12 or 13 frames every hour. If you work with those figures in mind, you'll have a decent idea of how much work needs to be done and how fast you'll need to do it.

Another way to go about creating an estimate is to divide the sections of the focus object and set up a timeframe in which you work a certain amount of time on the individual sections of the focus object. For instance, if the job in front of you has a figure doing relatively uncomplicated movements over the course of 100 frames, you could separate the body into six sections:

- Screen-right arm
- Screen-left arm
- Screen-left leg
- Screen-right leg
- Torso
- Head (for the sake of our example, let's say that it is a bald person)

With the figure sectioned off into those six sections, you then divide the 100 frames by the six sections of the focus object. This means that you can spend about an hour and a half on each of the sections of the focus object.

Both of these methods are excellent for accurate and timely completion of a shot, but it isn't always so straightforward. The movement or complexity of the focus object might require you to spend a longer time focusing on one section of the shot whereas other parts won't require as much of your attention. You must take the movement and complexity of the focus object into account when you're dividing up the allotted time on a frame-per-hour or a section-per-hour basis.

Most important, no matter how you choose to divvy up your time, don't get bogged down in the details. Yes, roto is a very detail-oriented practice, and you should create mattes that accurately reflect the edge and movement of the focus object, but getting sucked into tweaking each point along each spline is a terribly seductive quagmire. Sure, you might have created an ideal matte for 10 frames, but if the other 90 frames aren't perfect, what was the point? And if you spent an hour perfecting those 10 frames, that's great, but if the shot has 100 frames total and you've only got 6 more hours until the matte is due, you might want to rethink your approach.

Sticking to your personal shot completion schedule is important, but there are times when you just can't stare at a particular part of a focus object any longer. If spending any more time isolating the pixel-thin blonde hair gently waving on a cream-colored background would perhaps drive you to become a less than ideal cubical mate, you could take a break from that section of your matte.

If you find yourself tiring of a specific part of the focus object or you're having a tough time figuring out a shape breakdown or key framing method, step back and find an easy edge. Look for a shape within your focus object that you can isolate without too much effort. When that edge is done, find another easy edge, then another. Eventually you'll find yourself back at the troublesome section of your focus object. But instead of being intimidated and unable to complete that section, you'll now find that the other edges gave you insight into what you were missing in relation to the trouble edge, and you'll strike out at that edge with a newfound vigor and see immediately what solution will bring the fastest closure.

Every shot is different, so each shot will bring its own set of challenges. You'll probably be working on considerably different focus objects during your time as a roto artist, so it stands to reason that there might be a learning curve between the particular shots that you work on.

You might find yourself in the middle of a particularly tough shot and suddenly realize that there is a much faster way to do what you're doing. When you get to this point, you have to weigh how much you've finished against how much needs done versus how much time the new way of doing things will save you. If you find that the new perspective or technique will give you ample time to complete the shot, by all means, shift your workflow. But if the new approach will only make what you've already accomplished more complicated, continue on as you were.

Remember this, though: There is no one way to do anything as it pertains to roto. Being flexible with your key framing methods and shape breakdowns will often lead you to much more cohesive ways of working.

18.4 Getting (and Keeping) a Job

If you've chosen rotoscoping as your career choice, it might be a bit slow going at the start. Landing that first job right out of school is always the hardest. You've got a solid education and a healthy knowledge about whatever your particular focus is, but your résumé is probably a bit thin. Even if your reel is all sorts of amazing, if you don't look good on paper your chances of getting a job in the industry lean more toward the thin side.

Remember this, though: Companies always need roto artists. Whether the company is an established giant or a scrawny startup, most production facilities will need roto artists to create mattes for the compositors. And you, as the lover of mattes, will fill this need very easily. If you do your job with accuracy and within the deadlines, your career will flourish.

Roto work isn't something you necessarily have to be on location to do. There are tons of freelance opportunities that won't require you to even leave your work area.

Since a majority of our deliverables are just black-and-white frames, the time it takes to transfer your matte is very minor. This means that VFX hubs like Los Angeles and New York are only an FTP site away from your getting constant work in the industry.

You might not want to be a roto artist for your entire career, though, and that is completely understandable. This job isn't for everyone. But if you're reading this book, chances are your goals relate in some way, shape (total accident, that pun), or form to gaining a job in the VFX industry.

You, the budding compositor, can use the underdeveloped status of roto artists to your advantage. Honing your skills as a roto artist is often the foothold you'll need to get that first job in a production house. It is often the case that compositors start their careers in the roto department.

The skill set that comes from creating accurate mattes in a timely manner comes in handy in all aspects of the VFX industry. Roto artists tend to have an almost maniacal attention to detail and the ability to spot minor inaccuracies. Both of these traits are advantageous when you're looking to find work in the industry.

Roto is often considered an entry-level job. By no means is what we do simple or easy, but the caste system of the industry generally puts roto artists toward the bottom of the heap. Now, you could take that information and justify a complete ignorance of the art and technique of rotoscoping.

Or you could use that system to your advantage.

That position as a roto artist might be just the starting point for you to break out as a compositor, or match mover, or whatever your particular focus is. Companies generally always prefer to hire from within. It saves on paperwork, and it creates a whole department of established references that already work for the company. Developing positive relationships with people in the industry is always a good idea.

INDEX